2

SEVEN AGES OF BRITAIN

Also by David Dimbleby

HOW WE BUILT BRITAIN

A PICTURE OF BRITAIN

AN OCEAN APART
(with David Reynolds)

SEVEN AGES OF BRITAIN

THE STORY OF OUR NATION REVEALED BY ITS TREASURES

DAVID DIMBLEBY

MARTIN CARVER
JOHN GOODALL
SUSAN DORAN
CATHARINE MACLEOD
JOHN STYLES
LAWRENCE JAMES
FRANCES SPALDING

HODDER &
STOUGHTON

First published in Great Britain in 2009 by Hodder & Stoughton
An Hachette UK company

I

Copyright © David Dimbleby 2009

By arrangement with the BBC
The BBC logo is a registered trademark of the British Broadcasting Corporation
and is used under licence
BBC logo © BBC 1996

Seven Ages of Britain is a BBC/OU co-production and the Open University have produced a booklet entitled *Exploring History*. For your free copy call 0845 366 8012 or visit their website at www.open.ac.uk/openlearn

A CIP catalogue record for this title is available from the British Library.

ISBN 978 0 340 99408 5

Designed by Will Webb Design Ltd
Typeset in Gill Sans

Printed and bound by Graphicom, Italy
Hodder & Stoughton policy is to use papers that are natural, renewable and recyclable products and made from wood grown in sustainable forests. The logging and manufacturing processes are expected to conform to the environmental regulations of the country of origin.

Hodder & Stoughton Ltd
338 Euston Road
London NWI 3BH

www.hodder.co.uk

TO MY MOTHER

Contents

INTRODUCTION

BY DAVID DIMBLEBY

The past can be reconstructed in many ways. It may be through the study of old documents, or diaries and essays. It may be through visiting castles and palaces and grand houses. Or it may be through seeing art and handling objects that bring the past to life. This last path is the route chosen for this book.

I live in an old house, part sixteenth- or seventeenth-century, part Victorian. People have lived on the site long before that, but few traces of their homes remain. I have a print of a mansion that stood on the lawn two hundred years ago and when the grass is dry you can still trace the outline of its foundations. I sometimes try to picture the people who saw many of the same sights that I see, who walked down the same tracks. But one small object in the house brings the past alive for me more than any other. It is neither very distinguished, nor very beautiful, but it draws me back in time. It is the brass plate on our sitting room door – designed to stop the paint being discoloured by finger marks. The brass is thin and worn, its embossed border and criss-cross floral decoration now rimed with traces of brass polish. There is something simple and homely about this brass plate. Every time I open the door I think of previous generations who have come into the sitting room on all kinds of missions. I imagine a father exhausted after a day's work looking for a little peace to sit in his favourite chair. A child in her new dress bursting into the room to join the Christmas party. Solemn moments when death or war have preoccupied the family. Joyous moments of birth and weddings and celebration. All brought alive by this simple brass door plate – which each of them would have touched as I touch it now.

One evening while working on *Seven Ages of Britain* I was sitting in the Ashmolean Museum in Oxford after closing time. The last visitors had been ushered out and the galleries were empty. In my hand I held a small jewel, just over two inches long. It was pear shaped and made of gold. The main part was a piece of thick-cut crystal which protected a fine enamel picture of a man with a flower in each hand. At one end of the jewel was the head of an animal with its jaws clenched round a short hollow tube which looks as though it was designed to hold something which had gone missing.

This strange object was found on a peat moor on the Somerset Levels, the marshy land drained by ditches and canals in the northern part of the county between the Quantock and the Mendip Hills. It was here that King Alfred of Wessex (Alfred the Great) took refuge from the Viking invaders of England in the ninth century. He fortified a hill that rose out of these wetlands at a place called Athelney. Here he

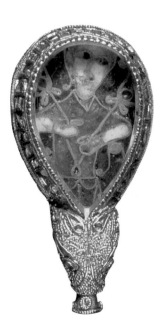

The Alfred Jewel. Mysterious fine gold and crystal jewel thought to have been given by King Alfred to his bishops, perhaps as a pointer for reading the Bible.

The Abbey of Iona with one of the Celtic Crosses that mark the arrival of Christianity from Ireland.

regrouped his army and drove the Vikings out of Wessex and out of England altogether. As King of England he returned to Athelney and built a monastery to commemorate his victory. This jewel that I was holding was found near Athelney in 1693, eight hundred years after Alfred's victory. But the Alfred Jewel, as it is known, dates back to that time. The gold and decoration is agreed to be of the Anglo-Saxon period but it is the inscription around the jewel that is really enticing. It is written in Latin script but uses old English words. It reads: 'Alfred ordered me to be made'.

No one can know for certain, but the likelihood is that this jewel was commissioned by King Alfred and most probably, according to the experts, given to his bishops to use when reading the Bible. They believe the hollow tube in the mouth of the beast would have held a piece of ivory or wood and it would have served as a pointer to follow the lines of text. To this day rabbis use a similar pointer called a yad to read from the Torah so that the human hand will not touch the book. If this interpretation is true, and it sounds convincing, I was holding in my hand an object held by Alfred the Great and presented by him to one of his bishops. Until this moment I had only thought about him as a figure of myth: the king who burnt the peasant woman's cakes while in

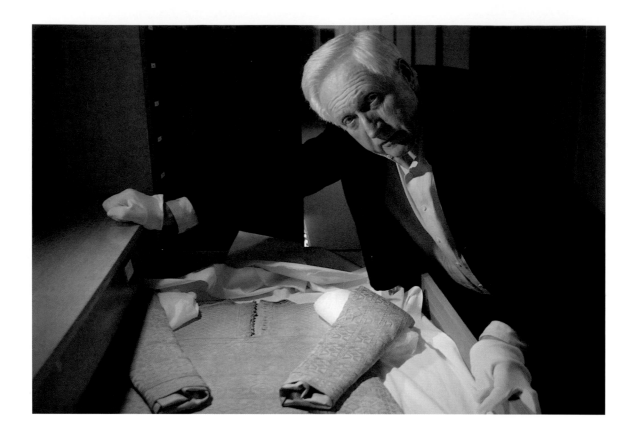

This stained shirt is kept in a drawer in the Museum of London. It was worn by Charles I at his execution.

hiding from the Vikings. Suddenly he had become a real person to me, just as the earlier families who lived in my house come alive when I see the brass door plate. Little things that bring the past alive.

Time after time in choosing the objects to illustrate the *Seven Ages of Britain* I have had the same emotion, of being connected to the past by something vivid, something real, whether a work of art or a book, or even, as with the stained waistcoat Charles I wore to the scaffold, a piece of clothing. These objects are not picked at random but are designed to serve a purpose: to illustrate what seems to be the prevailing mood of an age. The ages themselves do not fit any regular chronological pattern but are each chosen to illuminate a theme: the power of the church and dominance of religion, the power of the monarchy, the wealth of Britain as a trading nation and as an Empire, and running throughout, a description of changing morals and behaviour, different intellectual attitudes and curiosities. The whole makes up a portrait of a nation seen through its art and its treasures.

Our first age, the Age of Conquest, begins with the Roman invasion, the first era which has left behind sufficient material to identify the character of the occupation and its impact on British life. Most reminders of the Roman presence in Britain are peaceful, give or take a

fortified town or Hadrian's Wall. It is the remnants of Roman villas with their fine mosaic floors or the dazzling collection of Roman silver decorated with exuberant dancing girls, which thrilled me in the British Museum, that are most striking. It looks for all the world as though the Romans were benign conquerors welcomed with open arms. A visit to the ruins of Aphrodisias in Turkey changed my perception.

In the 1980s archaeologists discovered a set of marble reliefs at Aphrodisias. Among them was one showing the Emperor Claudius threatening and dominating the half-naked figure of Britannia. They are clearly named on the relief. Claudius has one knee firmly planted on Britannia's thigh, is pulling back her hair, and seems to be brandishing his sword at her neck. Rape or murder is threatened. The name Britannia was first used when we were conquered by Rome and given a female name like most provinces. Here in Turkey, on the eastern border of the Roman Empire, I was seeing Britain's humiliation at the hands of Rome, a sculpture designed to remind all her subjects that the Empire was invincible.

The demise of Rome was followed by the dominance of the Anglo-Saxons who came across the North Sea. Their sophisticated taste was revealed by the great hoard of treasure discovered at Sutton Hoo on the River Deben just before the Second World War. It had long been recognised that the great mounds of earth on the slopes above the river were likely to be a king's grave site but they had never been excavated. When the work began it revealed a burial ship and within it fine jewels: an engraved helmet of intricate design and, most exciting of all, belt buckles and shoulder clasps for a cloak, each decorated with delicate patterns and animal figures made of enamel and garnets, the garnets thought to have come from Afghanistan or India. The recent spectacular find of a hoard of gold in Staffordshire, three times the weight of the gold at Sutton Hoo, promises more evidence of the sophistication of our Anglo-Saxon ancestors.

The Age of Conquest ends with the Norman Invasion, the last large-scale invasion of Britain. Its brutality and the imposition of its alien culture and language only serve to highlight the originality and artistry of the Anglo-Saxon era. Some historians think this view is a sentimental fantasy, but to trace what remains of that time is inevitably to feel that much was lost at the Norman Conquest. I felt it when I stood in front of a Celtic cross on Iona, its granite eroded by centuries of fierce winds so that it looked like melted wax, a remnant of the arrival of Christianity from Ireland in the sixth century. I felt it when I held in my hands the heavy illuminated Bible made by the

monks of Wearmouth Jarrow in north-east England to be presented to the Pope in Rome. In Oxford I was awestruck to be allowed to turn the pages of King Alfred's own translation from Latin into Anglo-Saxon of Pope Gregory's wise words on pastoral care. There may be only a few buildings still standing, only a handful of fine objects, and a language that we cannot now speak, but it is enough to suggest a rich culture diminished by conquest.

Religious belief dominates our second age, the Age of Worship. Of all the ages this is perhaps the hardest to penetrate. Britain is a largely secular nation today, where many have no faith. It makes it difficult fully to grasp the impact of faith on a society dominated by religion. I attempted to immerse myself in the manifestations of faith as a way of understanding its hold on medieval man.

My search meant spending a morning suspended in a harness forty feet above the aisle of the Holy Trinity Church in Coventry, just next to the ruins of the old Coventry Cathedral. I do not enjoy heights but being hoisted up to the arch separating nave from chancel was the only way of seeing what I had come to see: one of the finest Doom paintings of the Middle Ages, only recently restored to its full glory. This Doom is a vivid, even lurid portrayal of the day of judgement. On the left side the dead are roused from their tombs and called to be judged. On the right side the wrongdoers are punished. The good ascend to heaven. Their trajectory is less dramatic than the sinners' descent into the jaws of hell. There, by my right foot, as I dangled in the air, were demons and monsters. The damned, chained together, were led down to the jaws of a monster baring its teeth. A group of women, who had watered down the beer they sold, were led to hell too – a salutary warning to Coventry's inn-keepers. The significance of this painting, generally held to be the best of its kind in Britain, is less its artistic merit than what it says about religious belief at the time it was painted, probably around 1400. The images are almost comic to us now but when they were first unveiled they carried a powerful message: there is a choice to be made. One way incurs the threat of damnation, the other offers the path to salvation. It was with both physical and spiritual relief that I was lowered back to terra firma.

Another insight into medieval faith came from some tiny lead and tin badges, no more than an inch or two wide, which were found on the mud banks of the Thames. They are called touch relics, in reality souvenirs bought by pilgrims who visited Canterbury to pray at the shrine of Thomas Becket, the murdered Archbishop. It was thought that touching Becket's shrine with these badges would protect the

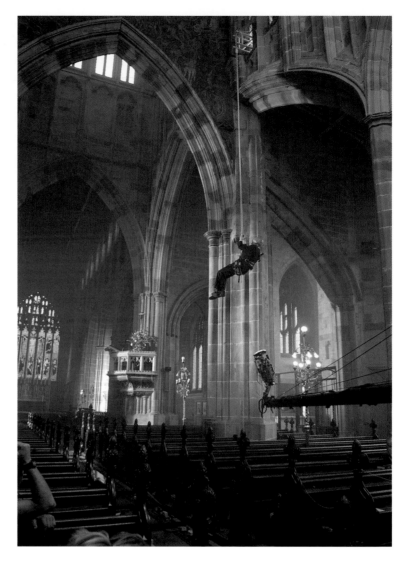

Not an elegant ascent, but the only way to have a close up view of the painting of the Last Judgment – the Doom – in the Church of the Holy Trinity, Coventry.

wearer from harm. Many also bought a phial of what purported to be Becket's blood as further protection. The badges are beautifully crafted. The most original example has Thomas coming back to England by ship shortly before his murder in the Cathedral. He stands, an unmistakable figure, looking ahead as a sailor adjusts the rigging of the ship. They sell replicas of these in the Cathedral today. I took the originals back to Canterbury and showed them to visitors in the cloisters, who were duly astonished.

The dominance of this belief in religion and the afterlife makes Henry VIII's break from Rome and his destruction of the monasteries seem all the more daring. He confronted his people with a challenge that threatened their immortal souls. He and his successor Elizabeth I are at the heart of our third age: the Age of Power. Much more is

known about this period of our history than any previous period. It abounds in powerful images ranging from the image of the dissolute Henry and his many wives to the picture of a Virgin Queen leading her country to greatness.

Henry's reign began in splendid style. He was a tall, handsome, energetic king, with great ambitions for his country. The painting at Hampton Court Palace of the *Field of Cloth of Gold* shows Henry at the high point of his career, meeting the King of France, François I, in an attempt to secure peace between England and her old enemy. The peace lasted less than a year but the two weeks of celebration is unsurpassed. Look carefully at the detail and you can see the palace of canvas and wood built like a stage set which was the centrepiece of the event. It is said that six thousand workers arrived in France to build it. In front of it stands a fountain flowing with wine and all around is the golden tented encampment from which the event takes its name. Henry, who was a vain young man, had taken great trouble before he went to France to find out how he compared physically with the French King. The Venetian ambassador to London records how he was quizzed by Henry on François' height and the size of his thighs. After swearing friendship the two kings dined together and danced, and they jousted and wrestled with each other in a trial of strength. The climax was a Mass celebrated by Wolsey before which, to universal astonishment, a giant firework in the shape of a dragon belching flames flew through the sky. All is recorded in the painting. It is Henry's moment of triumph.

Two of the most striking reminders of England's power under Henry VIII are nautical. It was he who realised that Britain needed a navy that could dominate the seas if his foreign policy was to succeed. The man appointed to buy guns and ammunition for the navy, Anthony Anthony, compiled a record of all his ships, illustrated with delicate paintings on vellum and listing their guns and crews in detail. They bring to life Henry's passion for naval supremacy. The other reminder of those times is the hulk of the *Mary Rose*, Henry's favourite warship, now under restoration at Portsmouth. In the museum are some of the objects found when the *Mary Rose* was raised from the sea bed in 1982. There are too many objects for them all to be displayed. Among the objects I saw in the storeroom was a bone nit comb, easily recognisable to parents of today, a pair of well-preserved leather shoes with a hole cut over the big toe of one foot, no doubt to accommodate an ill-placed bunion, and, still in working order, an alarming metal syringe used for plunging mercury down the penis of syphilis sufferers.

In the Tower of London on the other hand, is a poignant reminder of how the reign which had begun so glamorously ended in the physical collapse of the King. Holbein's familiar portraits show him vast, arrogant, an overpowering figure. But in the Tower is a suit of armour made for him in his declining years. He was by then too weak to support the armour without a special corset fitted to the inside so that the weight could be taken by his shoulders, and one leg is padded out to protect his ulcerated flesh.

Elizabeth, by contrast, remained an icon throughout her reign, feared but also admired and loved. The defeat of the Spanish Armada in 1588 marked a turning point after a rather shaky start. It consolidated our expansion abroad and at home encouraged the flowering of a new governing class, not religious but secular, courtiers who manifested their power and wealth in a surge of artistic energy and the creation of great estates and palatial homes.

Fine art and the power that funded it are united in a jewel presented to Sir Francis Drake by Queen Elizabeth, probably shortly after the defeat of the Armada. In contrast to the brute force wielded by her father, Elizabeth seduced and flattered her courtiers. The Drake Jewel is an exquisite enamelled gold locket, encrusted with rubies and diamonds and hung with pearls. On the front is a mysterious sardonyx cameo, a dark-skinned man's face superimposed on a white woman. There is a tiny catch at the back. I opened it cautiously. It revealed a portrait of Elizabeth herself in a lace ruff with jewels in her hair, painted by the greatest miniaturist of the age, Nicholas Hilliard. On the back of the lid is a phoenix rising from the flames. There exists a portrait of Drake wearing this locket, which, were it not for what we know of the Virgin Queen, could have passed as a love token.

The riches brought home by these intrepid explorers, Drake, Raleigh and others, were beyond the imaginings even of Elizabeth's extravagant court. Early in the twentieth century workmen demolishing a building in Cheapside, the centre of the jewellers' trade in the sixteenth century, found an old wooden box. Out of it tumbled a mass of jewellery and gems and precious objects. It is known as the Cheapside Hoard and I was able to examine it in the security of a basement of the Museum of London. There are emeralds from Colombia, topazes from Brazil, cat's eyes and moonstones from Sri Lanka, rubies and diamonds from India, lapis lazuli and turquoise from Persia, malachite from Russia, crystals and amethysts, amber, opals agate and onyx from Europe. There are cameos that were carved in ancient Egypt, Greece, and Constantinople. There are scent bottles,

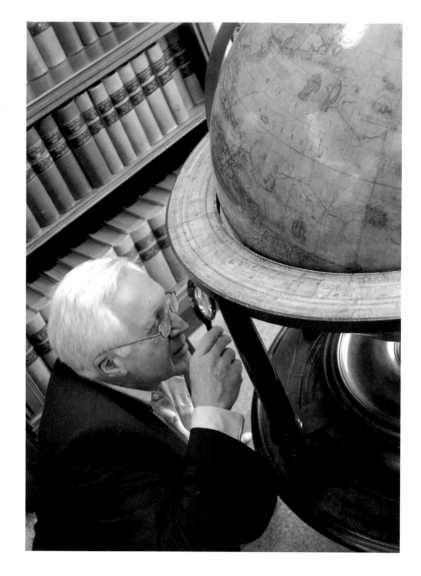

Using a magnifying glass to trace Sir Francis Drake's route round Cape Horn, drawn by Edwin Molyneaux on globes presented to Queen Elizabeth I.

necklaces, rings and brooches and even a clock set in a huge hexagonal emerald. This treasure is evidence of the trade that flowed to Britain as a result of dangerous journeys of exploration conducted in Elizabeth's reign. The explorers shared in this wealth, the reward for their daring, and no doubt their justification for the violence, cruelty and piracy that accompanied it.

Our fourth age – the Age of Revolution – put the wealth of Tudor Britain in jeopardy. I had an unexpected insight into this age. One weekend in the summer I joined twenty thousand people gathered in open countryside near Kelmarsh Hall in Northamptonshire for a Festival of History. The drama they had come to see was a historical re-enactment of great battles of the past. I went along in a somewhat sceptical frame of mind, thinking there must be better things to do

than spend weekends dressing up as anything from a Roman centurion to a First World War soldier. But I came away converted to the idea of re-enactment, not because it was always convincing but because those who took part were so obviously fascinated by the history they played out and were trying, as I had been trying, to enter into the character and attitudes of previous generations. There were all kinds of re-enactors: Boer fighters distinguished by their long beards, on horseback, Tommies from the Second World War, a First World War conscientious objector, working as an orderly, with his stretcher, Wellington's army from the Peninsular War, Romans certainly, and Vikings I think.

The group I had come to see was the Civil War Society, who were to recreate a battle between Royalists and Parliamentarians. Their demonstration was ferocious. Cavalry from both sides charged each other's cannon with gusto, horses reared as round after round was fired at them from almost point blank range. Pikemen lumbered towards each other with pikes so long and cumbersome it was hard to hold them at the charge. There was fierce hand-to-hand fighting. And at the end of the battle the troops marched off in file, silently, no chattering, under the command of their officers.

I was curious to know how they chose which side to fight on, and not surprisingly, this being an attempt to relive history, many chose the side which best suited their preconceptions of where their loyalties would have lain in the seventeenth century. A moustachioed Royalist officer explained that he could never play a parliamentarian: 'I am a Monarchist through and through you see,' while from the other side a Parliamentary pikeman explained his allegiance: 'I have always been a member of the Labour Party and a Trade Unionist so I suppose it's only natural I should be with this lot.'

The divisions were rather more painful in 1642 when war broke out between the two sides. Royalists like Sir Edmund Verney of Claydon felt compelled to support the King out of duty. 'I do not like the quarrel but I have eaten his bread and served him for nearly thirty years and will not do so base a thing as to forsake him.' Edmund's son Ralph, however, fought on the opposite side. To the dismay of the family, father and son were estranged when Sir Edmund was killed at the battle of Edgehill. It was claimed that all that was found of his body was his hand, still clutching the royal standard. I visited the church in Claydon where years later Ralph created a memorial to his wife. He used it for a touching but posthumous reconciliation with his father by giving him pride of place, with his and his wife's memorials below. Standing in front of this

memorial today I was transfixed at the thought of the misery of our civil war, less than four hundred years ago.

England in the middle of the seventeenth century was in turmoil. The Civil War re-enactors all tell you that more people were killed relative to the population than in either of the two world wars. But it was not just the horrors of the battlefields, the towns and villages laid waste, the pillaging and rape and hunger that singled out this age. It was the battle of ideas which lead to these divisions that was really remarkable, a battle that was fought out day after day in newspapers and pamphlets. Fortunately, a bookseller, George Thomason, a friend of John Milton and himself a Presbyterian, decided to collect every publication he could lay hands on. He did this secretly for fear of retribution from one side or the other, but by the time of the Restoration of the monarchy he had assembled over 22,000 different items, all carefully catalogued. I browsed among the many yards of shelving they now occupy in the British Library. Every kind of interest is represented from Monarchists to Republicans, Levellers and Puritans, the communist style Diggers and the Ranters. They argue fiercely with each other, no quarter given. The Ranters, who believed they were free from moral law and that hell did not exist, excited particular opprobrium and perhaps the envy of the Puritans. Vivid cartoons show them indulging in alcohol and tobacco and apparently practising a little free love.

There can never have been a time when there was such freedom of thought and so many religious sects vying for attention. One list compiled in 1645 includes the most arcane names: Brownists, Semi-Separatists, Familists, Millenaries, Hethringtonians, Traskites, Muncerians, Enthusiasts, Liberi, Bewkeldians, Melchiorites, Pueris Similes, Servetians, Libertines, Ainworthians, Castalian Familists, Grindletonians, Familists of the Mountains, and many many more. This ferment of ideas did not last. Cromwell proved a disappointment to republicans and revolutionaries alike by re-imposing order, ignoring parliament and even considering accepting the throne. After his death, and apparently with widespread rejoicing, England welcomed back Charles II. A sure sign of the new monarch's popularity is a souvenir struck to mark the occasion: the first coronation mug, with Charles's portrait on it and the letters CR (*Carolus Rex*).

The Restoration is best known for Charles's excesses, his libertine tastes, Nell Gwynne and many other mistresses. But one aspect of the period is often overlooked. The Puritan instinct encouraged by Cromwell had yielded benefits, among them a new

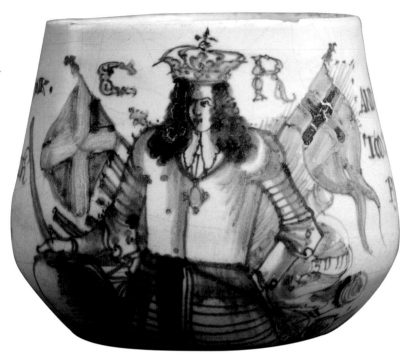

The first of many popular Coronation Souvenirs. This cup was to celebrate the restoration of Charles II to the throne. Rather crudely made but very valuable today, though no doubt cheap at the time.

seriousness of purpose in the country, with the intelligentsia focussing on scientific research and learning. Charles recognised this change and chose, between his pursuit of pleasure, to act as its patron, albeit treating it more as a hobby than a serious pursuit. He gave his blessing to the Royal Observatory and appointed John Flamsteed as the first Astronomer Royal. There is a replica of Flamsteed's telescope in the Observatory today. Through the original he plotted the positions of the stars, hoping to make an accurate map of the sky which would make navigation at sea more accurate.

On a much smaller scale were the objects observed by Robert Hooke. Hooke was curator of experiments at the Royal Society, also founded by Charles. I looked through the eyepiece of a microscope in the Science Museum that is thought to have belonged to Hooke. The slide beneath the lens was of a flea. Fleas and lice and even his own frozen urine and sperm fascinated him. He drew what he observed and published a famous book, the *Micrographica*, with fine engravings of what his microscope revealed. It was a bestseller when published and could perhaps lay claim to being the first coffee table book. Samuel Pepys was so intrigued by it that when he bought it he stayed up until two o'clock in the morning studying it.

Hooke's curiosity about the natural world was shared by his contemporaries. He worked closely with Christopher Wren, architect of St Paul's, on all kinds of scientific experiments. These were often conducted in public. Hooke had a particular interest in respiration. He put birds in vacuum jars to watch what happened when the air was drawn out. He tried to keep a dog alive by pumping air into its lungs. He even put himself in a sealed glass chamber to see what would happen when the air was removed – complaining only that he went temporarily deaf and suffered a pain in his ears.

This intense scientific curiosity and the inventions that accompanied it laid the foundations of our fifth age – the Age of Money – the eighteenth century. It is a century with an immediate popular appeal because its most lasting legacy is the classical architecture that has become widely accepted as being among our finest. The terraces of Bristol or Bath, Edinburgh or London are easily populated in our imagination by the grandees of that age. We know from their paintings how they dressed and from their literature how they lived. Dr Johnson and his circle remind us of the intellectual excitement of a time when a classical education underpinned the search for knowledge, a search which extended from philosophy to natural science, physics, chemistry, and medicine. The new wealth acquired through banking and commerce and expansion into overseas markets, all, it must be said, supported by the slave trade, created an era of sumptuous living on the one hand and high-mindedness on the other. The foibles of the age are not forgotten either, with Hogarth and Gillray revealing the underside of life in this era of prosperity.

I had a glimpse of the intellectual fervour of the century while sitting in a room above the bookshop that was owned by Samuel Johnson's father, in the market square of Lichfield in Staffordshire. Dr Johnson put his stamp on the century. A voracious reader in his youth, he devoted a decade to the production of his great work, the Dictionary. Published in 1755, it lay on the table in front of me: two volumes containing descriptions of over forty thousand words. Each entry is by turns erudite or witty, and full of references to the use of English words by his contemporaries. Here is the famous definition of Oats: 'A grain which in England is generally given to horses but in Scotland supports the people.' The dictionary, like his colourful speech as reported by his biographer Boswell, tends to show up the poverty of modern English. I was amused by his catalogue of insults, rich by comparison with our almost universal adoption of the F word. Under the letter 'F' Johnson lists far more imaginative rebukes such as

Fopdoodle, Flaggertors, Flasher, Footlicker and Fustillarian.

Great advances were made in medicine in the century. I have only once seen inside a living body. I was watching an operation on the liver and far from feeling faint, as I had expected, was entranced by the brilliant colours and curious shapes of the internal organs. I think I would have found it shocking had I not been a few months earlier to the Hunterian Museum in Glasgow to look at William Hunter's plaster casts of the wombs of women who had died in childbirth and his famous engravings of the gravid (pregnant) uterus which opened the eyes of his contemporaries to the mystery of creation.

William Hunter studied medicine in Scotland before moving south. His working life was spent in London where he practised midwifery. Hunter was friendly with a galaxy of London's intellectual elite. He was on equal terms with Dr Johnson, the painter Joshua Reynolds, the philosopher David Hume and the writer Henry Fielding. They were all intrigued by his work exploring the mother and child, work which he saw not just as the study of anatomy but as an art in its own right. He wanted to reveal how a child was formed and how it grew in the womb, and to do so with absolute accuracy. He defied the good taste that had not previously permitted the detailed illustration of

A plaster cast of a child in the womb, taken by distinguished doctor William Hunter, probably from a body bought from a morgue. Gruesome but beautiful too.

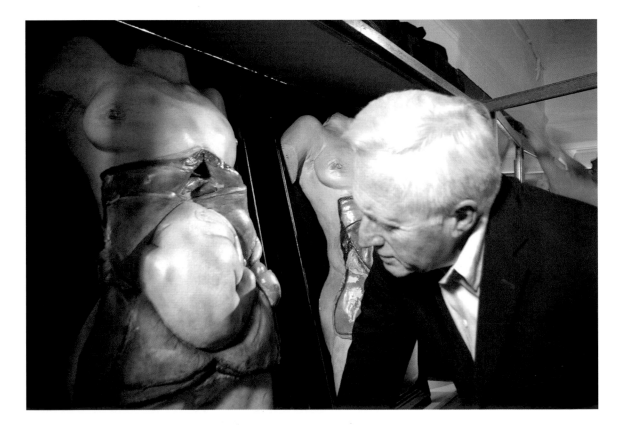

the vagina and pubic hair.

His method was meticulous. Acquiring the body of a mother who had died in childbirth, he cut it open and recorded what he found. His engravings show every minute detail of the vascular system. To achieve this he filled the veins with brightly coloured wax so that he could trace thousands of veins accurately. Wax casts were taken of the dissected wombs which in their lurid colours still shock. The impact of his work was to touch on the nature of procreation itself. It had been thought that a child in the womb was a really just a small version of a fully formed adult. Hunter's work demonstrated for the first time the reality of the intimate connection between mother and child as the foetus grew.

Hunter's exposition of human development was but one feature of the so-called Enlightenment, the dominant belief in the rational explanation of the natural world and human behaviour which has become the orthodoxy of our thought and culture. It was manifest in the energy with which the educated classes now pursued knowledge. People of 'the middling sort', as the new rich were called to distinguish them from the aristocracy, indulged their curiosity by engaging in debate, attending lectures on the latest developments in science and medicine, or watching public experiments. They also had a taste for all kinds of extravaganzas from demonstrations of air ballooning to travelling displays of the use of electricity.

Theatricality was particularly admired and not just in masques or at the theatre. The set designer and painter Philippe Jacques de Loutherberg invented a device called the Eidophusikon, a miniature theatre, in which he played out dramatic scenes from nature to thrill audiences in the drawing room. I have seen a reconstructed Eidophusikon in action, showing a ship in a storm on a moonlit night. Clouds race across the sky, the waves break on the shore and the ship is driven onto the rocks. So convincing was de Loutherberg's invention that the painter Thomas Gainsborough rarely missed a performance and later made his own version of the device, a simpler form using glass plates and candlelight, to provide a slide show of landscapes. This device can still be seen and operated in a gallery of the Victoria and Albert Museum.

For our penultimate age we turn from Britain at home to look at Britain's impact abroad, in the Age of Empire, an age which spans two centuries from the middle of the eighteenth century to the middle of the twentieth. It would have been perhaps more conventional to pick the Victorians as the next age, but just as the period of the Civil War and the Restoration seemed to warrant definition as an age that stood

alone, so the development of Empire and its impact on the history of Britain could not be ignored.

The Empire has always had its detractors but they were far outnumbered at the time by those who were attracted to it. Its ethos was embedded in the character of the British for many years: an arrogance based on our wealth and a conviction that our moral code and our political talent were superior to any other nation or race. What was missing was any realisation that, although we admired our civilisation and our culture and believed it to be the best in the world, it would not necessarily be seen the same way by others.

There is a famous children's book that tells it just as we saw it at the time without a hint of irony: *Mrs Ernest Ames' ABC for Baby Patriots*. A few letters give a flavour of the approach Mrs Ames took. 'C is for Colonies, rightly we boast, that of all the great nations, Great Britain has most', or 'E is for Empire where never sun sets. The larger we make it, the bigger it gets', and 'I is for India our land in the East, where everyone goes to shoot tigers and feast.'

The art of Empire begins early, capturing the adventurousness of its explorers. In the National Maritime Museum at Greenwich hang paintings by William Hodges which, while not great works of art, bring Captain Cook's journeys in the southern hemisphere to life. Hodges joined Cook in 1772 on his second great voyage. He was commissioned by the Admiralty to make drawings of the coastline for the purposes of navigation. He also drew sketches and made paintings of what he saw for his own profit. One famous painting depicts the moment Cook's ship, the *Resolution*, was caught in a monstrous storm with water spouts rising from the sea – a terrifying spectacle recorded by a junior officer on board. He wrote in his journal of the sky becoming overcast and the wind blowing from all directions. One water spout rising fifty or sixty feet into the air came so close that 'it put us in the utmost danger'. Hodges' painting of the scene has a family watching from the shore as the *Resolution* claws her way to safety. The father of the group has his hand raised as though in benediction, like Moses parting the waters of the Dead Sea, to allow *Resolution* through.

What started with exploration and developed into trading relationships, ended in takeover. A visit to India gives the best insight into the nature of Empire at its peak. After the loss of the American colonies, which were barely part of the Empire as we understand it now, attention turned to our possessions in the east. Britain had grown rich on its trade with India over two centuries, but, as we extended our rule, opposition to our occupation grew too.

In a storeroom in the Victoria and Albert Museum I was shown an object which vividly recalls that hostility. It is called Tipoo's Tiger. It was made for Tipoo Sultan, the ruler of Mysore, who fought four wars against the British. Tipoo was known as the Tiger of Mysore after his boast that he would rather live two days as a tiger than two hundred years as a sheep.

The model tiger is made of carved wood, brightly painted, with fierce eyes and sharp teeth. It is crouching over a man dressed in a red coat, a European and, most likely, an Englishman. On the side of the model is a handle which when turned has the tiger emitting a fearsome roar and the hapless man letting out screams of fear as, with his head thrown back, his arm raised in agony, he is devoured. It is a punishment Tipoo was rumoured to use to execute English prisoners. After Tipoo's defeat and death at the battle of Seringapatam in 1799 the tiger was brought back as a trophy to London. It was put on display to vaunt the triumph of the British over our oriental foe. In the years that followed so many people have turned the handle and listened to the terrifying noise of the encounter between man and beast that the mechanism is almost worn out. The roar now sounds more like the mewing of a cat and the Englishman can only emit a quiet moan.

Tipoo's Tiger, a toy model, gnawing at the throat of a European (probably British) soldier. Tipoo Sultan of Mysore kept it for his own amusement in his palace. After his defeat at the hands of the British it was displayed in London as propaganda.

Wall paintings in a remote part of Rajasthan showing the Indian perception of the British under the Raj. The painters relied on drawings in magazines and hearsay for these portraits of European life which they had never witnessed.

I saw a rather different view of Empire in the arid north east of Rajastan, a region known as Shekhavati. In the late nineteenth century it was the home of merchant families who traded throughout India, meeting the British everywhere from Calcutta to Bombay. The homes to which they returned after their journeys were decorated in spectacular style, with frescoes painted on the external walls for all the town to see. Many of the paintings, executed by local craftsmen, boast of the merchants' contacts with the Raj. The painters had not themselves seen what they were commissioned to paint and had to rely on hearsay or drawings from magazines. The result is a series of crude clichés in cartoon form, of the British as they were perceived by Indians at the time. There are men in top hats, driving in motor cars and women in voluminous skirts, pedalling their bicycles. Trains feature frequently. The railway had not yet reached Shekhavati and the artists seem to have painted from imagination. A train is quaintly depicted as a series of tiny houses on wheels with passengers waving from the windows all linked together and pulled by a steam engine in the shape of a bottle with smoke coming out of the top.

One of the most vivid embodiments of the spirit of Empire is the memorial to Queen Victoria which sits in front of Buckingham Palace

in London, so familiar that it almost passes without notice. The Queen is at the foot of a plinth looking out, rather boot-faced, towards Westminster. Around her are the reminders of what our Empire supposedly delivered: angels of Justice, Truth, and Charity, shown as Motherhood. There are prows of ships at the four corners as a reminder of who rules the seas. There is a water-filled moat with dolphins and mermen, mermaids and other sea creatures. The inscription reads simply *Victoria Regina Imperatrix* (Victoria Queen Empress). As a memorial it seems as distant from our own age as the monuments of ancient Rome and yet it is only a hundred years ago that it was erected to celebrate our might.

The last of our seven ages is the present age, an era that began with the First World War and that is still with us. This is an era of change on a scale never before seen in our history. It is not revolutionary change like that which followed the Roman and Norman invasions. It is not political change on the scale of the Reformation or the Civil War. It is social change that distinguishes our era, social change brought about largely by technology which has radically altered the way we all live. This is the era that has seen the motor car become an everyday form of transport for everyone. It is the era which has given us the aeroplane, radio and television, the fridge, the deep freeze, the microwave, the washing machine and the dishwasher, central heating and air conditioning, the computer and the internet, the mobile phone and Facebook.

I was reminded of the scale of the change recently, when I had a chance to drive an Austin 7 of the 1930s. This was the car designed by Herbert Austin to provide middle-class families with the freedoms previously enjoyed only by the rich. It sold for £165 and is in truth a work of art in itself. It bears out the theory that anything designed precisely for its function, with no frills, will be beautiful. Driving it cautiously at a top speed of forty miles an hour I was plunged back into the earliest days of this era of change. Here was a car in which for the first time, husband and wife and children could drive to the sea for the day, independently, an unheard-of luxury.

This astonishing catalogue of change compressed into such a short period has liberated us from much drudgery. The freedom it has given us has run alongside a profound change in our social structure. Deference has largely died. We are still not an equal society but our instincts are egalitarian. This freedom has led us to accept and value the right of self-expression as equal if not superior to all other rights, certainly equal to the rights of the state or of

The Austin 7 Chummy. One of the most beautiful and simple cars ever made in Britain. Selling for £165 in the early 1930s, it offered the freedom of the road to tens of thousands who had never been able to afford it before.

hierarchies of whatever kind. It is vividly reflected in our art, where a kind of anarchy has taken hold.

For my purposes the question of what should count as art is not strictly relevant. For the purpose of identifying the seven ages of Britain, my interest in painting and sculpture and installations – in everything from Francis Bacon and Lucian Freud to Tracey Emin or Damien Hirst – is in what they tell us about the nature of our society and our attitudes, and it seems to me that they tell us a great deal. After the Second World War prosperity slowly returned to Britain. For the first time money was in the hands of the young, a generation that had grown up in austerity and suddenly found itself relatively rich. It had the confidence to kick against the old establishment and artists followed suit. Painters like Francis Bacon saw their function as upsetting and overturning old attitudes. Hirst, with his diamond-encrusted skull, combined extreme materialism with the terror of death. Others mocked and teased. Everywhere there was, and remains today, a kind of artistic chaos which reflects a society uncertain about its goals, disunited in its aims, and disillusioned by promises of utopia.

A hundred years from now the art of today will be seen as a guide to the turmoil of the present, changes which have come at breakneck speed but which are still able to be tracked through our art. The lesson of the seven ages is that the art we have produced is always the product of the kind of society we have been, whether under the thumb of the church or the monarch or the rich and powerful. Today we like to believe we are no longer under anyone's thumb and, trying as always to keep in tune with the times, our artists claim their art is for all: a bold ambition that is easy to attempt but difficult to achieve.

Chapter 1

AGE OF CONQUEST

BY MARTIN CARVER

In this age Britain was invaded from overseas many times. There are a thousand years of treasures, everything from helmets and shields to jewels and illuminated manuscripts. This was a time of ingenuity, originality and imagination – an era to celebrate.

A tribute to British art in the eighth century. In the great library in Florence designed by Michelangelo for the Medicis I was able to examine the oldest Bible in the world to combine Old and New Testaments. It was written and illuminated by the monks of Bede's monastery at Wearmouth Jarrow in Northumberland and was intended as a present for the Pope.

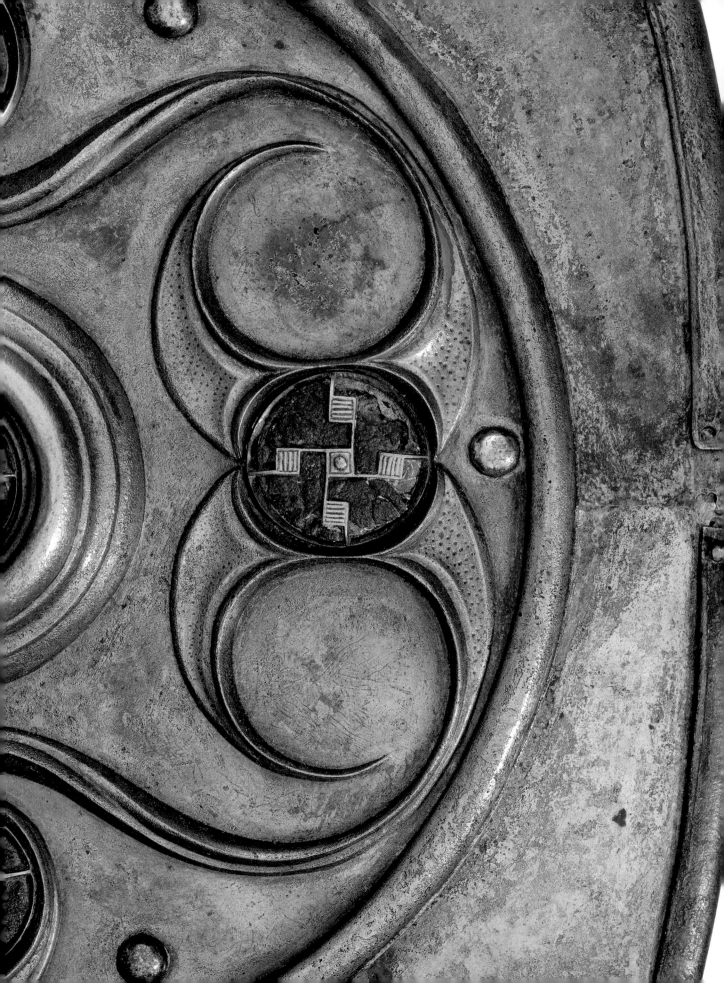

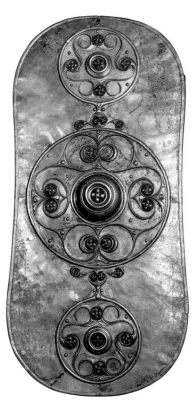

This masterpiece of Celtic art is the bronze parade shield of a British Iron Age warlord. It was made in the first century BC and found in the River Thames at Battersea.

Detail of one of the shield's roundels ornamented with red enamel and embraced by swirling ridges of bronze.

The first of our seven ages, like a childhood, is crammed with incident; events huge at the time, that glowed long in the mind and underpinned much of what was to follow. Between 500 BC and AD 1000, the people of Britain changed their economy, their lifestyle, their houses, their belief, their language and their arts. From the first millennium AD, we were no longer an island of Britons, but an island of Picts, Angles, Saxons, Jutes, Norse, Scots, Welsh and English. This was the real making of a nation: the meeting and fission of disparate cultures that created the excitement of endeavour, the chemistry of great art. These peoples belonged to a busy cosmopolitan theatre, in which were forged the big ideas that have driven and riven Europe ever since: ideas of territory, allegiance, religion, ethnicity, identity. If we are still confused or inspired by these things, it's all the fault of the so-called Dark Ages.

Britain's Iron Age Communities (500–55 BC) had deep roots in the previous three millennia, during which the occupants of the island developed agriculture and began to make permanent settlements and to compete for land. They farmed with scratch ploughs and lived in round houses; they were warriors who fortified hills and promontories to protect their families and stock and belonged to large tribal groups such as the Iceni or the Trinovantes. These Iron Age territories reflected natural areas of upland, lowland and firthland and have endured in our subconscious. They re-emerged as Anglo-Saxon kingdoms, such as Wessex and Mercia, which we remember in the names of our police forces and fire brigades. And they survived until the twentieth century in school playgrounds, in the games and sayings of children.

The invading Romans discovered and understood these tribal confederations, routed their reckless charioteers in battle and laid out a Mediterranean landscape with roads, towns and villas, especially in the favoured south-east. While brave and obdurate British warriors kept up a resistance in the hills, their upwardly mobile cousins, the New Britons (known as Romano-Britons), learnt how to take steam baths and build with mortar. They also began to domesticate their gods. For prehistoric peoples, religion had permeated every aspect of existence – they lived below a wild heaven full of beings requiring continuous placation. Now the gods were to be pacified in official temples with statues and regular sacrifices, leaving society to focus on the joys of social life. Civilisation meant pleasure – so long as you didn't step out of line. The New Briton joined the army as a fast way to fame,

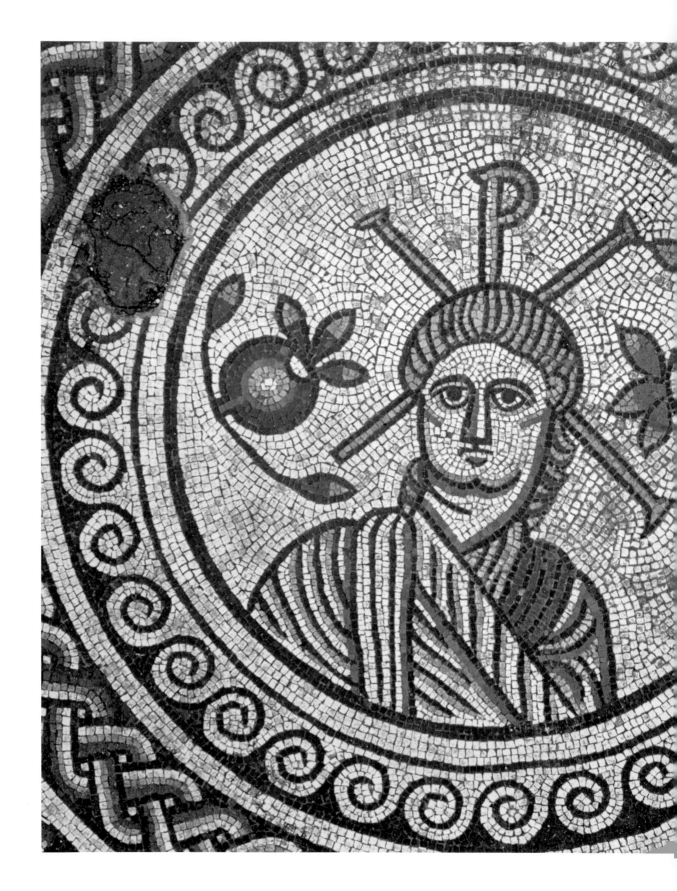

or took the slower route via local government and the law; the New Briton had his own villa, his town house, his special mosaic pavement made by one of the empire's travelling experts, little trophies and mementoes displayed on the exquisite imported furniture, exotic shrubs in the formal gardens. Civilisation also domesticated the aristocratic British woman. While Cartimandua, ruler of the Brigantes tribe, was a leader with her own husband, lover and chariot, the New Woman was mistress of an establishment served by slaves, where her diligence in the estate and discretion in love protected the dynasty's long-term genetic investment.

If the culture shock of the Roman conquest at the beginning of the first millennium was fairly extreme, imagine the still greater shock of its disappearance 400 years later. The country was divided: Britannia, the effete and wealthy lowlands, was surrounded by three upland frontier zones – roughly equivalent to Scotland (north of Hadrian's Wall), Wales and south-west England. Those north-south and east-west divides that we still complain about today, started with the Romans. The people of the lowlands were ploughing, sowing and selling grain: the empire's hard currency for which, according to the Romans, 'wave-washed Britain' was famed – along with the clever hunting dogs it exported. The upland frontiersmen by contrast, having relatively poor arable land, had little incentive to maintain settled communities. Their loyalty was to kin, clan, war band and local deity rather than town or regiment, and their output was cattle, soldiers and slaves. The Roman occupation forces kept these two parts of Britain separate – the civil and the uncivil – and when Rome retreated the two were bound to go different ways. And what different ways they were.

Whether large numbers of Anglo-Saxon people from north Germany and Denmark really invaded Britain and created England is still hotly debated. Stable isotope analysis – which uses teeth to locate the source of childhood drinking water – has been applied to excavated skeletons of the prehistoric and later periods, and its general message is clear: people were always on the move. The so-called Anglo-Saxons at West Heslerton in Yorkshire and Wasperton in Warwickshire came

The mosaic pavement, excavated in a Roman villa in Hinton St Mary, Dorset. This floor of a gentleman's residence in fourth century Britannia shows Christ or the Christian emperor Constantine.

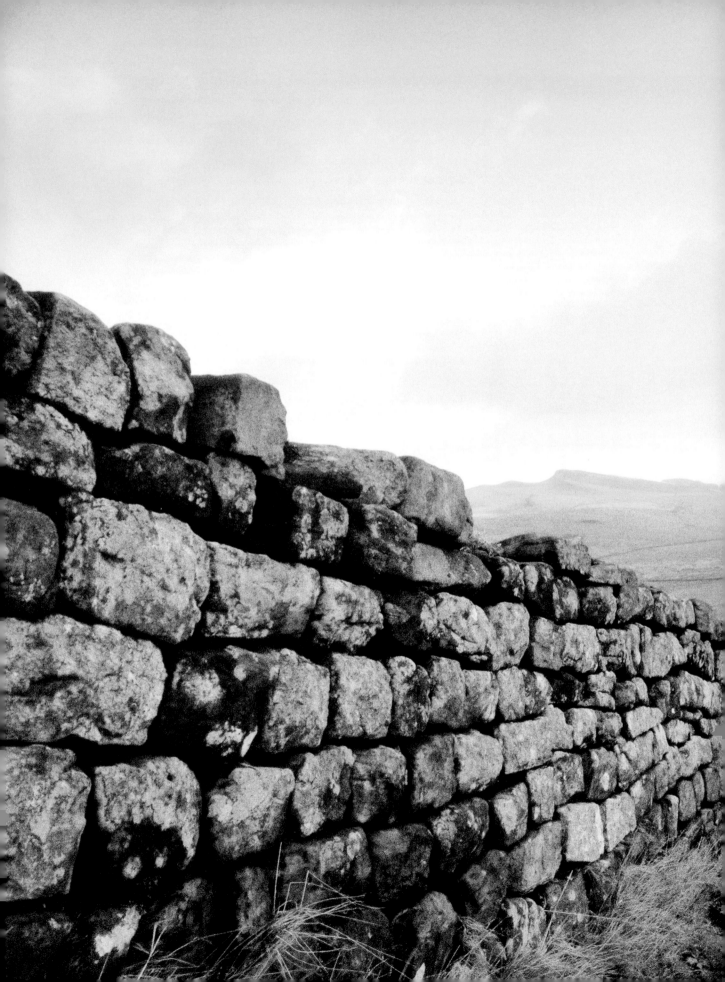

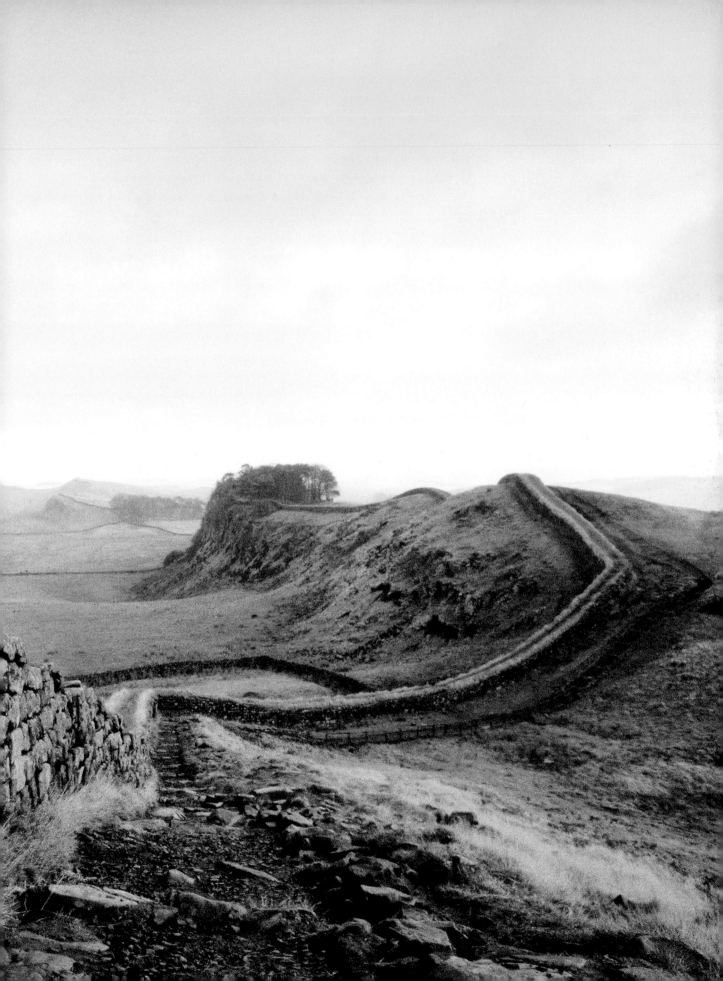

(on previous page) Hadrian's Wall, built in the early 120s by the emperor Hadrian, marked the northern limit of direct rule by Rome.

from north, east, west and south. Some people had almost certainly come over the North Sea from Germanic lands, but others were from the rocky lands of the west, and others again from the Mediterranean. The Roman Empire was already a complicated ethnic mix, so it was logical that Europe after empire should be a big potpourri too – a tangled net of DNA strands from different parts of the world.

Our descent is determined by the random forces of sexual attraction – and, in this period, also by the system of selling men and women into slavery. Both are processes that override all ethnic, political and cultural divisions. Thus the people of Wales, England, Ireland and Scotland, then as now, were mongrel and mobile. Our descendance is random and provides no reliable basis for early history. Nevertheless, after Rome, parts of Britain began to proclaim their differences, in territorial possession, in culture and in religion. The differences were real and deep: so if they were not biological, what were they?

Britain's regional cultures emerged as dozens of small shadowy kingdoms, their territories vague and their leaders vaguer still: Dal Riada in the north-west (joining Ulster with Argyll), Gododdin (in Lothian), Fortriu (around Moray) in the north-east, Gwynedd and Powys in the west, Deira where County Durham now is, Lindsey in Lincolnshire, Mercia on the Welsh Marches, Wessex and Kent in the south. Strangely it was not the province of Britannia (roughly modern England), but the military frontier zones that continued or revived the arts and language of Rome, mixing them with those of old Britain. On their tombstones they incised words in Latin letters, or in *ogham*, a new linear script, probably based on deaf-and-dumb signs and imported into Wales from Ireland. Their headquarters were often the old Iron Age hill forts, now fortified again by a new generation of freedom fighters. And their religion was the religion of the latter-day Roman Empire, Christianity – certainly an individual form of it, but one that was to find followers all over Europe. In return, the old empire came to them. Ships from Byzantium (now Istanbul) brought wine and olive oil to the shores of the Irish Sea throughout the sixth century, leaving a telltale trail of amphorae – oil and wine bottles – and plates of red slipware. The new arts of the Irish and British resurrected the themes of their Iron Age – delicate spirals in bronze and roundels filled with blue, red and white enamel. This was to be the first of many Celtic revivals.

The Picts (in eastern Scotland) were Britons too, but had little love for Rome, empire or Christianity – at least at first. These were

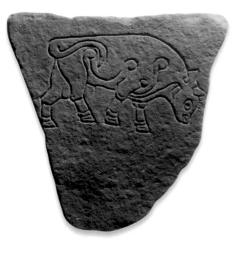

The Burghead Bull, made in the sixth or seventh century. The Picts decorated the walls of their promontory fort with stone slabs carrying powerful images like this.

the unconquered peoples of mountain and glen who styled their kings 'Bridei' (i.e. Britain) and although scarcely known today were probably then the oldest families on the island. They were nicknamed Picts – broadly, the 'painted people' – by the Romans, probably because they were extensively tattooed. They have left their traces on metalwork and stones in a very distinctive form – symbols of swords, spears, chariots and cauldrons – together with images of animals: cows, bulls, wolves, salmon and especially horses. These animals were etched on rock with consummate skill; not until the time of Picasso was Europe to see again the essence of a creature portrayed by a single line. Some of the Pictish symbols were added to Bronze Age standing stones – monuments that still had meaning in the landscape. Some symbols occurred in groups, some singly. Like all other images and scripts found on Dark Age stones, they are thought to represent the names of the dead – in this case names spelled out in pictures like Egyptian hieroglyphs. Their standardised forms, found all over northern and eastern Scotland, mean that they count as a real language, the unifying force of one of the most artistic of Europe's lost nations.

In the east and south, where the Romans had held sway for several centuries, the revolution following their departure was dramatic: the Romano-Britons became German. The old territories were renamed, East Anglia after Angles from Denmark, Essex and Sussex after those North Sea raiders, the Saxons – another nickname, this one meaning 'the knives'. The language of power became English, and the people left memories of themselves in thousands of graves. The composition of these graves leaves no doubt that something more was intended than the disposal of a body; the burial rites, grave goods and their art all speak to us of lifestyle, the social order and belief. The men were laid out with spears and shields. The women had costly apparel bedecked with intricate brooches. While the alpha-male might have a sword, the alpha-female would have a great square-headed brooch and a bunch of keys as the governor of the home. Male and female were commemorated as equal and opposite, and in death were expected to hold their own in the great hall of the hereafter.

We know precious little about Anglo-Saxon pagan beliefs, other than that they featured a next world and a hierarchy of gods. The intricate patterns on the brooches show entangled limbs of humans and animals, seemingly the fossils of lost myths and stories. The patterns change, from person to person and from place to place. In the greatest of all these theatrical burials, at Sutton Hoo, we

A Great Square-headed brooch made of gilded bronze featuring tiny images of animal mouths and claws. It was worn by a woman living in a sixth century Anglo-Saxon community in the village of Wasperton, Warwickshire.

42

Earth mounds which covered the early seventh century graves of the warrior aristocracy at Sutton Hoo, Suffolk.

see this myth-making writ large: the rich elaborate burials are eulogies and elegies to the dead, expressing the pride and the fears of a people robbed of a beloved old leader or a promising young person touched by magic (the cult of celebrity flourished in the Dark Ages). One twenty-five-year-old warrior was buried beside his horse, with gilded snaffle-bit and silver pendants on the bridle. Beneath the largest mound a ship thirty metres long was buried in a trench; within the ship was a wooden chamber made of giant logs like railway sleepers, and within the chamber a person was placed in a huge tree-trunk coffin with a heap of clothes and shoes. On the top of the coffin, a yellow cloak was spread and the dead man's parade dress laid out: a helmet resplendent with symbols, an ornamented belt and sword. At the head of the coffin were the regalia – standard and sceptre – and at its foot, feasting equipment, cauldrons and buckets. Here was the elaborate tableau of a great leader sailing off to represent his people as their ambassador at the court of the gods.

By the time this burial took place (around 625 AD), leadership was still a family business, but leaders were beginning to claim responsibility for specific areas. People once somewhat anonymously

The parade helmet from Sutton Hoo,
made of iron and decorated with a dragon
whose teeth meet the beak of the bird that
emblazons the face: its wings form the
eyebrows, its tail the moustache.

A shoulder clasp from Sutton Hoo, displayed closed (above), and open (below). The clasp is made of solid gold and inset with red garnets making images of wild boars and strings of interlaced animals.

termed the 'North Folk' and the 'South Folk' were merged into a kingdom of East Anglia. Their land was pagan at the time of the great royal burials at Sutton Hoo, but very soon became Christian. The loyalties of the first kings of East Anglia were initially directed towards their like-minded kin in Scandinavia, but swiftly turned in the late seventh century to Christianity and Christianity's emerging empire in continental Europe.

At this time, the influence of Islamic North Africa was being felt in Spain, and the Slavs were becoming dominant in Eastern Europe. There was a new world of politics to occupy the minds of European leaders in the seventh century, and there were plenty of hard decisions to make: decisions about political alignment, about the future, about keeping the people together and guarding territory. The 'big idea' of the time was the united Christian empire of Europe – an area of regulated and protected trade in the image of Rome. The question for the new leaders of Anglo-Saxon England was whether to sign up to this 'European Union' or to retain their independence and the old alliances with the Scandinavians.

Then, as now, expectations of affluence probably won the day – plus the prospect of greater social control for the ruling families, in which the Christian clergy played a pivotal role. At Sutton Hoo in the eighth century, we can see that the new Christian hierarchy had abandoned the wealthy rituals of royal burial for the harsher ones of ritual killing: thirty-nine people had been executed by hanging, with some left suspended on gibbets. Their offences remain unknown, but their context, next to the barrows of the pagan kings, raises the suspicion that these were dissidents: either rebels of the sword – like the young men who formed the majority of victims – or perhaps of the flesh – like the middle-aged man buried with two women face down. The new Christian spiritual authority, determined on orthodoxy and unity, met the diverse freedoms of the pagan mind with a heavy hand.

While the Anglo-Saxon kingdoms were adapting, one after another, to the stern new regime, the kingdoms of the north and west experienced a gentler transition. The fact that they were often of a Christian persuasion already gave many of them a special authority, not least the holy men of Ireland and Galloway. The members of this powerful and attractive confederacy of saints have survived in the dedications of innumerable small churches in Cornwall, Wales and Scotland. Among them were famous and influential names: spiritual leaders, such as Patrick, a Briton from Carlisle who converted the Irish;

Columbanus, who carried the Irish way of doing things to France and Italy; Ninian, whose headquarters were at Whithorn in Galloway; and Columba, who sailed from Ireland to Mull, set up a monastery on the island of Iona in 563 AD, and two years later led an expedition into northern Pictland.

The influence of these pioneers spread from very special settlements contained in small enclosures. They were known as monasteries – confusingly, since they were nothing like the later, greater monasteries of the Benedictines or the Cistercians. Their enclosures were oval or D-shaped like the local Iron Age forts, containing a small rectangular church, graves marked with carved headstones, a farm and clusters of workshops making holy books and church plate to equip other monasteries. Monastery by monastery, the network spread – in many ways they were the soviets of their day.

If we see Iron Age roots in these enclosures, we see them also in their artistic glories, such as the Ardagh chalice or the *Lindisfarne Gospels* or the great stone carvings of Easter Ross. Here curious, multifaceted animals entangle, like those of the Anglo-Saxon brooches, brilliantly symmetrical spirals and key patterns are laid in arithmetical blocks, individuals ride out on horses with hunting dogs and

The Ardagh Chalice, for use in the Christian Mass. It was made in northern Britain or Ireland in around 700 AD.

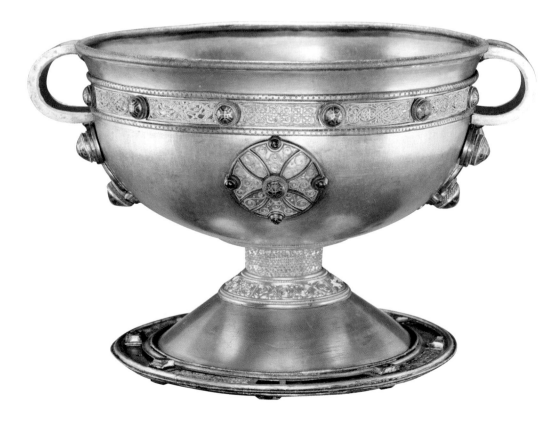

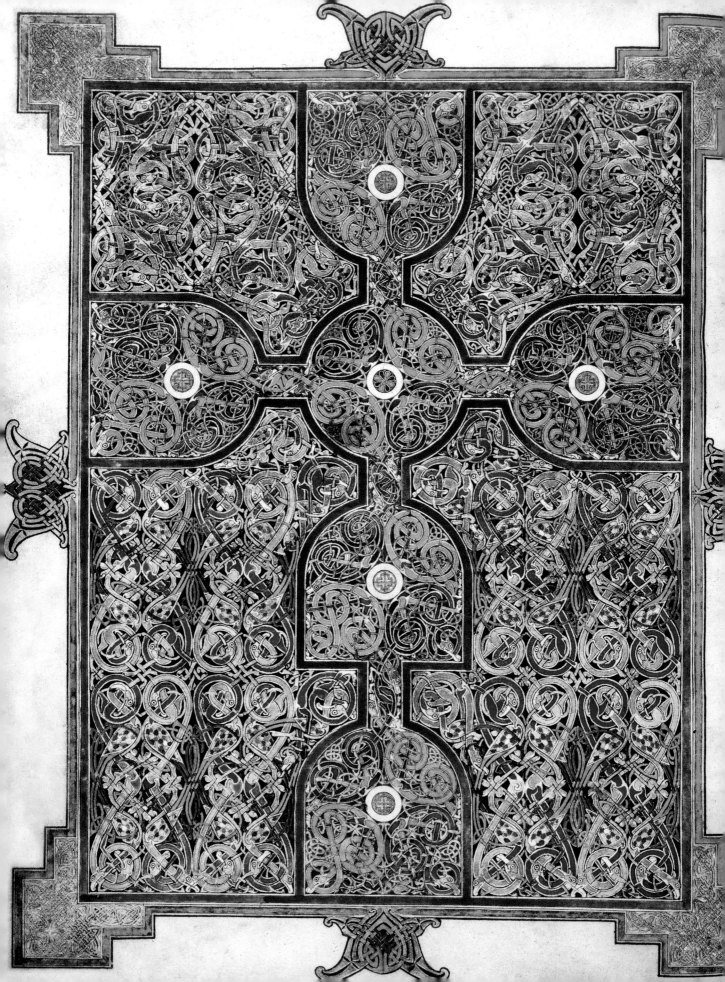

A carpet page from the Lindisfarne Gospels made on the island of Lindisfarne in around 700 AD. The book contained the gospels of Matthew, Mark, Luke and John, each preceded by an ornamental page like this.

A later medieval artist's depiction of the Venerable Bede, at work in his scriptorium at Jarrow, 1175.

trumpeters; and intermingled with these patterns from a deeper past are images the undoubted origin of which is in the Bible: King David rending the lion's jaw, the monks Paul and Anthony meeting in the desert, and the cross itself in a hundred different forms.

These are not blundered or barbaric renderings of a civilising message. They are great art in every sense. In the same way, great composers of the eighteenth and nineteenth centuries thrilled their audiences by incorporating folk tunes and national anthems into their symphonies. To appreciate these things and realise their relevance to us today, it is necessary to rediscover the Picts and the Saxons – and all the other peoples of Europe whose identities are all but lost to us. They were not deprived marginal communities awaiting the re-invention of Europe, but independent polities with minds of their own, choosing what to accept and what to reject from the ideas of the day. This resulted in a diversity of monuments, even among so-called Christians, that was perhaps greater in the eighth century than in any other European age.

The Anglo-Saxon zone too relied primarily on monasteries (anglicised to 'minsters') for its new ideological network. But here the roots were shallower and the model more recent. The monasteries at Monkwearmouth and Jarrow have been examined by excavation and found to have a different layout from those of their Celtic neighbours. They are rectangular in their form, like a Roman courtyard villa – the plan that will emerge four centuries later as the cloister. Jarrow is the most beloved of English monasteries, because that is where Bede lived, worked and prayed, and Bede was England's first historian. His works did much to give the English an idea of themselves, even though 'Englishness' was a relatively new cultural concept that had been on the island only a few generations. Monasteries were run by monks, but they were also in the hands of aristocrats. They offered a new way for the upper classes to win influence: with the tongue rather than the sword. Men had the lion's share of the new route to fame, although there were famous Christian women too: Hilda at Whitby held court to the greatest minds of the day.

Alongside Bede's creation of a unified England, there was, curiously, another political initiative, led by women, that showed itself as a burial rite new to the late seventh and early eighth century. Here famous women were remembered with elaborate burial rites – often in a bed as at Swallowcliffe or Streethouse (where the bed was surrounded by eighty unfurnished graves lined up two by two). These rich graves, found all over England, had in common a wealth of

The Hilton of Cadboll Cross-slab on the Tarbat peninsula, Easter Ross, erected about 800 AD. Beneath the Pictish symbols, a woman rides out preceded by the symbols of a mirror and a comb. The image has been interpreted as an aristocrat hunting, the life of a saint, or a Christian allegory.

jewellery in Roman or Byzantine style, as though the women were establishing themselves as the inheritors of an earlier, non-Christian, Roman Empire. The English were enthusiastic about Romanising their past, with men and women perhaps bringing different emphasis to the task. Whether secular or sacred in form, male or female in its politics, English ideology in the seventh and eighth century embraced the image of Rome, as well as its doctrines. For all the varied political adventures of the next millennium, the peoples of England, and of Europe, would repeatedly seek unity and renewal in the dream of Rome.

It would be hard to say whether the Irish or the English promotion of the Christian route towards statehood had the greater influence at this time. Irish ideas found their way to St Gall in Switzerland and Bobbio in Italy, while the English model was exported to the German lands. The similarities of approach were as important as the differences, and the differences were due more to differences in local inheritance – particularly in local prehistoric thinking – than differences in doctrine. But these things matter. Then, as now, the differences were cherished and accentuated by politics. In the later eighth century the English church was to turn increasingly away from its western and northern neighbours and towards France, while the Welsh, Scots and Irish gradually lost contact with the Continent. At least in English eyes, the 'Celtic lands' became a Celtic fringe and the division of Britain, originally created by resistance to the Roman conquest, became a permanent feature of the island.

On the European stage, the brief miracle of freedom and tolerance that was the seventh and eighth centuries was about to come an end in what might be described as the first pan-European war. If the leaders of France and Italy were engaged in building a Roman (Catholic) Christian empire in the centre of the Continent, the Norse and Danes were creating a maritime empire of their own, based on superlative seamanship, which in its day stretched from Arctic Norway to Sicily. By the early ninth century our island was in the front line, invaded in the north by the Norse – who occupied Shetland, Orkney, Caithness, western Scotland and eastern Ireland – and in the south by the Danes, who occupied the country from Newcastle to Nottingham. These 'Vikings' (the nickname given to raiders who dodged in and out of creeks) first fought for free trade and then for land. But there were ideological hostilities too. Around 800 AD at the Pictish monastery at Portmahomack the workshops were burnt down, and selected stone crosses were broken up with a sledgehammer and tipped onto the

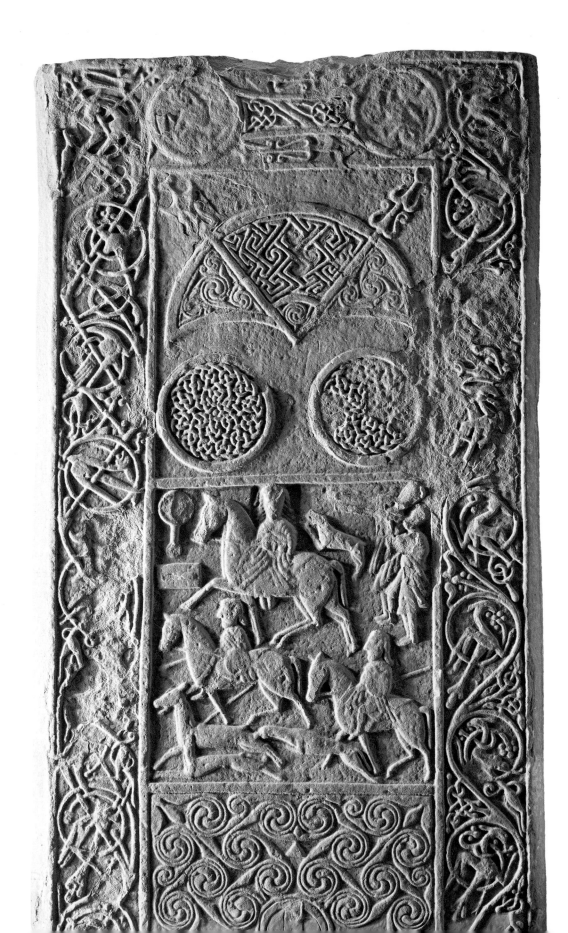

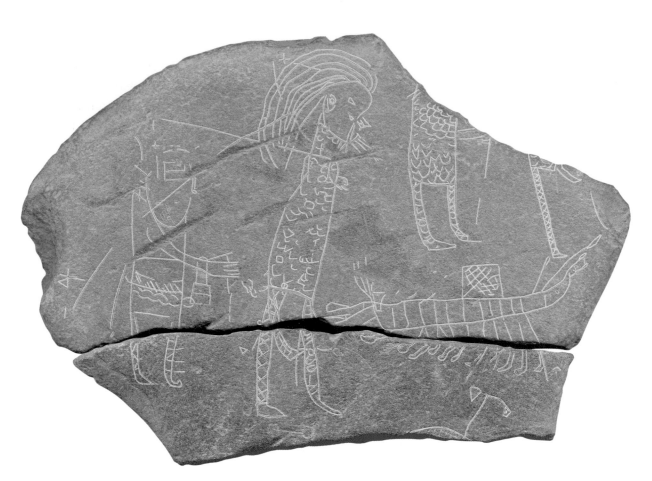

(below)The face of a British saint, a Christian holy man from the Pictish monastery at Portmahomack, north east Scotland, late eighth century. This was part of a monument broken up by the Vikings.

A Viking raid sketched by children on a slate during a ninth century history lesson at the island monastery of Inchmarnock, western Scotland.

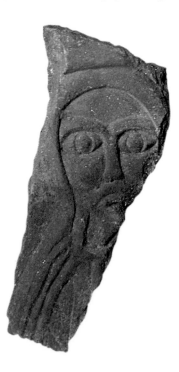

smouldering ruins. In the cemetery, at least four of the monks died from blade wounds. While the church and burial ground were then abandoned for two hundred years, the workshops and farm revived and started up again under new management – either the Norse or their sworn enemies, the Moray Mormaers, creators of Alba (a forerunner of Scotland).

Fashionable pictures of the 'nice' Vikings are tinged with rosy nostalgia. Theirs was an agenda of enforcement, and Portmahomack has reminded us that not all the stories of atrocities recorded by the outraged monks were invented for propaganda purposes. However, the Scandinavian 'enterprise culture' had reasons for objecting to the restrictive practices of the Christian empire, and the influence of their free-trade thinking has lasted in politics to this day. If they were concerned by Christianity's views about orthodoxy and power, they were also ready to absorb its details into their own commemorative

art. A tombstone at Middleton in Yorkshire shows a warrior with his sword, laid out as in a grave, but his effigy was firmly positioned on a cross shaft beneath the cross head of Christ. While Yorkshire's minsters were now mostly defunct, it was still a Christian land: the monastic network was replaced by the monuments and private churches of the local lords and Danish fellow travellers – an aristocracy who had their priests in their pockets.

Alfred the Great's battle for Britain and his subsequent accommodation with the Danes brought stability to the island; one reinforced by his children, Edward the elder and Aethelflaed, Lady of the Mercians. Alfred's family, with its conscript army, worked its way north from Wessex subduing or reaching agreements with leaders in the Danelaw, Wales and Scotland. The model for their strategy was the Roman conquest of Britain, and the instrument of subjection a type of Roman fort, which the English called a *burh*. These were built to a certain size to suit the garrison available, and, as has been seen in the Stafford excavations, they protected a central collection point for grain and for the mass production of enough bannocks (flat loaves) 'to feed an army'. Other provisions were put in standard-sized pots, made to look like the local Roman pottery, and another nod to Rome was the production of silver coinage carrying the head of the king. The inspiration for all this came partly from across the Channel, where Charlemagne was creating his own 'Romanesque' kingdom, with investment in towns, monasteries and illuminated manuscripts; but partly too from the remains of Roman Britain that lay in the countryside of Alfred and his supporters: old ruined buildings at Bath, described by a Saxon poet as 'The Work of Giants'; Roman bronzes; Roman pottery; Roman roads; and a Roman defensive wall (Hadrian's), imitated at Offa's Dyke (to keep out the Welsh). There is more than a suspicion too that the bookish Alfred knew something of the campaigns of Caesar and Claudius, the battles of Maximus and the institution of the church under the emperor Constantine. These upper-class families went to Rome and saw the sights in the old heart of Empire: the forum, the Coliseum, the Tiber bridges. They met leaders, engineers and artists. They even had their own hostel (the *Schola Saxonum*) near St Peter's. The young English nobles were not cut off from the Continent; they were Europeans who had done the tour.

By the tenth century, England was a very wealthy country, enjoying a golden age. It had strong centralised laws, a social hierarchy from serf, through lord, to earl, with the king at the top. The laws

Silver penny to commemorate King Alfred's reoccupation of London c.886. One side shows his portrait (top), and the other shows a monogram of 'Londonium' in the Roman manner (bottom).

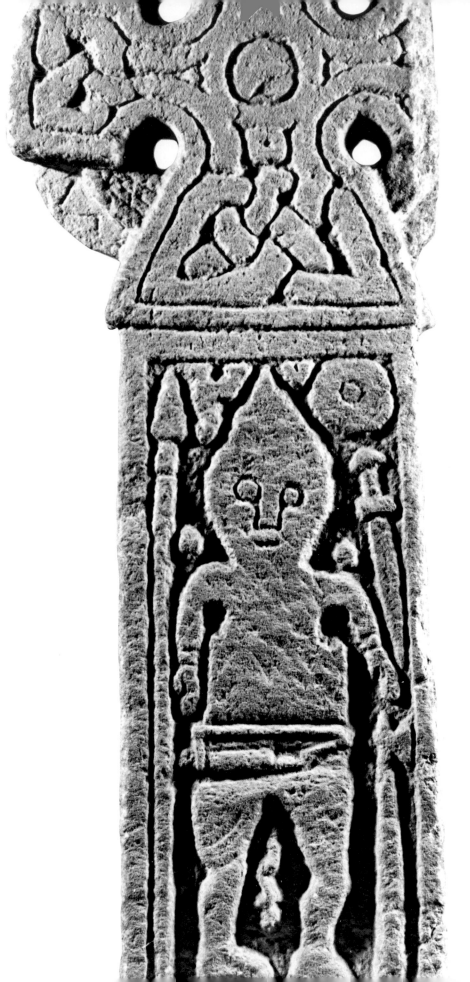

were tough: no trading outside a *burh*, an amputated hand was the reward for forgery or theft, and the gallows, initiated by the Christian kings at Sutton Hoo, were busy at the crossroads. There was some mobility: a self-made man could qualify as a sort of aristocrat with five hides of land, a gatehouse and a tower. As in Roman times, the army and trade were fast routes to advancement. By the late tenth century the creation of 'England' was complete; no longer functioning only as forts, its *burhs* were booming as markets and ports of trade. In this wealth-creating activity English and Scandinavian entrepreneurs found common cause; now English patterned cloth was famous on the Continent and Chinese silk was reaching York and Lincoln and the Oslo fjord.

The *burhs* had become the first English towns, but unlike their Roman counterparts, the main cultural investment was not in paved streets, town halls or statuary, but in the church. The successors to the eighth-century minsters were reborn as urban churches served by secular colleges: grand, aisled buildings at Winchester and Gloucester and dozens of parish churches reaching into every part of the country, served by a network of parish priests and bishops. The late Saxon church had a particular flavour to it: humorous as well as reverent, visible above all in the corpus of illuminated manuscripts – now little known, but which constitutes one of the cultural glories of Europe. Alfred initiated new book production, including texts in English so the priests would know what they were saying. And in among the initials of the script swing playful people, plants and animals, peeping and hiding and bringing a glint of joy into the solemn lines. Here we also see tall literary women, who although they illustrate a tedious religious tract, must have been taken straight out of court life, their critical opinions and scheming plans playing on their faces. More formal portraits tell us that, although denied the power exercised by priests and bishops, there were heavyweight female academics who had been abbesses as well as wives, steering the throne or the church. From early times, some career women had it all: Ealhswith, wife of Alfred, founder of the Nun's Minster at Winchester; Cynethryth, widow of Offa, abbess of Cookham.

At the summit of Late Saxon genius we see artists flooding the most ceremonial scenes with the sunshine of their humanity. The *Pierpoint Morgan* painter produced one of the most heart-rending scenes in all English art, the faces warm with stage presence and unmistakably of the early eleventh century: it is as though the most handsome of the young English courtiers had been present at the crucifixion scene from which the Middle Ages derived all its principles.

It would be hard to exaggerate the cultural pinnacle to which the

5 3

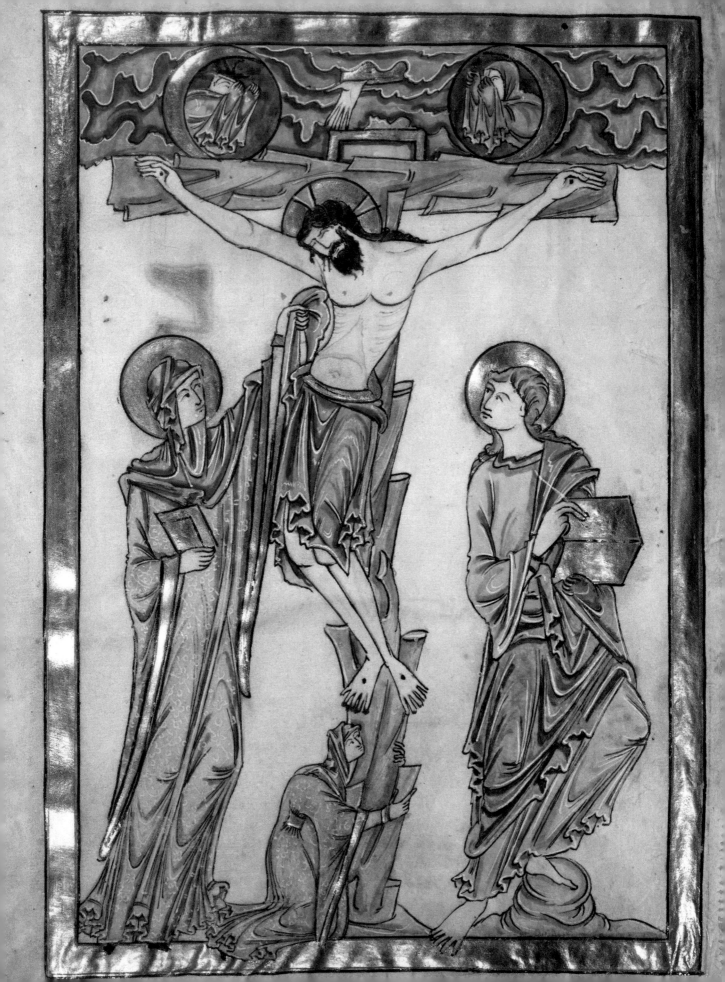

(left) The greatest picture in early English art, made just before the Norman Conquest. It depicts the crucifixion scene from Judith of Flanders' gospel, showing Christ with his mother Mary (left), Mary Magdalene kneeling, and John the Evangelist.

early English had climbed by the middle of the eleventh century. In art, architecture, music, poetry and religious philosophy, the aesthetic achievements of this short time were not to be matched until the reign of Elizabeth I – and perhaps they never were. The countryside was dotted with white plastered churches with square towers and bells ringing out for mass or the *Angelus*, when labourers in the fields paused for prayer and sandwiches. The streets were full of horses, carts, pedlars, courtesans and warriors clad in the richest of cloths, the *opus anglicanum* prized all over Europe, belts and harness dangling with black and silver strap ends. No-one doubts that this was a hierarchical society and a cruel one in its treatment of crime and punishment. And yet the figures depicted even in the most ceremonial arts are jaunty, cheeky and coiled with energy. One gets the feeling that, if only for one short century in all the Middle Ages, life was fun.

The Norman invasion brought this idyll to an end with conquest and violent suppression of personal freedoms, which even exceeded that of

(right) Cartoonists of Alfred's England; lively figures illustrate this edition of Bede's History.

EM:DVX:ETEXERCITVS:EIVS:VE NERVNT:

5 6

The Bayeux Tapestry is a unique narrative embroidery that tells the story of the Norman Conquest. It was made in England just after 1066.

their forebears, the Vikings. The whole land from Hastings to Durham was placed under martial law, exercised from the newly invented war machine, the motte and bailey — a great plum pudding of earth with a looping ditched enclosure around it. This is how the castle began; a personalised fortress from which a single warlord and his cronies could dominate territory. Once the Normans had control, they set about rebuilding England in what they imagined to be the contemporary European image: flattening the *burhs* and their minsters and replacing them with a castle at one end and a cathedral at the other. The late Saxon Roman-style pots disappeared and the enslaved English boiled their carrots (and beef, if they were lucky) in dark handmade earthenware.

The story of the Norman Conquest is told in one of the world's first cartoon strips: the Bayeux tapestry — actually neither a tapestry nor a French creation, but an embroidery, made by English women, in England (probably in Canterbury). It was the last exquisite flowering of late Saxon wit and wisdom. It is a curiously even-handed and unsentimental production, with the lively figures we have admired in the Late Saxon manuscripts redeployed to enact Norman history. Buried in the 'footnotes' beneath the story-line are a number of

scurrilous jokes and innuendoes, some known only to the gossips of the day.

The ghosts of the many territories, communities and cultures of first millennium Britain were long remembered in subtle, subterranean ways and they are present in the land to this day. The culture and language of someone living in Reading is rooted in the Iron Age tribe of the Atrebates. They had their Roman capital in Silchester and became the people of Wessex, who under Alfred were to create the kingdom of England. The peoples of the Moray Firth remembered the Iron Age Verturiones, and became the men of Fortriu and the Moray Mormaers who, under such leaders as Macbeth and Duncan, drew a permanent frontier with the Norse in northern Scotland. When the Normans invaded, those ruthless modern entrepreneurs took hold of a land of extraordinary diversity. Beneath all the political dressing-up that has followed, that diversity has endured; in dialect, in regional accents, in the games of children, in cooking, in attitudes to art and poetry, in the love of mountain, or firth, river, lake or fen. The roots put down in the first millennium were deep and hardy. It is hardly surprising that this multicultural, experimental age, brimming with ideas, has so much in common with us today.

Chapter 2

AGE OF WORSHIP

BY JOHN GOODALL

Medieval life was controlled by two great forces: the crown and the church. These days, the church no longer dominates our society, but in the Middle Ages religion was everything. It gave purpose and structure to daily life. It helped protect the sick and the poor. And although it sought to control peoples' thoughts and deeds, it inspired artists to create some incredible works of art.

Tombs of the Crusader Knights in the Temple Church in London. This magnificent round Church was modelled on the Church of the Holy Sepulchre in Jerusalem. It was built by The Knight's Templar, an order of crusading monks whose role was to protect pilgrims going on pilgrimage to the Holy Land in the twelfth century. The tombs show the dead knights as they were in their youth, hands poised to unsheathe their swords and their feet not in repose but waiting to leap into action should Christ call again.

At sunset on 29 December 1170, while the monks chanted their evening prayers, four armed knights forced their way into the cavernous and darkening interior of Canterbury Cathedral. They came in pursuit of Thomas Becket, Archbishop of Canterbury, the leader of the English church. Becket was engaged in an acrimonious dispute with Henry II, the King of England and the effective ruler of a vast empire stretching from Ireland to the French Pyrenees. The king had been overheard a few days earlier furiously denouncing the archbishop, and the knights came as self-appointed agents of his rage.

Their noisy entrance in armour and with drawn swords brought ordinary life in the building to a halt. From the host of onlookers who rapidly assembled there survive no fewer than five eyewitness accounts of what happened next. Becket, who was surrounded by a small group of his household, confronted the men in the north transept of the church. There he replied boldly to their accusations of treachery to the king. The knights then attempted to drag their victim out of the building, but he clung determinedly to a pillar.

Reginald, the leader of the knights, tried particularly hard to dislodge Becket's grip. 'Pimp!' the archbishop swore at him. Provoked by this and other insults, Reginald swung his sword and sliced off the

Canterbury Cathedral, Kent, the star of the English church and the scene of Thomas Beckett's murder in December 1170.

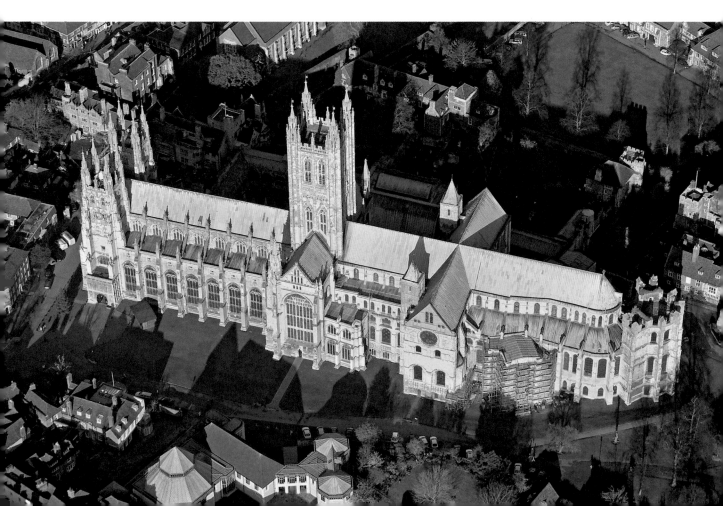

crown of Becket's skull. While one of the knights kept back the crowd an absurdly botched murder ensued. Becket required two more blows to his unprotected head before he fell to his knees and then on his face. A fourth blow cut through the skull so that the blade shivered in two on the church flagstones. Finally, a clerical companion to the knights placed his heel on the neck of the archbishop and with his sword scattered the blood and brains – white and pink, as the witnesses carefully noted – across the floor. 'Let's be off knights,' he called, 'this fellow won't be getting up again,' and the men jostled out of the cathedral.

Henry II was appalled to hear of the murder that had been committed in his name, but much worse news was to come. Within a week, Thomas Becket began to work miracles from beyond the grave; that is to say, people invoked his help – mainly the injured and the sick – and he healed their complaints. By these miracles Becket won a popular following and was proven – against the wishes of many influential people – to be a saint and the murder, therefore, a martyrdom.

Such was Becket's support that he was formally canonised as St Thomas by the Pope in March 1173. Then in July 1174 Henry II performed public penance for his part in his death, walking to the archbishop's tomb and submitting himself to a public scourging at the hands of the Canterbury monks (each of the eighty men laid on three strokes). By any standards such self-abasement was astonishing; we would scarcely be less surprised to see a modern head of state atoning for their faults in this way. The penance was seen to have an immediate effect: the very next day, William the Lion, King of Scotland and a troublesome enemy of Henry II, was captured outside Alnwick in Northumberland. To the king, this miracle proved that he was reconciled to his dead archbishop.

Two months later, in September 1174, a fire in the cathedral – quite possibly started deliberately so as to force the issue – encouraged the monastic community at Canterbury to rebuild their church. Senior masons from England and the Continent were gathered together in what amounted to an open competition for this plum job. Eventually the monks chose a certain William of Sens for 'his lively genius and good reputation'.

William brought to England designs and patterns from his native France and began work on a splendid building in a new architectural style. Since the Norman Conquest in 1066, England had witnessed a huge building boom in a style termed the Romanesque, after its imitation of classical Roman architecture. At Canterbury William of Sens worked in a new idiom, creating a delicately ornamented interior

The stern figure of St Thomas Beckett from the late twelfth century glass of Canterbury Cathedral.

with large windows. Since the eighteenth century this style of architecture has been termed Gothic.

In the autumn of 1178, while working on his new design, William of Sens was crippled in a fall from the scaffolding and was forced to return home to France, where he later died. His place was taken by another William known – presumably after his birth – as 'the Englishman', and a new phase of work to the church began.

Up to this point the rebuilding of the cathedral had not been formally connected with Becket's cult. But in August 1179 the saint received his two grandest pilgrims to date: Louis VII, King of France and the Count of Flanders. Henry II took care to conduct these powerful men to Canterbury personally from their landing place at Dover and then back to their ships. Around 1180, probably in direct response to this visit, William the Englishman modified the design of the cathedral to create a prominent and public setting for Thomas's tomb behind the high altar. Canterbury was effectively being converted into Becket's church.

The unexpected burgeoning of Becket's cult clearly concerned Henry II and in 1181 he began an architectural riposte to the rising cathedral at Canterbury. Dover, where the French king had landed, was the front door of his English realm, its natural harbour offering the shortest sea crossing to the Continent. It was here, therefore, that he initiated the total reconstruction of the castle that commanded the harbour. The project, overseen by a royal mason called Maurice, was probably the most expensive architectural commission of his reign. By its sheer size, this castle conveyed a clear message to all who passed the Straits of Dover: whatever the fortunes of Canterbury, Henry II was still a king to be reckoned with.

For those privileged enough to enter it, the new Dover Castle also made one remarkable reference to Becket's cult. The architectural centrepiece of this great complex was a huge tower or keep built between 1181 and 1188. It was appointed with every domestic luxury, including a system of lead pipes that provided running water to all the principal apartments. Also incorporated within the tower was a sumptuous chapel identical in architectural detail to the new work at Canterbury and dedicated to St Thomas Becket. It is as if Henry wanted the tower with its chapel to express his mastery over Canterbury Cathedral and its new saint.

Whatever Henry II's hopes, however, the cult of St Thomas Becket continued to thrive throughout the Middle Ages. Part of its appeal was political: St Thomas had been murdered resisting a king and

he came to be viewed as a champion who opposed the arbitrary exercise of royal power. When, for example, Henry III's new and much-resented fortifications at the Tower of London twice collapsed in 1241–2, St Thomas was represented as having struck them down as a threat to the liberty of the city.

Precisely because of its popularity, the poet Geoffrey Chaucer (d. 1400) chose St Thomas's shrine as the notional context for his most celebrated literary work. *The Canterbury Tales* is set of stories told by a group of pilgrims to each other as they journey to the Canterbury shrine one spring. Chaucer chose the pilgrimage as the context for his tales because it brought together a complete cross section of his society in a common endeavour that effectively broke down social differences.

Visiting Canterbury Cathedral today it is still possible to get some sense of the visual riches that would have greeted Chaucer's pilgrims at the end of their journey. St Thomas's body was housed in a shrine that stood on a rich marble floor and encircled by polished marble columns behind the high altar. The marble in the immediate setting of the shrine is predominantly pink, a very rare colour in English medieval buildings. It was almost certainly chosen to evoke St Thomas's brains when they were dashed across the floor.

In the spaces between the columns there gradually built up a collection of grand tombs of those who placed themselves in death under the protection of St Thomas. Among them are monuments with life-sized effigies of Henry IV and his queen, Joan of Navarre (d. 1437), and one of the flowers of English chivalry, the Black Prince, son of Edward III (d. 1376). Astonishingly, the prince's so-called 'achievements' (equipment, including his helm, shield and sword, that hung above the tomb to celebrate his martial prowess) still survive. The presence of these monuments and their trappings reflected on St Thomas's power and added both interest and lustre to the shrine.

Meanwhile, the late twelfth-century stained glass of the windows around the shrine presented narratives of St Thomas's miracles. Set low in the walls, these must have been easily legible to all visiting pilgrims. In sunlight their bright colours also turned the church into a physical evocation of the Heavenly Jerusalem, which is described in the biblical Book of the Apocalypse as possessing walls built of many-coloured jewels. As the columns made architecture of Thomas's brains, so did the church become a man-made image of heaven.

Magnificent though Canterbury Cathedral remains to this day, the real focus of its medieval interior is lost. Becket's shrine took the form of a small, free-standing house with the saint's coffin raised to public view

The tomb effigy of the Black Prince in Canterbury Cathedral. A celebrated soldier, his military equipment was hung above his tomb.

on its upper floor. Beneath were a series of small niches in which pilgrims could kneel in prayer. Becket as a saint in heaven was understood in some sense to be connected still to his earthly remains. Proximity to his body, therefore, not only promised petitioners the saint's attention but brought them into vicarious contact with the celestial world. In reflection of its sacred contents, the shrine was

A woman injured in an accident (left), visits the shrine of St William at York Minster to be healed. Two scenes depicted in the fifteenth century stained glass windows at York Minster.

decked in precious metals and jewels.

The shrine was also separated from the high altar by a tall screen of beaten silver set with the figures of saints. Virtually all we know of this fabulous arrangement is that after three centuries, when Henry VIII's commissioners destroyed the shrine in September 1538, they pillaged an astonishing twenty-six cartloads of bullion from this space. In its entire history, Britain has probably never again created a single artistic assembly of such material value.

The architecture and ornament of the shrine area must have resembled nothing so much as a great treasury, filled with colour and coruscating light. It was, however, a living space too. During the celebration of the liturgy, the clergy dressed in rich vestments, performed elaborately choreographed rituals and filled the space with

sound and music. Meanwhile, the pilgrims who passed were both onlookers and participants in the spectacle. As Chaucer makes clear, these were not just pious multitudes but real people: men and women; young and old; priests and laity; the devout and the grasping; the rich and the abjectly poor; the credulous and the worldly. They made a distinctive artistic contribution to the space of a very different character.

Pilgrims often gave quantities of wax either in expectation or in thanks for the saint's favour. The wealthy, for example, might donate their body weight in wax for candles that stood in their hundreds on iron beams and racks all round the shrine. Alternatively, wax might be modelled into memorials of healing and hung up in the same way: a wax leg or arm representing the injured part of the body that St Thomas had healed. In addition, those whom he helped would hang up

A late fourteenth century lead pilgrim badge depicting St Thomas Beckett. It was found in the Thames at London, where it was probably dropped as a token of a successful pilgrimage.

tokens of their former suffering: the shackles of a prisoner released or the crutches of a lame petitioner made able.

And as a mark of their journey to visit St Thomas, pilgrims took back with them mementoes, little badges cast in lead representing the martyrdom. Some were made to contain water that had been poured on the shrine or its relics and had thereby become impregnated with the saint's power.

The story of Becket's martyrdom and the art it generated is worth telling in detail because it illustrates so vividly how the medieval world created, used, encountered and consumed art. In all kinds of ways, this is completely at odds with the mainstream of modern experience. Most importantly, medieval art was functional and created with a purpose: the shrine and cathedral at Canterbury celebrated the power and glory of God and his favoured servant, Thomas Becket. The chapel at Dover Castle underlined the power of Henry II.

By extension, while medieval men and women certainly appreciated the beauty of objects – the delicacy of paintings or the curiosity of worked gold – they were not used to marvelling at art in neutral gallery spaces. Nor did a medieval audience necessarily compartmentalise art into formal categories (although they were perfectly aware of them). Their experience of the shrine and its surrounds was of a combination of arts and materials – architecture, music, painting, sculpture, metalwork, stone, glass, timber, jewels, rich fabrics and wax – integrated into a single, symphonic sensory effect.

Finally, this description of the shrine illustrates an important practical point. Just as Canterbury Cathedral has lost its shrine and most of the trappings that would have made it recognisable to medieval pilgrims, from jewels to wax pilgrim tokens, so has the vast majority of art from this period been consigned to unrecorded oblivion. The British medieval art that we admire and study is the tiniest fraction of that which was created. Moreover, the lion's share of what survives reflects the interests only of the wealthy and powerful.

When so little art survives it is small surprise that the names of those who made art and architecture are often forgotten too. Nevertheless, it is a mistake to suppose that important artists and craftsmen in the Middle Ages were – as modern myth would have it – pious and anonymous individuals working solely for the glory of God. The fact that the names of the three principal masons involved at Canterbury and Dover survive underlines the status that leading artists might enjoy.

Writing in about the year 1000, Aelfric, Abbot of Eynsham observed that in his world there existed:

> Three orders set in unity: those who work, those who pray and those who fight. Those who work labour for our living; those who pray plead for our peace with God; those who fight battle to protect our towns and defend our land against an invading army.

Aelfric's vision of society with its peasants, priests and knights would have been recognised by men and women throughout the Middle Ages (and even beyond it). It omits mention of only one significant group: the urban rich. From the late twelfth century onwards, the merchants of cities such as Edinburgh, York, Bristol, Norwich, Dublin and London became increasingly important in financial and political terms.

The wealthy in this society eagerly patronised art as a means of social advertisement. Whether in architecture, the decoration of chambers, clothing, or even the ceremonial presentation of food, medieval society was intensely concerned with the outward expression of wealth and status. Art was the means by which you represented who you were. This imperative is still strikingly apparent in medieval funeral monuments across the country. Images of the dead are rarely portraits (in the modern sense of physical likenesses). Rather, they show individuals in the trappings of social identity: knights in armour or priests in vestments.

Of all the medieval arts, architecture – as represented, for example, by Britain's cathedrals, castles and parish churches – survives more completely than any other into the twenty-first century. In one important sense, this survival is a happy accident. Architecture was the highest of the medieval arts: it notionally replicated in physical form the harmonious proportions and natural geometry of God's own creation.

As a reflection of its importance, architecture was extremely expensive to commission. By comparison, the figurative arts, such as painting, sculpture and stained glass – which are today so highly prized – were cheap, their chief cost being the materials involved. In the case of a goldsmith's work, this meant the weight of bullion and the value of jewels, or in painting and manuscript illumination, the price of precious pigments.

When costings survive for commissions, therefore, they can make strange reading for a modern audience. In 1385, for example, Richard II installed new life-sized sculptures of kings in his hall at Westminster.

Non mortui laudabunt te domine:
necp omnes qui descendunt in infer
num. Et nos qui uiuimus benedicimus
domino: er hoc nunc et uscp in secu
lum. Ilexi: quoniam eraudiet do
minus uocem oracionis mee. Quia inclinauit aurem suam mi
chi: 7 in diebus meis inuocabo. Circumdederunt me dolores mor
tis: et pericula inferni inuenerunt me. Tribulacionem 7 dolorem inueni: 7
nomen domini inuocaui.

(left) A page from the Luttrell Psalter, c. 1325-45. Geoffrey Luttrell is seated at table with his family and guests (bottom), and a monstrous beast is depicted in the top margin.

(below) The beautifully styled effigy of Queen Eleanor of Castille in Westminster Abbey. It was made by goldsmith William Torel in 1290-1. The indentations would have originally contained jewels.

These were expensive objects, each costing over £2 – about the annual wage of an unskilled labourer. Six of the sculptures were painted at a total cost of nearly £9, practically doubling their price. But the most expensive feature of the work by far was the construction of elaborate stone niches for the figures. Excluding materials, the architectural detailing of each niche cost just under £5 to make – over twice the price of the statues they contained.

Because of the prestige it enjoyed, architecture was fundamental to all types of medieval design. Furniture, for example, was usually architectural in form. Moreover, architectural elements, such as arches, battlements, pinnacles, rose windows and flying buttresses, were used in miniature to decorate everything from stained glass to clothing.

In acknowledgement of its importance and sacred purpose, art produced in the Middle Ages for the church was necessarily richer than

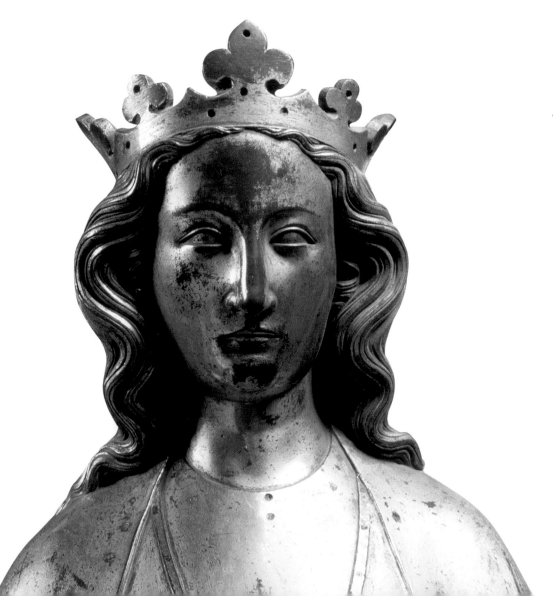

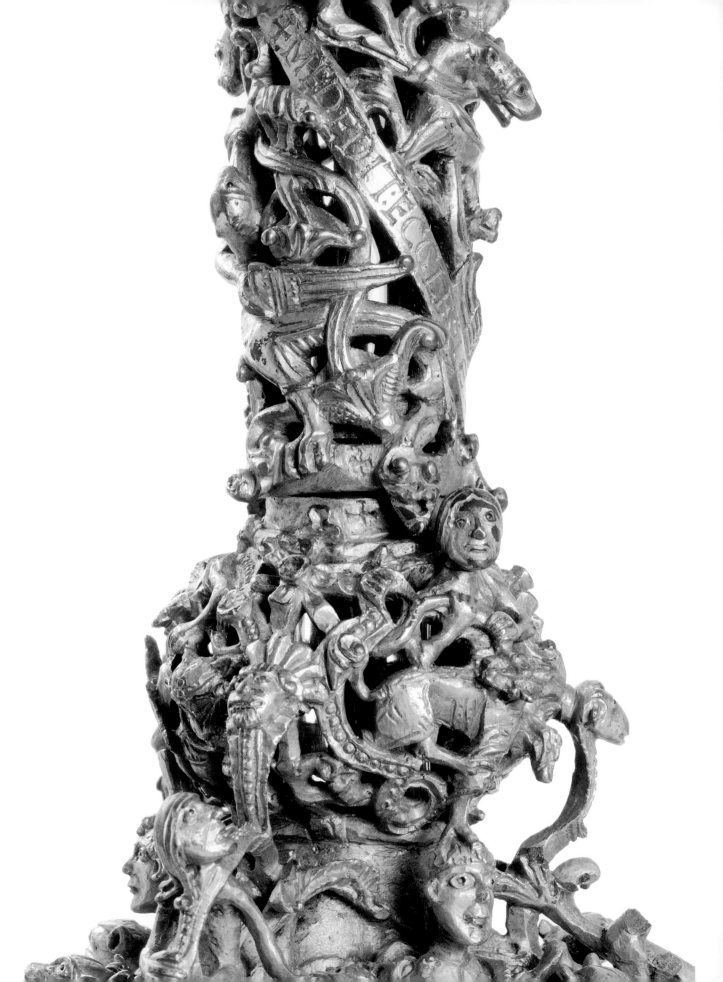

The Gloucester Candlestick, 1107-13, is a virtuoso work of copper alloy casting. An inscription records it as a gift to the abbey of Gloucester.

any other. For the same reason, it was generally in the context of the church that great artistic innovations occurred; as, for example, the introduction of the Gothic style to England at Canterbury. It was in the life of the church that the medieval world found its focus.

To medieval society at large, religion was less a matter of theological belief than of practice. Between birth and death, every Christian lived within a framework of rituals managed by the church. They also lived its calendar of feast and fast; saints' days and festivals. Men and women could no more choose to opt out of the life of the church than individuals in Britain today could turn their backs on the state. As a reflection of its importance, the church was hugely wealthy and its organised ranks were well populated. In the late twelfth century, for example, it is estimated that one in six people enjoyed the legal status of clergy.

The central justification for the scale, wealth and influence of the church was its role as a mediator. The medieval mind saw the day-to-day world as inextricably connected with its celestial counterpart. God, the Devil and their respective servants were acknowledged to intervene directly in the affairs of the living. The church managed the relationship of the world with these powers: it offered up worship to God both for the good of society and also for the benefit of the dead, whose helpless souls awaited judgement at the end of time. On that judgement depended the future of all mankind in the afterlife.

It was as a reminder of this fact that by the fifteenth century many churches came to possess as their visual centrepiece a particular iconographic programme. Above the screen that isolated the high altar was suspended a sculpture of Christ on the cross, dying to save humanity from its sins. And around this crucifixion there was commonly painted a so-called Doom or Last Judgement. A well-preserved example at Holy Trinity Church, Coventry, is typical of the genre. Christ, surrounded by apostles, saints and angels, sits in judgement as the dead are raised from their tombs by the last trumpet. To either side are shown the two possible fates of these multitudes of men and women: the gateway to Heaven or the monstrous mouth of Hell, with its flames and lurid torments.

Because of the centrality of Christian practice to daily life, religious art was not just the preserve of churches. Great houses always possessed their own chapels and even domestic chambers were commonly decorated with the images of saints. In 1237–8, for example, Henry III ordered his chamber at Clarendon to be painted with scenes from the life of St Margaret and the four gospel writers or Evangelists. Religious subject matter appeared too on the homely

(left) Detail from the Gloucester Candlestick, showing the elaborate design of writhing figures and monsters – a depiction of the struggle between good and evil.

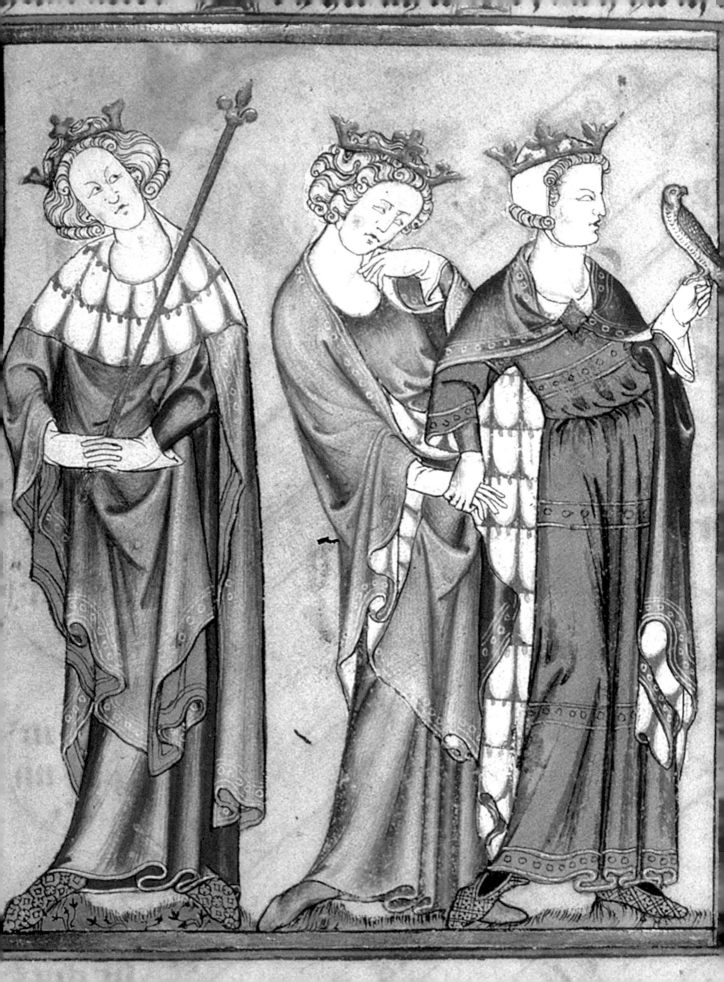

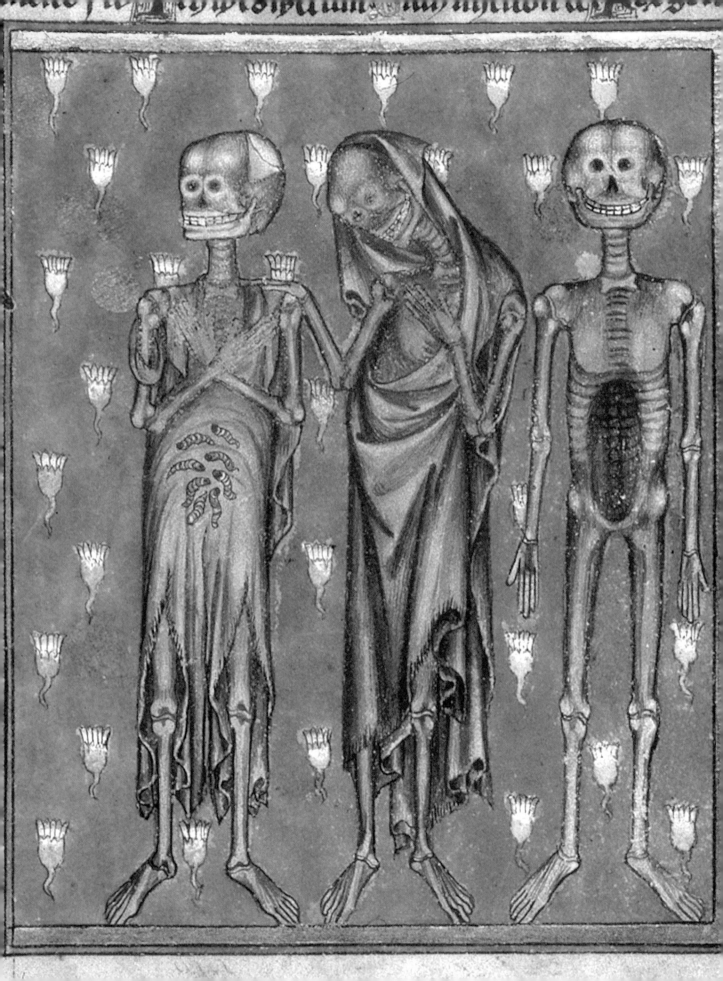

objects familiar to those in the lowest level of society; their cheap glazed pottery, wooden plates and small trinkets might be inscribed with prayers or devotional images.

In modern Britain every attempt is made to distinguish between religious and secular affairs. The Middle Ages, however, integrated them not only in daily life but in politics. At the very summit of the social pyramid, kings were (as they still are) consecrated rulers and priests of their people. This dual character could be powerfully expressed in art.

On 17 November 1387 the hall at the royal palace of Westminster was the setting for a dramatic meeting between Richard II and his political critics. The king, who carefully stage-managed the occasion, may have chosen the hall deliberately as the architectural backdrop for this trial of strength. Built in the 1090s, the huge interior of the hall served as a physical embodiment of the power of the English kings and the seat of royal justice. It was a building, in short, that spoke more loudly than words of his power and majesty.

For all Richard II's preparations, the event was a humiliation. In its aftermath he reacted by interpreting his identity as an anointed

The cavernous interior of Westminster Hall with its great angel roof, begun by Richard II in 1394. The hall is still used for great state occasions.

This crown, set with pearls, sapphires and rubies was probably brought to England by Richard II's wife, Anne of Bohemia in 1382. It shows the glittering sophistication of court dress.

ruler and God's deputy on Earth in ever more extreme terms. To this end, new and high-flown terms of address were introduced to court along with additional ceremonies and protocol to ritualise his life. Some aspects of this process appear innocent enough – the pocket handkerchief, for instance, seems to have been introduced to England by his ever more refined court. Others were not.

The king increasingly distanced himself from all his subjects. According to one contemporary, for example, it became his habit to 'have a throne prepared for him in his chamber on which he would sit ostentatiously from dinner till vespers, talking to no one but watching everyone; and when his eye fell on anyone, regardless of rank, that person had to bend his knee towards the king.'

Art played a crucial role in Richard II's efforts to aggrandise himself. He is the first English monarch to have collected tapestry in quantity; a fabulously expensive type of woven hanging produced on the Continent that was hung on the walls of his apartments. In addition, he paid assiduous attention to his dress, wearing rich clothes and adopting the hart with 'royal' or twelve-pointed antlers as his badge. One crown, probably owned by his wife Anne, still survives and gives a vivid impression of the spectacular dress of the court.

The Wilton Diptych, commissioned by Richard II c. 1395. The back (top) shows the king's arms and the royal stag. The front (bottom) shows Christ presenting the youthful king with a banner representing England.

Two other outstanding objects on very different scales reflect the nature of Richard II's political aspirations. The first of these is a two-leaved panel painting known as the Wilton Diptych. Nothing is definitively known about the provenance of this exquisite object. The inner leaves of the panel depict Richard II as a young man – crowned and in splendid dress – being presented to Christ and the Virgin Mary by a group of patron saints.

Around the Virgin and Christ stand a group of angels, all of whom declare their allegiance to the king by wearing his badge. One of the angels additionally holds a banner, which Christ leans forward to bless. Depicted in tiny detail on the golden ball of the standard – as if reflected in it – is an island with a castle; an unmistakable image of England. Here Richard is unequivocally being shown as receiving his kingdom with the sanction of Christ.

Richard II explicitly underlined his role as a divinely appointed monarch in one of the outstanding architectural works of the reign. Perhaps to efface all memory of his humiliation there, from 1393 Richard II completely remodelled Westminster Hall. The entrance of the building was reordered in the manner of a great church front with two towers, as if visitors were entering a sacred space.

Meanwhile, a huge and splendid new roof was raised over the hall – one of the acknowledged masterpieces of medieval carpentry. Viewed from beneath it appears to be supported on the backs of thirteen pairs of hovering angels. The number – which matches that of Christ and his apostles – is very significant. It suggests that the celestial court protected its terrestrial counterpart in the space beneath. Moreover, it implies that on state occasions Richard II played the role of Christ to his own followers.

Kings were not only sacred figures; they also led their kingdom into war. This role made them the leaders of the nobility and knightly classes, men who lived for war.

To the popular imagination, the knight on horseback is perhaps the defining image of the Middle Ages. It was the expense of his equipment, and the rehearsal of its skilled use in mock battles, or tournaments, that first helped forge a sense of common social identity among knights. Around 1200, tournaments were not conducted as orderly contests with two knights charging at each other down clear lists. They were instead confrontations of teams and the winners ransomed everything from their vanquished opponents. They were also extremely dangerous; indeed tournaments accounted for far more deaths among the great than war did in this period.

Hoghtbek.

320

37

Gatyston

(on previous page) *(on previous page) An early fifteenth century herald's manuscript depicts two knights, Troghtbek and Watyslon, clashing in a tournament.*

A cloth painted c. 1470 for the Buxton family, whose coat of arms it displays. The figures of night and day appear to the left and right.

86

Along with the popularity of the tournament there emerged in the twelfth century the concept of chivalry, a word that literally refers to the behaviour of *chevaliers* (cavaliers) or those who rode horses. There also became established two closely related registers of knightly display. The first of these was heraldry, a system of identification for knights in battle. In Britain, heraldry became widely popular from around 1250. It was not only applied to armour but to personal possessions of all kinds – including clothing, tombs and buildings – as a mark of ownership.

Besides heraldry proper, there also developed the 'arms of peace'. The term refers to the armour and heraldry of the tournament field. In concession to the medieval love of display, this could be fantastical; during a tournament you could dress as someone else.

The most popular group to be impersonated in the tournament field was the legendary court of King Arthur. The tale of the 'Once and Future King' was first brought to the attention of Europe by *The History of the Kings of Britain*, written by Geoffrey of Monmouth in the 1130s. Extravagant Arthurian tournaments or 'round tables' subsequently became a commonplace of the thirteenth-century court. One table that was presumably used as a prop for such a gathering

survives in the great hall of Winchester Castle.

One such occasion still resonates in modern Britain. In January 1344 a great tournament was held at Windsor Castle by Edward III. In its aftermath the king declared his intention of founding an Arthurian chivalric order with 300 men whose members pledged mutual assistance and loyalty to him. Work then began on a home for this order, a circular building – evoking Arthur's Round Table – in Windsor Castle, two hundred feet in diameter. In mysterious circumstances this project was abandoned and then revived in a different form: on 24 June 1348 the Order of the Garter was established. This order still survives and membership of it remains the highest honour for a British subject.

As first constituted, the order comprised twenty-five knightly members and the king; in effect two groups of twelve men led respectively by Edward III and his eldest son, the Black Prince. The number was intended to mirror the number of Christ and the apostles. As a matter of fact, it also conformed conveniently to the usual size of competing teams in court entertainments and tournaments; this was an order that combined devotion with pleasure. The first formal meeting of the Order of the Garter took place on 23 April 1349, the feast of St George, who thenceforth deposed St Edmund as the patron saint of England.

As a reflection of their martial lifestyle, noblemen and knights also occupied a distinct type of residence. Castles advertised the vocation of their owners by their battlements, towers and other fortifications. They were also the means by which this social group defended and managed their property; and from which they practised their profession. Castles were much more than merely defensible buildings. They could also be theatrical, making reference in their architecture to the same fantastical ideas apparent in the tournament field.

Like the society that produced it, medieval art in Britain was in some ways very ordered. There existed within it, however, a natural spirit of riotousness, which created a genre of art unique to this period. Pushed to the margins of medieval manuscripts, on the parapets of churches, and even on the edges of maps of the world often lurk legions of bizarre figures: men with the bodies of animals; sprigs of foliage that grow into human heads; mermaids; dragons; and ludicrous images of monsters farting into instruments. Side by side there also appear ridiculous scenes: knights fighting snails; men browbeaten by women; or monkeys acting out scenes of human life.

The imposing walls of Caernarfon Castle, begun by Edward I, 1283.

These so-called marginalia or grotesques were once dismissed by scholars as childish absurdities. Certainly, they are playful images intended to fascinate, delight and frighten. Nevertheless, they are carefully devised. The medieval conception of the world was one of opposites that confirmed and defined each other. Good necessitated evil; order implied chaos; and beauty demanded a correspondent formulation of ugliness.

This notion of opposites created a type of art that celebrated the real world by perverting its forms. The absurd, the frightening or the ridiculous became an assertion of their opposites: the sensible, the comforting and the apposite. When inhabited by monstrous images, the edges of a map or the margins of a page served to reinforce the truth of the known world or the text they ornamented.

As the term suggests, the 'Middle Ages' is no more than a block of time that falls between two intensely studied periods. Defined most broadly, it follows the early fifth century collapse of Roman power and precedes the sixteenth century revival of Classicism known as the Renaissance. By comparison to these periods, and despite its great length – over a thousand years – it remains relatively unknown in a

popular sense. Indeed, the names of Julius Caesar and Henry VIII are probably recognised more universally than those of any intermediary ruler in Britain. In the grand narrative of British history it is as if the Middle Ages has been collectively accepted as the period that falls after you care, but before it matters.

It is not the fate of the Middle Ages, however, simply to be overshadowed. Scholars have been complicit in actively belittling its achievements to make the world of Rome and of the Renaissance shine brighter. So reflexive has criticism of this period become that the very word 'medieval' is now commonly applied – usually by those who know nothing whatsoever about it – as a strongly derogatory adjective synonymous with barbarity, bigotry and religious zealotry. It is a profound irony that at the very moment when technology has made it easier than ever before to witness man's inhumanity to man across the globe on a daily basis, the evils of the modern world are characterised as belonging to an historically remote period. The implication, moreover, is deeply unfair.

Viewed in their own terms, the High Middle Ages are astonishingly rich, fascinating and important. Between 1200 and 1500, Britain as a whole became appreciably wealthier and more populous. It produced in the process art of unrivalled quality. Indeed, there is hardly a town or landscape today that does not bear some physical mark of this period, either a church, a castle or a house. Off the beaten track of mainstream interests, but with its magnificent remains nevertheless easily accessible, medieval Britain stands as one of the most beguiling and exotic destinations in British history.

THE ENDVR
VVORDE ETH
OF THE FOR
LORDE EVER

IDOLATRY

SVPERSTICION

ALL FLESHE
IS GRASSE

FEYNED
HOLINE

Few periods in history capture the imagination like the Tudor Age. It was a time of adventure and exploration, power and glory. And as the imposing portraits of Henry VIII and Elizabeth I suggest, they were not interested, as before, in the power and glory of heaven, but in power and glory here and now on Earth.

I am printing a page of the Bible on a reproduction of a printing press of the early sixteenth century. It took me several minutes but craftsmen were said to print a page every fifteen seconds. Eight thousand copies of the Bible in English were distributed by Henry VIII after the Reformation, each with his portrait dominating the image of God.

In the National Gallery in London hangs *The Ambassadors*, a life-size double portrait of Jean de Dinteville and Georges de Selves, painted in 1533, while the two Frenchmen were on a diplomatic mission to England. This complex and magnificent painting embodies and illustrates several important characteristics of sixteenth-century English art. It reflects the fact that the visual arts of this period were primarily produced by foreign craftsmen rather than by home-grown talent. The painter of *The Ambassadors* was Hans Holbein the Younger, a German from Augsburg, who had worked in Basel before coming to England for the first time between 1526 and 1528 and then again in 1531 for a longer visit that lasted until his death from the plague in 1543. Holbein was just one of the many craftsmen who came to England from Germany and the Low Countries (present-day north-eastern France, Belgium and Holland), and dominated the English artistic scene from the late fifteenth century until well into the reign of Elizabeth I. As foreigners they were not permitted to establish workshops, but they had wealthy patrons and often used assistants to help with large-scale paintings. Holbein himself was especially successful, taking up the official position of 'the King's Painter' sometime in the mid-1530s and uniquely being allowed to set up a workshop.

The Ambassadors also illustrates the growing popularity of portrait painting during this period. Not just Tudor monarchs and courtiers, but numerous men and women of wealth and standing in their neighbourhoods clamoured to have their image captured in paint, and by the Elizabethan period these portraits were hung in large private and public spaces – often the long gallery of their country homes or the town halls of urban centres. Some people wanted a life-like portrayal and favoured a Northern European naturalistic style that was achieved by making a preliminary drawing from life, using fine brush strokes, and employing colours mixed with oil rather than tempera. Other sitters preferred a flatter image, without shadowing, depth or detail, provided that it conveyed their lineage, wealth and status. In *The Ambassadors*, as always, Holbein goes for naturalism

The Ambassadors *by Hans Holbein the Younger, 1533. This portrait of the French ambassadors to England, Jean de Dinteville and Georges de Selves, contains many symbols of the Renaissance.*

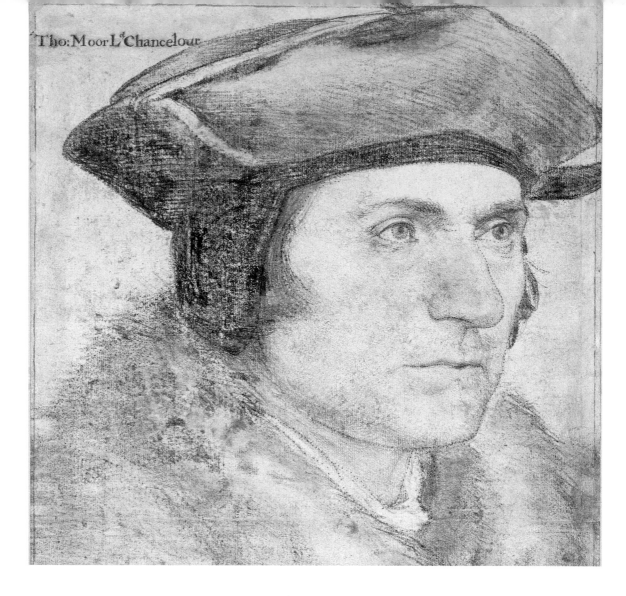

Tho: Moor L.d Chancelour

A drawing of Sir Thomas More by Hans Holbein the Younger, c.1526-7, which portrays the scholar characteristically in thought.

and successfully presents the individuality of the two ambassadors. The stance and face of de Dinteville (on the left), for example, project a confident, even arrogant personality, whereas de Selves's representation suggests introspection and greater modesty. Holbein reveals character equally well when he works on a smaller scale, as shown in the preliminary sketch of the scholar, Thomas More. What a contrast these portraits make to the lifeless *Portrait of an Unknown Lady* now in the Tate Gallery and to the icon-like representations of Elizabeth I. Not only are the women's faces mask-like but also the backgrounds are flat, making little or no attempt to convey spatial depth.

The Ambassadors is full of symbols: the distorted skull at the bottom, the mosaic pattern on the floor, the different objects on the two shelves of the table, and the half-hidden crucifix in the top left corner. Sixteenth-century artists and their patrons loved complicated symbols that needed unravelling, and art historians

Portrait of an Unknown Lady *painted by Hans Eworth, c.1565-8. The lady's mask-like face contrasts greatly with Holbein's life-like portraits.*

have spent many years of research in trying to explain them.
The symbols in *The Ambassadors* are especially interesting because
a number of them seem to relate to the two central European
developments of the period: the Renaissance and the Reformation.
'The Renaissance' is shorthand for the intellectual and cultural
movement that placed great value on a classical education for lay
people as well as for clerics, and promoted the study of the humanities
and liberal arts (especially history, grammar, rhetoric, moral philosophy
and astronomy) via the original Greek and Latin texts. This 'New
Learning', sometimes called humanism, is represented in the painting.
Both the lay courtier de Dinteville and de Selves, the Bishop of Lavour,
are shown as scholars, with their arms resting on a shelf laden with
objects that display their interest in arithmetic, geometry, music and
astronomy – four of the liberal arts popularised in the Renaissance.

The Reformation is the name given to the religious and political
upheavals that followed the German theologian Martin Luther's
challenge in 1520 to the authority of the Pope and doctrines of the
Roman Catholic Church. Over the next decades Christendom became
divided between Roman Catholics and religious reformers, who were
later to be called Protestants. In *The Ambassadors*, the religious

(on previous page) A detail of the distorted skull from The Ambassadors, *denoting man's mortality.*

divisions within Europe are alluded to symbolically: the Lutheran hymn-book; the dividers among the geometrical instruments; the lute with a broken string; the arithmetic book open on a page beginning with the word divide; even the misalignment of the instruments for use in the northern hemisphere. As well as highlighting this discord, the painting reminds us of the core belief that united all Christians: namely that Christ's death on the cross offered them the prospect of everlasting life. The two skulls (a small one attached to de Dinteville's hat as well as the larger one on the floor) denote man's mortality, while the promise of everlasting life through Christ's redemptive power is depicted through the crucifix and in the date, 11 April (Good Friday in 1533) on the sundial. The patron, de Selves, clearly hoped that an emphasis on this shared statement of faith would overcome the increasingly bitter religious divisions that were tearing Europe apart.

The Renaissance and Reformation not only influenced this particular painting, but also had a huge impact on English art in general. In England the Reformation began during the 1530s when Henry VIII's marital difficulties led him to break with the papacy and assert a royal supremacy over the English Church. Henry went on to close all the monasteries in his realm, launch a campaign against what he saw as superstitious practices (such as the cult of relics, pilgrimages and adoration of images) and promote the use of the Bible in English. Then during the reign of his son, Edward VI (1547–53), the English state completely rejected Catholic teachings about the nature of salvation and transformed religious worship by introducing an English prayer book and banning traditional religious customs and festivals. As far as art was concerned, these reformations had a devastating and destructive effect. Under Henry VIII (1509–47), elegant monastic buildings were left to fall into ruins, and their collections of fine art works dispersed or destroyed. Many illuminated manuscripts in monastery libraries, for instance, were used for scouring candlesticks, scraping boots, or as toilet paper. Under Edward VI, the destruction of medieval English art became even more widespread and systematic. Protestant reformers feared that religious paintings and statues encouraged idolatry and superstitious saint worship, while the most zealous of them argued that figurative art contravened God's commandment prohibiting 'graven images'. As a result, carved figures of angels, saints and the Virgin Mary were defaced or demolished; medieval stained glass was removed; wall paintings and screens in churches were whitewashed; and the huge ornamental crucifix on top of the screens was taken down, often to be replaced by a royal coat of arms.

Zealous Protestants under Edward VI also viewed other kinds of church ornaments with suspicion, considering them superfluous to the needs of a purified religion as well as liable to instil false doctrine in the laity. Consequently, the elaborate and fine medieval metalwork found in crucifixes, crosiers, candlesticks and chalices was melted down, while richly embroidered priestly vestments were picked apart and used for secular purposes. Some images and church furnishings were saved when parishioners or priests hid them in their homes; others in inaccessible places within the church also survived – at least until they too were destroyed under Elizabeth I (1558–1603) or during the English Civil War. However, thanks to a proclamation issued by Elizabeth at the beginning of her reign, tombs, brasses and monuments were on the whole protected from religious vandalism. Indeed, during the queen's reign the erection of elaborate tombs and monuments for the dead became popular once again. Late Tudor men and women wanted to be remembered by posterity for their lineage, power and piety, and they consequently built monuments that were decorated with heraldic devices, inscribed with a list of their achievements and contained effigies depicting them and their families at prayer. The vast majority of sculptures that were produced in the Elizabethan period exist as part of tomb monuments.

The tomb of the Earl of Leicester in St Mary's Church, Warwick. Elaborate effigies were popular with wealthy Elizabethans who wanted to be remembered for posterity.

While rejecting images of angels, saints and the divine, the Reformation produced its own art. Under Henry VIII, anti-papal propaganda and representations of the king as a church reformer appeared in drawings, watercolours and woodcuts that were sold separately or reproduced in printed books. To take one example, the woodcut title page of the English Bible, produced in 1539, (see page 102) communicated the visual message that Henry VIII was the Supreme Head of the English Church by placing at the top of the page the enthroned Henry receiving the Word directly from God. The repeating motif of the *Verbum Dei* (the Word of God) shows how it flows from Henry to the clergy through Thomas Cranmer, the Archbishop of Canterbury (on the left), and to the nobility through Thomas Cromwell, the king's secular deputy in church matters (on the right). At the bottom of the page, even the poorest of people have access for the first time to an English Bible and gratefully cry out '*Vivat rex*' (long live the king). As Bibles were ordered to be placed in every parish church in the land, this image of Henry was widely disseminated.

Under Elizabeth, visual propaganda continued to be produced. The most famous examples are the illustrations in the various editions of John Foxe's *Actes and Monuments*, commonly called the *Book of*

Edward VI and the Pope, c 1568-71. This painting portrays an allegory of the Reformation, with the pope knocked out by a bible.

(left) The title page to King Henry VIII's 'Great Bible', 1539, depicts the king as the Supreme Head of the English Church at the top.

Martyrs. Lesser known at the time and afterwards, but equally interesting, is a small painting, *Edward VI and the Pope*, which celebrates the anti-papalism and iconoclasm (destruction of images) that occurred during the young king's reign. Edward's dying father, Henry, is pointing towards his heir and passing on to him the duty of reforming the Church. On the other side of the boy king and facing outwards are councillors who favoured reform, whereas the figures facing inwards opposed it. On the floor lies the Pope, who has been knocked out by an open Bible displaying a text from Isaiah often quoted by Protestants; in the background on the right, there are two soldiers pulling down a religious statue from a column and another man smashing images. The picture looks rather like a cartoon, and it is in fact a composite of images taken from engravings that were printed in the Low Countries and readily available in Elizabethan England. The empty blocks of space originally contained inscriptions but their text is now lost. Produced in Elizabeth's reign, the painting celebrated the Edwardian Reformation and was perhaps intended to spur the queen on to carry out further acts of purifying the Church.

The Protestant suspicion of images and hatred of Rome also had an impact on secular art. Indeed it possibly explains why the Italian

style of painting that prevailed in the European Renaissance took so long to become fashionable in England. The Italians favoured naturalistic painting that used perspective, foreshortening, shading and chiaroscuro (a contrast of light and dark) to create the illusion of reality. Holbein used a similar technique in *The Ambassadors*, although like most Northern Europeans he was more addicted than Italians to detailed, fine brushwork. However, these kinds of *trompe l'oeil* were condemned by many Protestants who argued that the work of creation should be left to God. As a consequence, after Holbein, relatively few portraits seemed to reflect nature. Instead patrons, especially under Elizabeth, tended to commission painters to produce flat images, very different from the art of contemporary Italy. Nonetheless, a few Elizabethans did admire the Italian style of painting. One of these was the famous courtier and poet, Sir Philip Sidney. While on his travels in Europe during the mid 1570s, Sidney had his portrait painted by Paolo Veronese, one of the two premier artists then working in Venice. Sidney, who wrote the great epic poem 'Arcadia', was an ardent Protestant who died from a wound that turned gangrenous while he was fighting in Holland against Catholic Spain, but had no qualms about commissioning a portrait that his friend, Hubert Languet praised as: 'rather than representing you, it seems to be someone resembling you.' Although this particular painting is now lost, another one of Sidney as a young man by an unknown artist was painted, at around the same time, using a similar naturalistic technique.

The Italian Renaissance influenced the English visual arts in at least one way that was totally unaffected by the Reformation: the emphasis on 'magnificence'. Because humanists (advocates of the 'New Learning') extolled the importance of 'magnificence' – a notion defined by the classical Greek philosopher Aristotle as 'excellence of work on a great scale' – princes, cardinals, courtiers and merchants in fifteenth- and sixteenth-century Italy commissioned private and public works of art that were designed to be lavish, grand and elegant. Such art was justified by humanists on the grounds that it served the common good, but its main purpose was really to display the patron's power, wealth and discrimination. In England, Henry VIII and Cardinal Wolsey (Henry's chief minister until 1529) set the trend in establishing the sixteenth-century English taste for 'magnificence'. Both men were great builders. Wolsey began the magnificent residence at Hampton Court, which he designed as an Italian Renaissance palace – imposing in size, harmonious in its use of space, and embellished with classical features, such as terracotta roundels of the Caesars that were fixed to some of

the outer walls. Henry VIII ordered over forty royal residences to be built or rebuilt during his reign, including Whitehall Palace, a sprawling building that was the largest in Europe at that time. However, few of Henry's palaces adopted the stylistic innovations of Italy, but rather took their inspiration from France. Nonsuch Palace, for example, was a confection of ornamentation that more closely resembled the chateaux

This incredibly realistic painting of Sir Philip Sidney, c. 1576, uses naturalistic techniques favoured by Italian artists.

AN° DNI 1577
ÆTATIS SVA 22

PHILIP SIDNEY.

who giues him selfe, may well his picture giu
els weare it vayne since both short tyme doe r

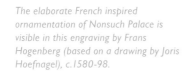

of Chambord and Fontainebleau, constructed for the French king
Francis I of France, than the plain and geometrically satisfying
structures recommended by the fifteenth-century humanist Leon
Battista Alberti in his influential treatise *De Re Aedificatoria* (*On the Art
of Building*). Under Elizabeth, classical decoration on houses proved
even more popular. Although the queen was not herself a patron of
new buildings, her courtiers, aristocrats and gentry built country
homes that incorporated arcaded loggias and classical columns as
part of their ornamentation. Nonetheless, Elizabethans still tended

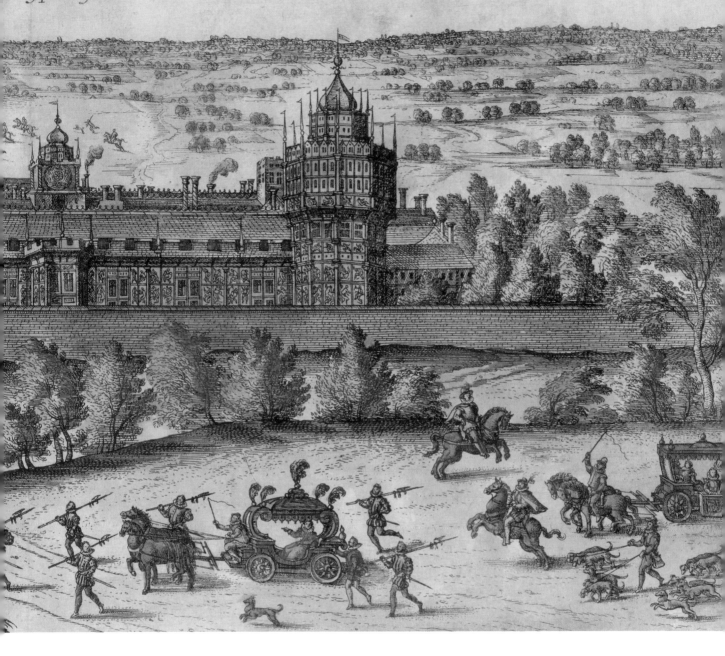

to design their houses around courtyards in the traditional way, and
generally avoided the symmetry and simplicity so admired in Italy.
They much preferred to display 'magnificence' through mountains
of glass windows, decorated chimneys, and ornamental turrets
and battlements.

The interiors of these palaces and country homes were as
magnificent as their exteriors, fitted out with the finest tapestries,
expensive carpets, ornamental plate and other rich furnishings – all of
which demonstrated the owner's wealth and social standing. Tapestries

Henry VIII by Hans Holbein the Younger, 1537. Henry and his children Edward VI and Mary I favoured these imposing 'power portraits'.

were especially valued as a vehicle for 'magnificence' because of their grand scale, costly materials and the technical skill involved in their production. Indeed they were so highly prized that painted cloths were often hung on walls without frames as if they were woven tapestries. The subject matter of wall hangings came from the Bible, medieval legend, classical history or mythology, and these illustrated scenes told a moral story. The aim was to inspire viewers to behave virtuously, wisely and heroically, for art was expected to teach as well as delight. Some owners of tapestries clearly chose individual pieces, because they identified themselves with the virtues on display and presumably wanted others to do the same. Among Henry VIII's huge collection of tapestries, for example, there were pieces depicting Hercules, the hero and demi-god of Greek legend who was renowned for his strength and courage, while Elizabeth, Countess of Shrewsbury (better known as Bess of Hardwick), purchased for her new house at Hardwick Hall wall hangings portraying Penelope (the patient wife of Ulysses), Cleopatra (who stood for fortitude and justice) and Lucretia (the Roman matron who chose death over dishonour). So that observers would know the source of the 'magnificence' on show, tapestries were often ornamented with the coats of arms and emblems of the owner. This could, however, reduce their value if the tapestries exchanged hands, and Bess of Hardwick demanded to pay a lower price for an expensive set on sale because the previous owner's coats of arms would have to be removed from the material and replaced with her own. In the event, although she paid less, she did not bother to remove the original coats of arms but simply had her own sewn over them.

Paintings were generally far less valued as expressions of 'magnificence' than expensive furnishings. Perhaps one reason for this was that painters in England continued to have a relatively lowly status. Very few artists signed their works, and almost all received a lower remuneration than carpenters, joiners, embroiderers and goldsmiths. Not thought of as specialists, and certainly not as artistic geniuses, painters were expected to take up commissions for many different kinds of work. Even the monarch's official painter and the Serjeant Painter (the officer who supervised the visual arts at court) were responsible for carrying out a range of decorative projects, whether designing elaborate tableware or producing backdrops for masques at court. Yet despite its inferior status, painting flourished in this period and particularly during the second half of the century. Colourful wall paintings decorated the interior of many Elizabethan houses; the production of portraits painted on panels greatly expanded, reflecting

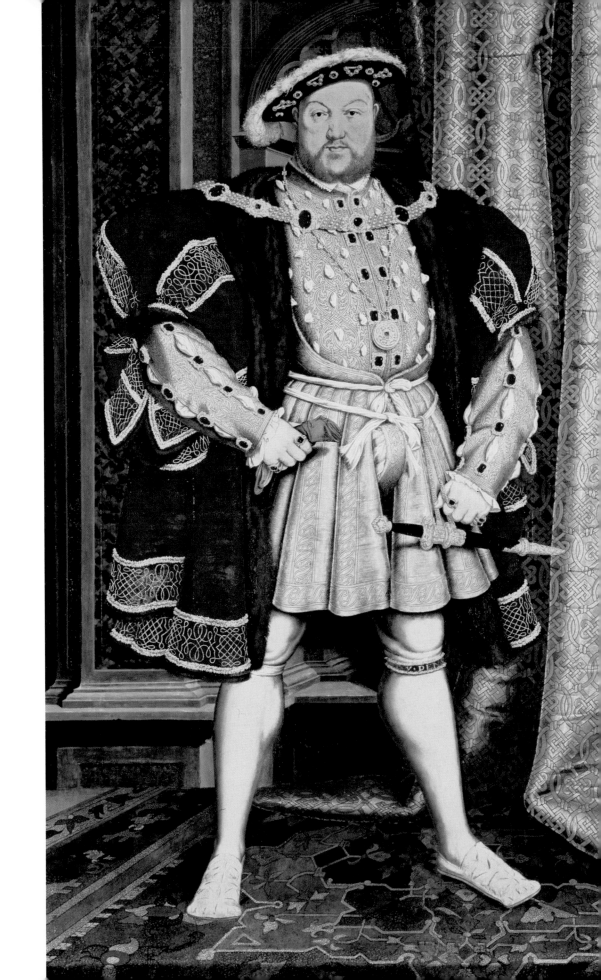

a Renaissance culture that venerated ancestors and approved of the acquisition of worldly fame.

Royal portraits were on show at court and in private houses, academic institutions and civic buildings. They fulfilled a variety of functions and were of great importance as expressions of 'magnificence'. For a variety of reasons (not least dynastic insecurity), Tudor monarchs were keen to communicate their majesty to subjects and foreign rulers. Aware of the power portraits of his arch rival Francis I, Henry VIII employed Holbein to paint his own larger-than-life image (see page 109). The first of Holbein's commissions was the mural for the Privy Chamber at Whitehall Palace (later destroyed by fire), and the royal image constructed there was to be reproduced many times in Holbein's workshop and by individual copyists. Unlike portraits of his father, Henry is shown full-length, facing the viewer directly; his legs stand astride exposing a prominent codpiece, which was a symbol of virility. Henry's broad shoulders and great bulk of a body project his power while his bejewelled attire establishes his wealth. Although he does not take up the typical classical pose (whereby the shoulders are rotated and one leg is flexed), Holbein's representation of the king nonetheless illustrates perfectly the Renaissance ideal of 'magnificence' in art. Both Edward VI and Mary I (1553–8) favoured power portraits of this kind, although Mary is sometimes shown seated on the throne.

Portraitists of Elizabeth developed a different approach to displaying her majesty. After early paintings that simply depicted her as a gentlewoman of high status, learning and piety, artists began surrounding her with symbols that represented her allegorically. In the mid-1570s, for example, Nicholas Hilliard painted the *Pelican Portrait* in which the queen is shown wearing a pendant brooch in the form of a mother pelican feeding her young. As the pelican was mythically believed to nourish her offspring with blood pecked from her chest, Elizabeth is here portrayed as the loving and selfless mother of her people and the nursing mother of her Protestant Church. The cherries by Elizabeth's ear possibly relate to her virginity; at any rate, the fruit is later mentioned in Shakespearean plays as slang for a woman's maidenhead. As the years passed, Elizabeth's virginity was to become a central part of her representation. Through the use of symbols, the queen was identified with virginal figures, such as the Roman priestess Tuccia, who was renowned for her power to carry water in a sieve without it leaking, and the classical goddesses Diana and Astraea. Not only are they allegorical in subject, but the style of these later royal portraits became increasingly non-naturalistic and thus moved

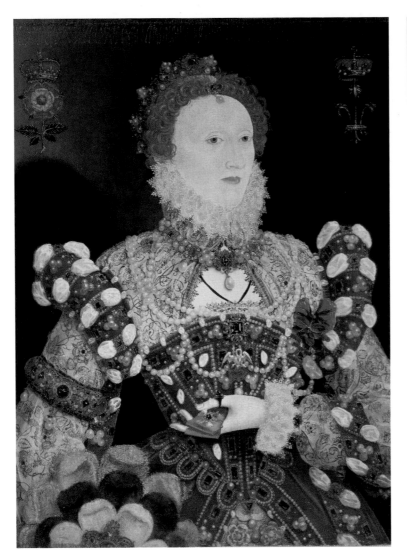

A detail from The Pelican Portrait, *of Elizabeth's brooch depicting a mother pelican feeding its young. This symbolises Elizabeth's selfless love for her people and church.*

The Pelican Portrait *of Elizabeth I by Nicholas Hilliard, c.1574. Artists began to fill portraits of the queen with allegorical symbols.*

even further away from the values of mainstream contemporary European art. In the 1580s and 1590s Elizabeth's body is often shown anatomically distorted or subsumed into the background of the painting, while the space is determinedly two-dimensional. The huge Ditchley Portrait by Marcus Gheeraerts the Younger is a good illustration of this trend (see page 113): Elizabeth's torso is unnaturally elongated; her shoulders are extraordinarily wide; her face is like a mask; and the setting is, of course, imaginary – she stands in the heavens upon an England depicted on a globe. Like her father's before her, Elizabeth's visual image came to symbolise the English nation; while Henry embodied England's power through his virility, his daughter's chaste body represented England's invulnerability to invasion. This type of unrealistic and allegorical image resulted in part from Elizabeth's

(on opposite page) The Ditchley Portrait *of Elizabeth I by Marcus Gheeraerts the Younger, c. 1592. This type of unrealistic image of Elizabeth was partly due to her aversion to portraits that exposed her growing age.*

Self-portrait miniature by Nicholas Hilliard, 1577. Unlike most painters he was considered a gentleman, as his elegant attire in this portrait suggests.

aversion to portraits that exposed her growing age. At the same time, associating her chastity with power was a way of dealing with both the national anxieties and fears of war against Spain, and the sense of triumph experienced after the defeat of the Spanish Armada in 1588.

At the other end of the physical scale, miniature portraits that were seldom more than two inches in diameter came to be widely produced during Elizabeth's reign. They had first appeared in England under Henry VIII who had employed the services of two leading families of miniaturists from the Low Countries, the Horneboltes and the Bennincks. However, under Elizabeth the art became really fashionable at court, not least thanks to the superb craftsmanship of the English-born painter Nicholas Hilliard. Elizabethans called miniature painting 'limning' (from the same Latin root as 'illumination') because small-scale painting had evolved from the art of manuscript illumination. Even when the word 'miniature' was first coined in the next century, it did not refer to the size of the pictures but to the origins of the artistic technique, for 'miniature' was derived from the Latin *miniare,* which meant 'to colour with red lead' – a practice that was used to decorate capital letters in manuscript illuminations.

Nicholas Hilliard was originally apprenticed to a London goldsmith and probably taught himself the art of limning from foreigners working in London. Unlike most painters, he was considered a gentleman. His title was 'Master', and a self-portrait miniature of 1577 shows him dressed in black with an elegant ruff and a bejewelled bonnet – appropriate attire for a member of the social élite. Hilliard was also unusual because he wrote a treatise about the art of limning – one of the very few to have survived in England. From Hilliard's description of his methods we learn that he drew sitters from life in full sunlight, avoided shadowing the face and rejected chiaroscuro. He would provide depth, only if it were strictly necessary, by adding a deeper tone of the same basic flesh colour. We learn too that Hilliard used only the highest quality materials: the finest vellum (parchment), 'from young things found in the dam's belly', that he mounted onto card, and gold and silver leaves ground into powder that he mixed with a little gum water and burnished with, 'a pretty little tooth of some ferret or stoat or other wild little beast'. The finished miniatures were glittering, delicate pieces of art that were greatly admired by the queen and her courtiers. The only rival to Hilliard for skill and popularity was his pupil, Isaac Oliver, who was probably born in France but lived in England from childhood. Oliver differed from his teacher in applying a restricted source of light that cast deep shadows, for which he used

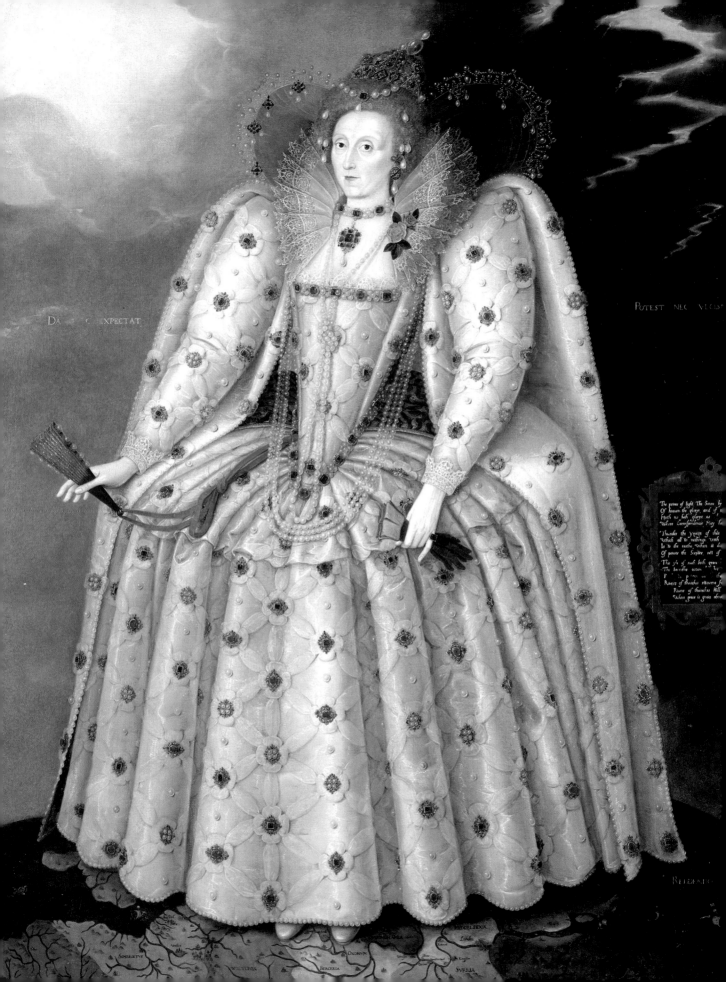

POTEST NEC VECIS

DA EXPECTAT

The intimate quality of miniatures is clear in this family portrait of The Browne Brothers *by Isaac Oliver, 1598.*

darker pigments. This gave a three-dimensional realism to his portraits that was lacking in Hilliard's. It is possible that Oliver learned this technique during his travels in Italy; by contrast, Hilliard travelled only to France, where the style was more linear and ornamental.

There was an intimate quality to miniatures that was quite absent from large-scale works. It is true that panel portraits were sometimes hung behind a set of curtains that had to be drawn back to reveal the painting, but miniatures were kept in private places, such as in a bedchamber, where they were wrapped up and tucked away in an elaborate box kept hidden in a drawer or cabinet. When viewed, miniatures were cradled in the hand and brought up close to the eye – an experience that was confined to an individual onlooker. Admittedly, some miniatures were set into jewels or lockets and displayed for public view, but even then there was an intimate quality as they were usually worn as tokens of affection or affiliation and could still be seen properly only when close-up. Often the sitters in miniatures were presented in an allegorical way or posed to express a particular emotion. Hilliard, for example, portrayed Elizabeth as the moon goddess Cynthia, while his *Young Man Among Roses* represented a melancholy courtly love.

The *Young Man Among Roses* is a good example of a miniature that was also an impresa (see page 116). An impresa (as the Italians called it) was a combination of a picture and motto or short message that signified the personal ideals, aspirations and achievements of the sitter. Impresa were an important part of court culture during Elizabeth's reign, greatly admired for their wit; today, however, their meaning is obscure and often eludes us. In this particular impresa the Latin motto, 'Dat poenas laudata fides' ('my praised faith procures my pain') alludes to words that were believed to have been uttered by the Roman general Pompey the Great. The picture, meanwhile, shows a lovesick young man who is wearing black and white (the personal colours of Elizabeth, signifying constancy and chastity) and entangled in white eglantine roses (an emblem also associated with the queen). Put together, this miniature most likely depicts Robert Devereux,

Young Man Among Roses *by Nicholas Hilliard 1585-95, probably depicts Robert Devereux, Earl of Essex, offering his services to Elizabeth I.*

Earl of Essex, who is offering his service to Elizabeth as a man of military ambitions and courtly love.

Away from the English court, another kind of painting owing something to miniatures was created during the mid-Elizabethan period. These were the watercolours – made by the artist and colonist John White – that depicted the natural life and indigenous peoples encountered in America. White was probably trained as a miniaturist, for he had a good eye for detail, used precise and delicate brush strokes, but also lacked a mastery of foreshortening and perspective. Unusually, White applied his brush directly onto unprepared paper, a technique he sometimes used to provide an effect of light.

Among White's surviving watercolours are two portraits of three Inuit inhabitants of Baffin Bay. Several times during the mid-1570s English explorers, under the captaincy of Martin Frobisher, crossed the Atlantic in search of a North-West Passage to Cathay (China) and landed in Baffin Bay. On his second voyage in 1577, Frobisher captured these three Inuit whom he brought back to Bristol: a man (called Kalicho or Collichang), a woman (Arnack or Egnock) and her baby son (Nutaak or Nutiok), who is shown in White's drawing nestled in his mother's hood (see page 118). It is possible that White accompanied Frobisher to Baffin Island, but he may have drawn and painted the watercolours in England where the Inuit were entertained by the Mayor of Bristol, put on public display and attracted a lot of interest. A curious feature of the drawing of Egnock is that her navel can be seen through the thick sealskin jacket. White was probably following here the convention of Roman sculpture in which body contours were visible beneath light drapery. He was not the only person to paint the Inuit; indeed a chronicler recorded that their pictures were available for view in England over many years. There was clearly an appetite for the exotic in England. Tragically, the adults died within a month of their arrival, while the child died shortly afterwards in London, where he was taken to be presented to the queen.

White definitely went to America in the spring of 1585. He was the official artist of the Roanoke expedition that was led by Richard Grenville and Ralph Lane and sponsored by Walter Ralegh. Their project was to plant the first English colony on mainland America, but the 108 colonists were not experienced farmers and could survive only by trading with the indigenous peoples. For a time, as White's drawings show, the colonists and Native Americans got on well but relations between the two groups badly deteriorated, and in 1586 the colony had to be abandoned. Although later attempts were made to re-

*An Inuit woman, Egnock, and her child,
Nutiock, c. 1577, who were brought back
to Bristol from America. Tragically, they
both died shortly after arriving in England.*

establish a colony on Roanoke, it was not until the next century –
under James I – that a successful settlement was established in the
area that was renamed Virginia after the Virgin Queen Elizabeth.

Together with Thomas Harriot, White was given the task of
collecting and recording information about the local people, plants
and animals. During his short stay, he completed many hundreds of
drawings of the Secotans or Algonquians (as the tribe of Americans
living in present-day North Carolina came to be called), but
unfortunately most of his portfolio was lost at sea when the ships
carrying the colonists back to England ran into rough seas when leaving
Roanoke Island in July 1586. Only seventy-five of the original drawings
survived and these were water damaged, but several copies were
subsequently made on White's return. Some of the drawings were

then given to the engraver and printer Theodor de Bry, who adapted twenty-two of them to illustrate Thomas Harriot's book, *A Briefe and True Report of the New Found Land of Virginia*, printed in Frankfurt in 1590. These copperplate engravings were far less accurate than White's drawings, not least because de Bry played down the racial characteristics of the indigenous Americans and set their bodies in poses that resembled classical statuary. As Harriot's book was reprinted many times and in several languages, it was de Bry's image of the life and peoples of the new continent that became most familiar to Europeans and was to influence later representations in art.

The visual arts in sixteenth-century England have been widely criticised as insular and unsophisticated. It has become something of a commonplace that the sixteenth century was the golden age of English poetry but a dark age of English painting. Holbein is thought to have been the only painter of note working in England, and even his English oeuvre has been dismissed by some commentators as undistinguished when compared to the great masterpieces of contemporary Italy. The paintings of Elizabeth's court have been treated in some quarters with virtual contempt, since the linear, non-naturalistic style – not to mention the emphasis on heraldic and allegorical ornamentation – offends the aesthetic sensibilities of the many admirers of Italian Renaissance art. Even if these harsh judgements are true – and I am not convinced they are – English art of the Tudor period is nevertheless important in the history of British art. The style of miniature painting was innovative and its technique high quality, and the workshops of miniaturists became training grounds for English painters of larger-scale works. The royal images of Henry and Elizabeth (and to some extent Edward and Mary) are instantly recognisable and have been stamped onto the national consciousness. English art was not operating in a cul-de-sac, entirely cut off from continental developments. Flemish, Dutch, French and Italian influences were present throughout the century, and Renaissance ideals informed the commissioning of many works of art. Finally the art of the Tudor period was able to reach an accommodation with the Reformation; portraiture continued despite Old Testament prohibitions; funeral monuments became a site for sculpture; and religious and political propaganda brought woodcuts and engravings to a wider population through the thriving medium of print.

Chapter 4

AGE OF REVOLUTION

BY CATHARINE MACLEOD

This is a time when art was used as a weapon on the battlefield of a world turned upside down. Art couldn't be neutral – it took sides as the people divided themselves between Parliamentarians and Royalists, between Catholics and Puritans. Art shows the turmoil and unrest of the civil war.

A model made by Sir Christopher Wren of a proposal for St Paul's Cathedral. It was an early design, not in the end adopted. Peering through this archway, as Charles II would have done when Wren tried to persuade him to agree to his plan, I felt the interior of the Church spring to life as though I was a giant watching tiny figures conducting a mass inside.

With the death of Elizabeth I in 1603 came a new century, a new ruling family in England, and, gradually, a new approach to art. As in the previous century, painting in Britain was still hugely dominated by portraiture, and it was still relatively inexpensive compared with other kinds of luxury production, such as tapestry making. It was increasingly within the reach of prosperous people outside court circles – including merchants, provincial officials and gentry – but the important developments and innovations continued to take place largely in the context of the court. The king himself, James VI of Scotland and now also James I of England, was a passionate scholar, theologian and huntsman, but does not seem to have been particularly interested in the visual arts, and his own portraits tend to be conservative and repetitious. His queen, Anne of Denmark, however, became an important patron of the visual arts in various forms, and passed on her interests to her three surviving children, Henry, Prince of Wales, Princess Elizabeth, later Queen of Bohemia, and Charles, later Charles I.

The leading artists at the beginning of James's reign were mainly highly skilled immigrants, and in spite of the continual struggles of native-born artists and craftspeople to curb this dominance, this remained generally the case throughout the century. Many came from the Netherlands, and brought with them a range of skills against which most British artists simply could not compete. In painted portraits, the polished depictions of costly velvets and silks, elaborate embroidery and exquisite jewels were designed to dazzle the spectator. Inside their sumptuous clothes, the sitters themselves seemed to take a secondary role, standing stiffly in implausible spaces. Gradually, throughout James's reign, there was a movement away from such glittering surfaces and linear patterns in painting towards more naturalistic depiction, in which creating the illusion of a real person standing or sitting in a convincing space became more important than displaying the costume and accessories in exquisitely minute detail. These developments were supported by the patronage of the queen and of a group of courtiers who were enthusiastic patrons and collectors. Their enthusiasm came

The adored young Prince of Wales is portrayed in this mysterious painting, Prince Henry Leading Time by the Forelock *by Robert Peake, c. 1611*

partly from a genuine interest in art, but also partly from a desire to appear knowledgeable and sophisticated both at court and on the wider European stage.

James's elder son, Henry, was the focus of much attention, both at court and beyond. For the first time in sixty years Britain had a male heir to the throne – a Prince of Wales. Regarded as brave, cultured, intelligent and athletic, Henry was perfect for the part. His chosen portraitist was Robert Peake, who also held the office of Serjeant Painter to James from 1607 (alongside John de Critz). Peake's most striking image of Henry is an extraordinary painting in which the young prince, full-length and in full armour, rides a white horse. He is accompanied by the semi-naked figure of Father Time, who holds Henry's magnificently plumed helmet and whose forelock of hair is tied into a sash twisted around the prince's arm. The prince's highly decorated armour, designed for jousting and court festivities rather than for battle, is covered with circular images of hands reaching up, holding anchors. This mysterious and compelling painting is sometimes called *Prince Henry Leading Time by the Forelock* but the meanings that it must have conveyed to its original viewers have become obscured over time and will probably never be fully recovered.

The theatrical qualities of this painting might be seen as reflecting the huge popularity of drama during this period. The time of Shakespeare's full maturity as a playwright, the Jacobean period was also the era of Ben Jonson and many other writers, less well known today but prolific and popular in their lifetimes. Playwrights were generally regarded as working writers catering for a demanding audience of frequent theatregoers, rather than great geniuses producing works of inspiration and intellect. Their relatively humble status at this time is the main reason why there are so few known portraits of them, which has led to the endless debates over the true image of Shakespeare. Very few plays were published; most existed only in manuscript copies. The standing of these writers began to change when Ben Jonson published a collection of his own plays during his lifetime; other playwrights followed suit, and the Jacobean literary world began to regard plays, and therefore their authors, as worth celebrating. This led most famously to the posthumous publication of the First Folio of Shakespeare's plays in 1623. Collected works needed an engraved portrait for their title pages, and this also fed the growing trend for successful writers to have their portrait painted.

Ben Jonson's distinctive features are recorded in a small but striking portrait, one of a few surviving likenesses of professional

This remarkable portrait of the playwright Ben Jonson by Abraham van Blyenberch, c. 1617, was dramatically different to most portraits the Jacobean viewer would have been familiar with.

writers that were painted at this period. The painting, which is modest in size and approach, shows him simply dressed in black with a plain white collar. But the broad, vigorous handling of the paint and the tremendous sense of character and life conveyed by the artist make this an exceptional image among portraits of Jacobean writers. The viewer is simultaneously made aware of the artifice – the brush strokes – that have created the portrait, and presented with a real person gazing out from the canvas. In this way the portrait differs dramatically from most of the paintings that the Jacobean viewer would have been familiar with: images in which enormous effort has gone into creating an illusion of real, rather than painted, surfaces – fabrics, jewels, furs and lace – but in which the end result has the polished stillness of a doll or a mask rather than the vitality of a living person. The painter of

Jonson's portrait was Abraham van Blyenberch, a Flemish artist who worked briefly in England. Blyenberch's paintings offered the court of James I a glimpse of the direction in which painting was moving in the Low Countries, and paved the way for the arrival of Anthony van Dyck in England in the 1630s.

That Jonson should have had his portrait painted by such a skilled and, in effect, avant-garde artist reflects his position in early

Inigo Jones' costume design for The Lords' Masque *by Thomas Campion, performed at Whitehall on 14 February 1613. These spectacular theatrical performances aimed to convey the magnificence of the monarch, as well as to entertain.*

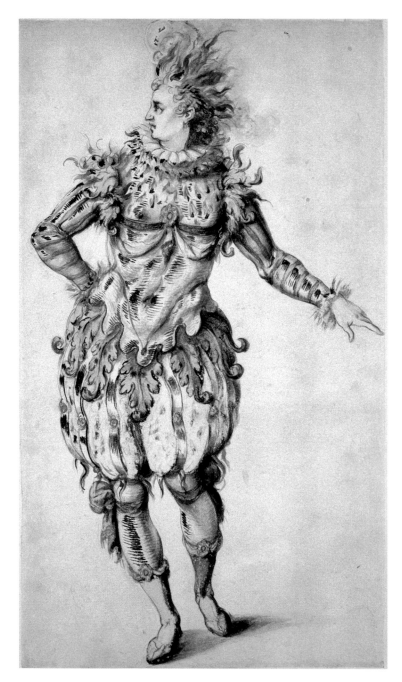

seventeenth-century London, straddling the worlds of the court and of the city. His success during his lifetime rested not just on the very popular plays, especially comedies, that he wrote for the public theatre, but also on a more specialised, élite type of theatrical production in which he was involved: the extraordinary court entertainments known as 'masques'. Masques were spectacular theatrical performances combining music, dance and drama with elaborate costumes and scenery, and often including complicated stage machinery and special effects. Their purpose, in addition to pure entertainment, was to convey to the audience the sophistication and magnificence of the monarch, and they often had elaborate allegorical plots in which disorder was banished and order restored by a character representing the king. Jonson collaborated most famously with Inigo Jones, an artist and designer who was later to become a highly influential and innovative architect. Many of Jones's beautiful designs for scenery and costumes survive, and these give us an insight into the elaborate and fantastical worlds he created.

The young Henry, Prince of Wales, on whom the hopes of so many rested, was suddenly taken ill shortly before his nineteenth birthday. All the leading doctors in the land were summoned but their combined ministrations could not bring about any improvements in the prince's condition. Detailed notes were kept of the prince's illness and the various 'remedies' applied, which read today more like witches' spells than attempts at medication. Prince Henry died on 6 November 1612, probably from typhoid fever. His family were, inevitably, distraught, but the mourning went far beyond royal circles and there seems to have been a genuine outpouring of public grief.

With the loss of Prince Henry, attention turned to his younger brother, the as yet fairly insignificant Prince Charles. Lacking his brother's athletic prowess, but apparently a more assiduous student than Henry, the reserved young prince inherited not only his brother's position as Prince of Wales but also many of his possessions, including his art collection. Encouraged by a group of knowledgeable courtiers, Charles developed a real understanding of and taste for art. After he ascended the throne in 1625 as Charles I, he began to use art to express his personal philosophy of kingship. Like his father before him, Charles believed passionately in the Divine Right of Kings: their God-given right to rule, without Parliament if necessary. He used court ceremonial, religious services and court masques to express his views on royal authority and power, and he also used painting and architecture.

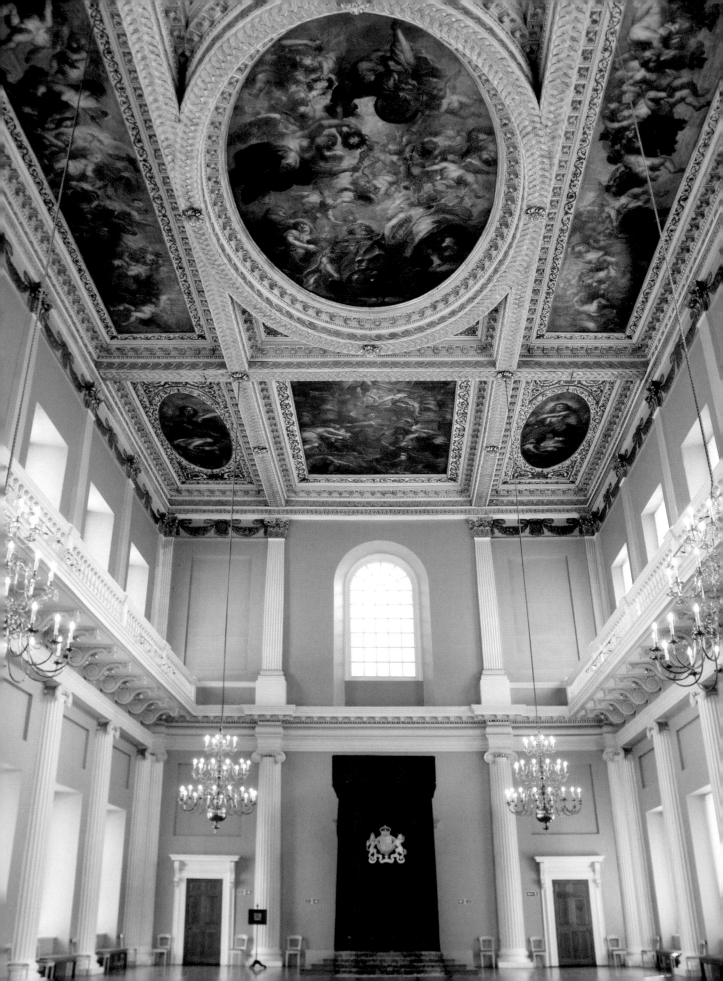

The Banqueting House, Whitehall, designed by Inigo Jones. The ceiling painting of the apotheosis of James I by Peter Paul Rubens, completed 1635, was an expression of royal confidence and power.

The most important space for symbolic displays of the king's philosophy of divine right was the Banqueting Hall in Whitehall Palace. In 1619, during James's reign, the banqueting house had burned down, and a replacement was commissioned from Inigo Jones, who oversaw the rapid rebuilding which was complete in 1621. The new building was an astonishing piece of architecture – perhaps the most influential English building of the seventeenth century. It drew on the designs of the sixteenth-century Italian architect Andrea Palladio, and on other Italian architecture – particularly that of Roman antiquity – but it used these elements in a new, English context. Elaborate and yet ordered, grand and yet serene, its beautiful façade concealed a spectacular single space, which became the impressive setting for displays of royal power and authority, including court masques and ambassadorial receptions.

Architecture of this importance deserved a magnificent painted ceiling, and the Flemish artist Peter Paul Rubens, whose extraordinary abilities were not limited to painting and drawing, was commissioned to produce the ceiling during a diplomatic visit to London on behalf of Philip IV of Spain in 1629. Its subject would be a celebration of the rule of James I, particularly the uniting of the Scottish and English kingdoms. The central image was to be James ascending to heaven, carried by an eagle (symbol of the Roman god Jove) assisted by figures of Justice and Wisdom. The completed ceiling, which used a mixture of Pagan and Christian imagery, left the viewer in no doubt about the god-like qualities ascribed to the king, nor about the artistic abilities of the artist who designed it. Finally shipped from Rubens's studio in Antwerp in 1635 and installed in 1636, the ceiling, full of swirling movement, daring foreshortening and rich colour, was an expression of both painterly and royal confidence and power that gave no hint that such authority might ever be challenged.

Meanwhile Charles I developed another artistic relationship that transformed court portraiture. Described by Rubens as his best pupil, the painter Anthony van Dyck had visited England briefly during James I's reign in 1620–21, and, after periods of time working in Flanders and Italy, he returned to England in 1632. He was appointed Principal Painter to Charles I and spent most of the remainder of his life in England. Van Dyck painted most of the important people at the English court, presenting them to their contemporaries and to posterity as a series of supremely elegant, graceful men and women, innately noble, sometimes perhaps a little wistful, often standing or walking in evocative landscapes. His rapid, free, but sensitive brush strokes conveyed a sort of quivering movement to his paintings and

Charles I was actually a small and slight man, but this portrait, Charles I on Horseback with Monsieur de St Antoine by Anthony Van Dyck, 1633, portrays a powerful and authoritative king.

firmly established the direction that portraiture of the British social élite took for the next 300 years. The polished stillness favoured by most of his Anglo-Dutch predecessors at the English court was largely abandoned, and with it the concept of the court painter as humble artisan. Van Dyck, like Rubens before him, was knighted by the king, and, while running a large and very productive studio and working exceptionally hard himself, lived in a style previously associated only with members of the nobility.

The king's personal relationship with the painter was clearly of the greatest significance to them both. Shortly after Van Dyck's arrival in London in 1632 he produced a number of portraits of the royal family – images that endowed the king with the appearance of natural authority and celebrated the harmony of his domestic life, such as *The Greate Peece*. The most magnificent depiction of the king, however, shows him without his family, seated on a huge white horse, riding through an enormous arch. He is dressed in full armour and holds the baton of a military commander; beside him an attendant carries his helmet. The painting does not refer to an actual military event; armour of this kind was not worn for fighting at this period and the king was in any case not engaged in battle at this time. The purpose of the painting is simply to convey King Charles's authority and power, and to suggest that it would be supported by military might if the need arose – and it serves this purpose superbly. Charles, in fact a small and slight man, is shown towering over his attendant (his equerry and riding master, the Seigneur de St Antoine) and over the viewer. The vast size of the painting – it is nearly four metres high – and its steep upward perspective combine to give the viewer a sense of his or her own insignificance and the splendour of the king. A huge shield with the royal coat-of-arms, topped by an imperial crown, rests almost casually against the arch. It is this sense of effortless grandeur and unstrained authority that gives Van Dyck's portraits of Charles I such impact, and must have been greatly valued by the king himself.

The world that Van Dyck created was, however, largely an illusion. Although evidently a devoted father and husband, the king was not widely popular or revered, and his great expenditure on the arts – especially on his large and important collection of continental paintings from the sixteenth century and earlier – only fuelled the growing criticism of his rule. His God-given right to reign was no longer taken for granted by many of his subjects. The imposition of certain religious practices and intolerance of others, the levying of taxes and the suspension of Parliament, among other factors, all contributed to

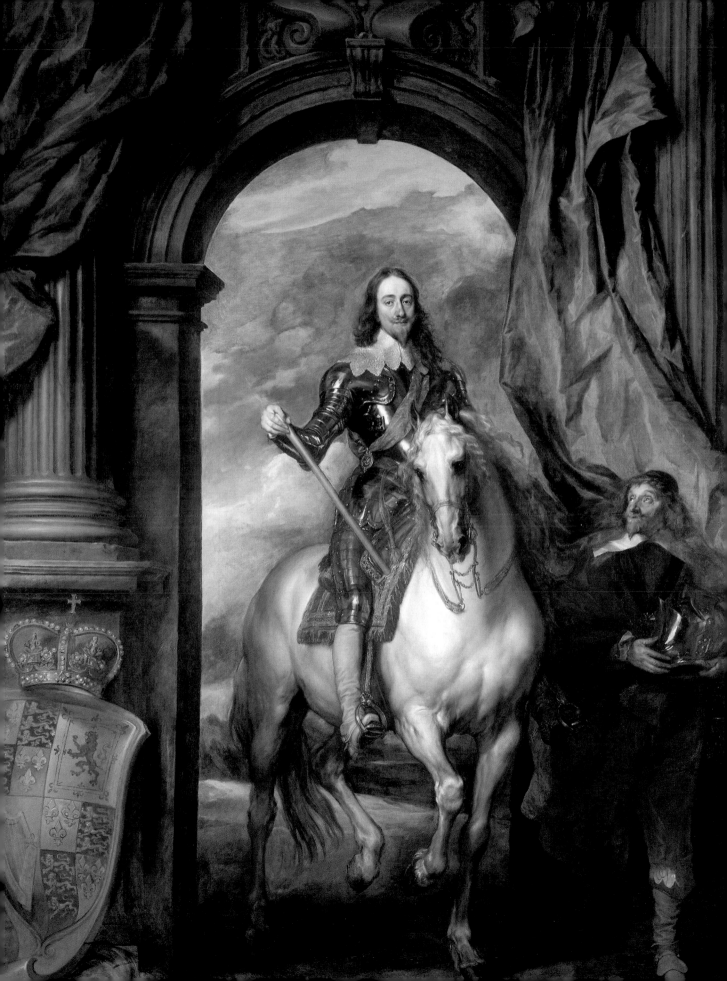

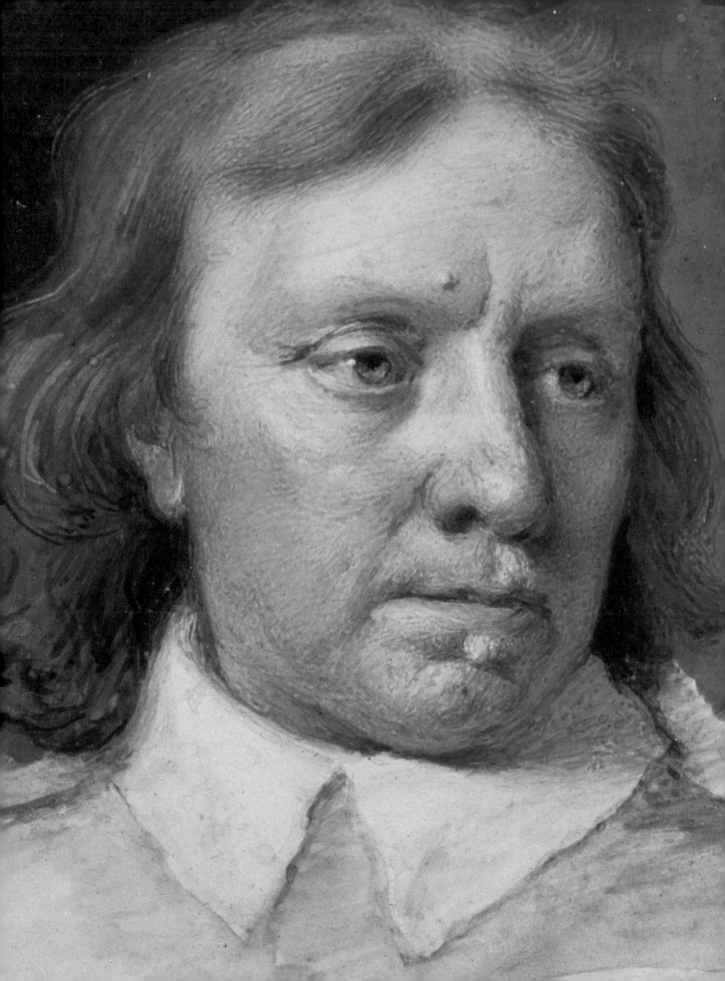

A miniature portrait of Oliver Cromwell by Samuel Cooper (enlarged detail), early 1650s. This portrait shows Cromwell when he was battle weary, politically compromised and 'warts and all'.

growing unrest, which erupted eventually in civil war – first in Scotland and then in England. But the enormous disruption brought about by war did not mean the end of art. There was still a need for images, often for propaganda or other political purposes.

Portraits were in demand on both sides of the political divide. The artist favoured by the Parliamentarians was Robert Walker, a native English painter. Revolutionary politics did not, however, lead in this case to revolutionary art. Walker did produce highly original paintings on occasion, but for his portraits of soldiers he favoured the compositions of Van Dyck. In fact, he presented the great Parliamentarian leader Oliver Cromwell in a pose that Van Dyck had used for a portrait of the Earl of Strafford, Charles I's Lord President of the North and Lord Deputy of Ireland. Other important allies of Cromwell were portrayed in poses used previously for supporters of the king. The reason for these borrowings seems to have been largely Walker's admiration for the earlier artist, and an absence of alternative ideas for the creation of the Parliamentarian image; Walker, when challenged about using Van Dyck's compositions, replied, 'If I could get better I would not do Vandikes [sic].' His sitters appear to have been happy to be endowed with much the same air of power, grace and authority as their adversaries.

It was however, the skilled miniaturist, Samuel Cooper, who painted the most penetrating likenesses of Cromwell. Like most portraitists working during the civil wars, and then during the Commonwealth and Oliver Cromwell's protectorate, Cooper took employment where he could find it, painting portraits of sitters with a range of political allegiances. He depicted Cromwell first in 1649, when he was full of revolutionary zeal and republican idealism, but his second miniature, painted a few years later, is most memorable. A vivid and moving likeness, it shows the Parliamentarian leader when he was balding, battle-weary, politically compromised and, most famously, it shows him 'warts and all'. The eighteenth-century antiquarian George Vertue first told the story of Cromwell instructing the painter Peter Lely to 'paint my picture truly like me & not Flatter me at all. But . . . remark all these ruffness, pimples warts & everything as you see me.' Lely's portrait of Cromwell, however, appears to be a copy of Cooper's miniature, and in fact omits the warts. It seems likely that, if the story is true, Cromwell's instruction was given to Cooper, who followed it faithfully and created a sympathetic portrait of a man without personal vanity, who had learned bitter lessons about the realities of political leadership.

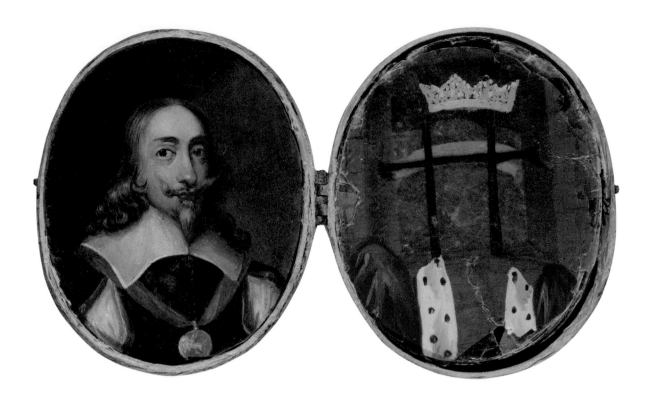

Miniature portrait of Charles I with painted mica overlays by an unknown artist, after 1649. The image to the right shows Charles preparing for his execution, with a blindfold covering his eyes.

Cooper's portrait of Cromwell shows him during the period when, as Lord Protector, he ruled Great Britain as king in all but name. He had overseen the execution of King Charles in 1649, on a scaffold erected, ironically, immediately outside the windows of the king's magnificent Banqueting House. He had created a Commonwealth – a political and social experiment, that eventually failed. Subsequently established, in effect, in a court of his own, Cromwell, like the king before him, needed supporting visual imagery, and great numbers of copies of his portrait were produced for his supporters.

In a more clandestine way, posthumous images of Charles were also being produced for his supporters, many of whom were in exile abroad. These increasingly depicted the king as a Protestant martyr, executed unjustly for his beliefs. Most were produced on the Continent, and they included paintings and prints, as well as enamels and watercolour miniatures, which were frequently set into rings and lockets. Often the identities of the makers of these objects are lost and it is difficult to tell whether they were made during the interregnum period (between the death of Charles I and the restoration of Charles II to the throne in 1660), or later. Some of the most fascinating products of this industry were small oil miniatures painted on copper showing Charles I's head and shoulders,

accompanied by a set of painted mica overlays. Mica, a transparent mineral, was sliced very thinly and trimmed into an oval shape that could be laid over the oval portrait head of the king. Each mica overlay (and some sets had over twenty) was painted in such a way that, when laid over the miniature, the whole assemblage represented a different part of the story of the events leading up to, and following, the execution of Charles I. The simplest overlays add a hat, a crown, or a change of robes to the king; the more complex show him being prepared for execution or, in fact, being executed. It seems likely that these were made for followers of the king – as they usually include images of his heavenly transfiguration – but they spare none of the gruesome detail, and include depictions of the severed head held aloft, and of the bleeding, headless torso. It is difficult to imagine today by whom, and in what context, these objects might actually have been used.

Although painting flourished in court circles during the seventeenth century (including Cromwell's 'court') and gradually became more accessible to a wider range of people, the British public, especially in the first half of the century, were on the whole still more at home with the written word than the painted – or printed – image. Britain had relatively high levels of literacy compared with other European countries, and while images were used to an extent as tools by both sides of the political divide, the biggest propaganda battles were fought in words. Of the thousands of civil war pamphlets and broadsheets collected by the remarkable seventeenth-century bookseller George Thomason, now kept in the British Library, fewer than one hundred are illustrated with woodcuts or engraved prints. There simply was no tradition of making visual depictions of historical events in Britain at this time; all the depictions of the Gunpowder Plot, for example, were made abroad, as were all the prints showing the execution of Charles I. Censorship was partly to blame for this, but perhaps more important was the strength of the verbal, as opposed to the visual, tradition.

One of the relatively few propagandistic illustrated broadsheets of this period was 'Englands Miraculous Preservation Emblematically Described, Erected for a Perpetuall Monument to Posterity', printed in 1646. The print shows an ark, containing the Lords, Commons and Assembly, about to reach the safety of the land, while the enemies of Parliament are shown drowning in the sea. Ovals depicting the Parliamentarian generals surround the ark. This is an unusually elaborate illustration for a broadsheet. Most of those that were

Earle of Essex

Earle of Warnick

Earle of Man...

Though Englands Ark haue furios storms jndurd
By Plotts of foes and power of the sword
Yet to this day by Gods almighty hand
The Ark's preſerud and almost ſafe at land

House of Lords

House of Comōs

Aſſembly

S.r Tho: Fairfax

THis Ark cal'd Union hath not her Peer
On Earth, & 's laden with a fraught ſo dear
To her Almighty Pilo, that no waves
Of might or malice rais'd b' infernal ſlaves
Of human ſhape and lofty high eſtate,
Nor yet their father that inveterate
Old Serpent raging 'gainſt this bleſſed Bark
The *Antitype* of righteous *Noahs* Ark
Can make to ſink or ſplit upon the rocks
Of ruine, maugre all their furious knocks
Of powdered bals, and force of armed ſteel
By violence to make this *Ark* to feel

And raiſe tempeſtuous ſtorms about this *Ark*,
And now they cannot beat by force, they *bark*
Belch, and diſgorge their *Stygian* deſpight
'Gainſt the Protector of this *Ark* outright;
And ſtil their horrid rage doth more abound
Becauſe this *Ark* of Union is not drown'd;
But wait a while, and ſee this curſed crew
Pertake of that reward, that's here in view:
For fix your eyes upon theſe Seas of ire
Involving thoſe, that did 'gainſt th' *Ark* conſpire:
See here ſome headleſſe floating in the waves
Of direful death, ſome dead, and wanting graves:
See all their warlike Engines, and their Forces.

Generall Lasley

Lei.nt Gen: Cromwell

Reader pause, and judge our Land is free,
onicle for our posteritie ;
dhath brought them, lo their pride doth swage
e made happy in a peaceful Age.
t the *LORD* bin for us, they had won,
oth'd this Land with red confusion ;
w fail on you worthies through the Ocean
distempers, let your winged Motion
ce the flight of Eagles, that aspire
e your Senses fil'd with zealous fire :
th command the way, by her the *Ark* is guided,
t the *Gospel* sway, and *Errors* be avoyded :
God of wind & sea, who searchest thro' the dark

illustrated had simple, even crude, woodcut images. Broadsheets were usually quickly and cheaply printed, in multiple copies, and sold in the streets for a penny or so with the aim of reaching the widest possible audience. It is not known how many copies of this particular broadsheet were printed, but at the bottom end of the print market, broadsheets were available to most people. Even the prints at the top end of the market, while aimed at a smaller and wealthier élite, were increasingly more widely available than paintings, as the century progressed and Britain's small printmaking industry grew rapidly.

It was during this mid-century period of interregnum that one of the few women to earn a living as a painter in the seventeenth century began her career. Mary Beale was the daughter of a Puritan rector and amateur painter from Suffolk. It is not clear where and how she received her training, but she quickly gained a reputation for her painting – initially portraits of her family and friends, not done for commercial profit. However, in 1670 she and her family settled in London in order to set up a commercial portrait practice. Mary's husband Charles acted as her partner in the business, providing practical and technical support by making pigments, preparing canvases and keeping the accounts; her sons Bartholomew and Charles became her studio assistants. The elder Charles Beale also contributed to the family income by selling pigments, and he kept detailed notebooks, some of which survive, recording the activity of Mary's studio. Although she had clients from among court circles, many of her sitters were churchmen who were also friends. In addition to her commercial work she painted a number of self-portraits, including one that shows her holding a canvas on which she has begun to paint portraits of her

In her self-portrait, c. 1665, Mary Beale
depicts herself as a confident professional
artist holding a portrait of her sons.

two sons. That she is not just the mother of these boys, but also the painter, is made clear by the unfinished nature of the painting she holds, and by the painter's palette hanging on the wall behind her.

By the time Mary Beale was painting professionally in London, the Commonwealth period and Oliver Cromwell's protectorate were long over. Cromwell's death in 1658 marked the beginning of a new time of uncertainty, during which, for a short period, his son Richard attempted to take his place. But Richard was not the leader his father had been, and increasing dissatisfaction with the government and rebellion within the army led eventually to the restoration to the throne of Charles II, the long-exiled son of Charles I. Although the new king was not without his critics, on the whole it was with eager anticipation and joyous celebration that Charles II was greeted on his entry into London on his thirtieth birthday, 29 May 1660. Charles had not inherited his father's passionate interest in the visual arts, but he knew that among other forms of image-making, the creation of a visual image for the new court was essential in giving it a sense of confidence and permanence. He lost no time in appointing a painter to take the role performed by Van Dyck in his father's court: the Dutch artist Peter Lely.

Lely had arrived in England shortly after the death of Van Dyck in 1641, and had established a successful practice during the civil wars and interregnum. At first he mainly painted delicate, mysterious scenes from history, mythology and the Bible, but he soon found, as had many Dutch émigrés before him, that the type of painting for which there was most demand in Britain was portraiture. He turned his hand to this more profitable area, and produced sensitive, often rather melancholy-looking portraits for a network of families on both the Parliamentarian and Royalist sides. When the king was returned to the throne in 1660, Lely was the obvious painter to step into the rather large shoes that had been occupied by Anthony van Dyck in the king's father's reign. He was appointed Principal Painter to Charles II in 1660, and began to create a new visual image for the court.

Although of course Lely painted the king himself, and indeed everyone who was anyone at court, it is his luxuriant portraits of heavy-eyed court ladies, clad in loose, linen shifts and satin gowns, which have become for many the dominant image of the reign of Charles II. The 'sleepy' look so characteristic of these portraits was ascribed by his contemporaries to the influence of Barbara Villiers, Countess of Castlemaine (and later Duchess of Cleveland), the king's favourite mistress during the 1660s. Famous for her languorous

Frances Teresa Stuart, later Duchess of Richmond by Peter Lely, c. 1662. It was said of her that, 'it would have been difficult to imagine less brain, combined with more beauty.'

expression and heavy-lidded eyes, she set the standard for fashionable beauty in her day. Something of her look seems to inhabit all Lely's portraits of young women from the early 1660s onwards, giving rise to the comment that 'Lilly's [sic] Pictures was all Brothers & Sisters'.

One of the most beautiful of these portraits shows a young woman, dressed in a shimmering yellow satin dress, walking through a wooded landscape; she holds a bow, suggesting that she is loosely disguised as the Roman goddess Diana, the huntress, famed for her chastity. This is Frances Teresa Stuart, later to become Duchess of Richmond, about whom one of her contemporaries wrote that 'it would have been difficult to imagine less brain, combined with more beauty'. She had, however, intelligence enough to achieve something particularly rare: she successfully resisted the persistent advances of the king himself. So keen was he to seduce her that at one point the possibility was investigated of him divorcing his unfortunate Portuguese queen, Catherine of Braganza, in order to marry Frances. But after coming to the conclusion that this was not going to happen and that 'she could not longer continue at Court without prostituting herself to the king', Frances eloped with Charles Stuart, 3rd Duke of Richmond in 1667. The king was devastated, but had larger concerns – particularly war with the Dutch – to occupy his attention. Having gone through the plague year of 1665, followed by the Great Fire in the following year, London came under attack from yet another direction in the summer of 1667, when the Dutch fleet succeeded in sailing up the Medway and destroying a large part of the navy. This near-disaster was a gift to the political satirists of the age, who blamed the king, accusing him of dallying with women when he should have been attending to matters of state. The poets Edmund Waller and Andrew Marvell both wrote verses in which they compared the Dutch attack on Britain with the king's attack on the virtue of Frances Stuart, who had, usefully for their poetic analogies, modelled for the figure of Britannia used on an important naval medal (and later on the coinage) shortly before her elopement.

It would be wrong, however, to characterise the reign of Charles II as simply a period of excess and licentiousness, reflected in luscious, sensuous portraiture. Amid the natural disasters and political crises of the time, the king and his advisers managed to keep the ship of state on a steady enough course so that other areas of culture could develop; it was a time of scientific advances, of important developments in literature, theatre and music, and of the beginnings of the commercial art market and of a flourishing print industry in Britain,

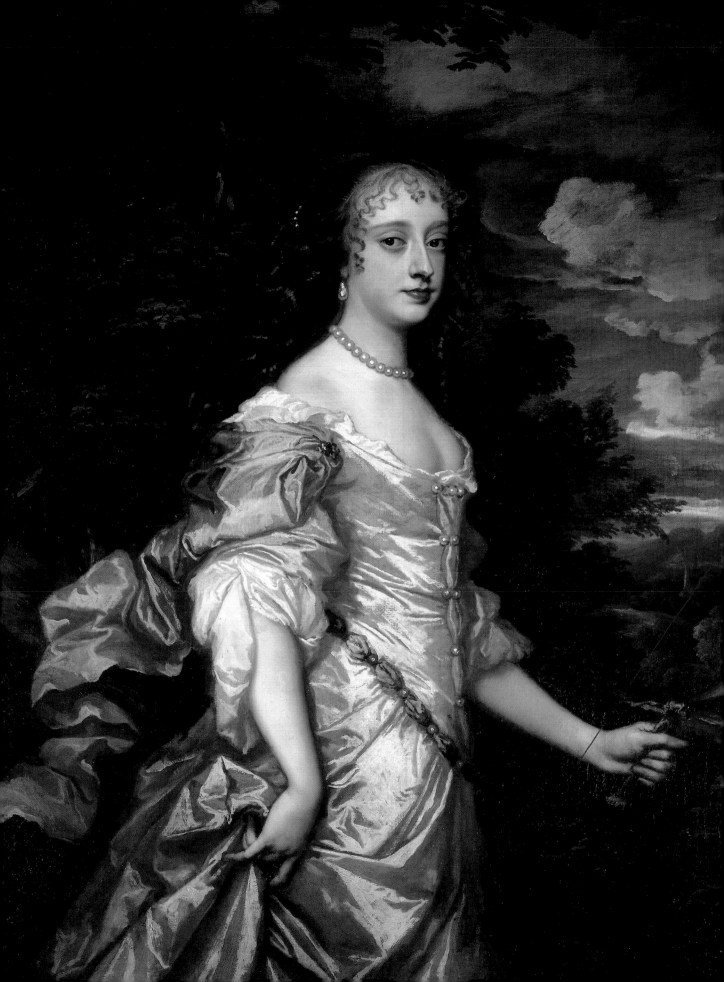

(on previous page) The Great Fire of
London in 1666, depicted here by an
unknown seventeenth century artist,
was just one of the disasters that beset
Charles II's reign.

bringing art to an ever-wider public. The king himself was patron of the
Royal Society, which was founded in 1660 to promote experimental
science. The divisions that exist today between the arts and the
sciences were not felt in the same way in the seventeenth century;
the ideas of the great Jacobean politician, philosopher, writer and
scientist Sir Francis Bacon were the inspiration behind the founding of
the Royal Society, and his late seventeenth-century successors were an
appropriately diverse selection of people. They included Prince Rupert,
the king's nephew, a civil war hero and an experimental scientist who
also introduced a new form of printmaking, called the mezzotint, into
Britain; John Evelyn, the diarist and friend of Samuel Pepys, who wrote
on subjects as wide-ranging as marriage, medals and trees; and Isaac
Newton, famous for his discoveries about gravity and achievements in
mathematics, but also an alchemist and idiosyncratic writer on religion.

The official moment of the founding of the Royal Society came

Sir Issac Newton's reflecting telescope,
1746. Charles II's reign was a time of
great advances in science, literature,
theatre and music.

after a lecture given by Christopher Wren, then Gresham Professor of Astronomy. Regarded as a prodigy as a child, Wren's contemporaries continued to be astounded by his abilities as an adult. One wrote that 'there scarce ever met in one man, in so great a perfection, such a Mechanical Hand, and so Philosophical a Mind.' Among all his other achievements, notably in mathematics and astronomy, it was as an architect that Wren made the greatest public impact. Within weeks of the Great Fire of London, Wren had made plans for rebuilding the city. Although his plans were not implemented, being too time-consuming and costly, he was responsible for helping to draw up new regulations for building (including the prohibition on building in timber) and, most famously, for designing about fifty new churches. The crowning achievement of his architectural career, however, was St Paul's Cathedral – a project with which he was associated for most of his professional life. Wren had submitted plans for rebuilding the old cathedral shortly before the Great Fire, but the destruction of the medieval building in 1666 led to a more radical design. The extraordinary new building, with its double-storey façade and enormous dome was finally completed in 1711. It attracted controversy from the start, differing as it did so dramatically from its medieval predecessors. Wren's inspirational design was made possible by his mathematical skills, enabling him to create a building without precedent in Britain, a building that has both the ordered serenity of classicism and the dynamism and drama associated with the Baroque style of his European contemporaries.

Charles II's reign was followed by the brief and disastrous reign of his brother, James II, which ended with the Glorious Revolution – a bloodless, and now often forgotten revolution that effected changes to British government of much more significant and lasting impact than those brought about by the civil wars. The revolution brought William of Orange and his wife Mary, daughter of James II, to the throne, and it established a more restrained, sober and Protestant court. The last Stuart monarch was Queen Anne, Mary's sister, who died in 1714.

The seventeenth century was a time of extraordinary political change and social disruption, and yet throughout the turmoil, artists continued to work, adapting their art to the circumstances in which they found themselves, endlessly innovating for new purposes. Although many artists worked largely for networks of clients who knew each other, at a time when people's religious and political affiliations could not have been more significant, there is no evidence

Sir Christopher Wren's early design for the rebuilding of St Pauls after the original cathedral was destroyed in the Great Fire. It was the crowning achievement of his architectural career.

that artists were expected to show loyalty to one political or religious group or another. They seem to have taken work when and where it was offered. Those most in demand, including Van Dyck and Lely, managed teams of assistants producing enormous numbers of paintings in almost factory-like systems. Increasingly paintings, particularly portraits of well-known sitters, were produced for stock, feeding, along with growing numbers of prints, the burgeoning commercial art market. Amid all this, however, art frequently transcended the practical purposes it was produced to serve, and, in addition to casting light on the needs and desires of its seventeenth-century patrons, it continues to enthral, or amaze, or move us today.

Chapter 5

AGE OF MONEY

BY JOHN STYLES

For the first time, Britain in the eighteenth century was becoming a place we might recognise today. As commerce opened up new avenues of life, a new class was born; a group of people who sat somewhere between the lord and the labourer. It was the beginning of what we today call 'the middle class'.

The eighteenth century was mercilessly mocked for its extravagances and corruption. Hogarth showed the temptations facing the new rich. This is a cartoon by Gillray whose merciless satires on political and royal life were eagerly awaited by the buying public. That he was never imprisoned for his ferocious and often scatological portrayals of the leading figures of the day is a tribute to a free thinking age.

Admiral Lord Nelson died on board HMS *Victory* on 21 October 1805, shot by a French sniper in the heat of the Battle of Trafalgar. Despite the admiral's death, Trafalgar was the greatest naval victory during an era of great British naval victories, the culmination of a century of naval warfare against the French, which was fought across the globe. Nelson's destruction of the combined French and Spanish fleets at Trafalgar was the very foundation of Britain's nineteenth-century imperial and economic hegemony. It inaugurated an era of undisputed British command of the world's oceans. It also established Nelson as the definitive British hero. His state funeral was more spectacular than many royal funerals. Celebrated by rich and poor alike, his fame inspired a flood of commercially produced memorabilia. Nelson's image appeared in expensively painted oil paintings and cheaply engraved prints, on fine porcelain plates and simple earthenware mugs.

Nelson was a very eighteenth-century hero. The son of a Norfolk clergyman, with distant family connections among the nobility, he came from the middling ranks of English society: not especially rich, but far from poor. He ended life as a viscount, but began it as a commoner. His rise through the ranks of the navy owed something to patronage from the rich and powerful, but more to talent. Revered by his sailors, he amply fulfilled the popular stereotype of the pugnacious, virile British tar – his pugnacity demonstrated by his aggressive seamanship in battle, his virility by his celebrated mistress, Lady Emma Hamilton.

The ways Nelson was commemorated in the aftermath of Trafalgar tell us much about the visual arts in late-Georgian Britain. Particularly striking is a Coalport porcelain plate depicting Britannia unveiling a bust of the dead admiral, produced the year after his death. It displays, at one and the same time, the British enthusiasm for portraiture, for the cultures of ancient Greece and Rome, for technical innovation and for xenophobic nationalism.

The figure of Britannia on the plate is taken from a drawing of Emma Hamilton. The beautiful daughter of a Cheshire blacksmith, she started life as a maidservant, progressed to become mistress to a succession of wealthy gentlemen, made her fortune by marrying Sir William Hamilton, ambassador at Naples and a titled member of the landed gentry, before eventually becoming Nelson's lover with her elderly husband's acquiescence.

Elevation from penniless mistress to ambassador's wife accounts for some of Emma Hamilton's notoriety, but her fame also rested on a series of portraits by some of the finest artists of the age, including Sir Joshua Reynolds and George Romney. In these paintings she posed as scantily clad mythological characters from ancient Greece and Rome, becoming renowned as the quintessential neoclassical beauty.

Yet the image of Emma Hamilton as a warrior Britannia, draped in white fabric like a Greek or Roman statue, appears not in a painting, but on a dinner plate. The plate was made at the Coalport pottery in Shropshire, just a couple of miles from Coalbrookdale in the Severn Gorge. This was a crucible of the Industrial Revolution, where iron smelting by coke was invented at the start of the eighteenth century and the world's first iron bridge erected in 1779. The exquisite

Plate with Emma Hamilton as Britannia unveiling a bust of Admiral Nelson, 1806. Made at the Coalport porcelain factory, Shropshire.

(on previous page) Philippe Jacques de Loutherbourg, Coalbrookdale at Night, *1801. Buildings at a Coalbrookdale ironworks are shown silhouetted against the glare as molten iron flows from a blast furnace.*

158

porcelain from which the plate was made was itself a novelty – an ancient and technically sophisticated Chinese art, which Europeans mastered only in the course of the eighteenth century. Coalport was one of a number of commercial porcelain factories established in Britain to take advantage of the newly discovered technique, including famous names like such as Chelsea, Worcester and Derby. Nevertheless, the decoration of this Coalport dish was carried out not at the Shropshire works, but in Thomas Baxter's studio off Fleet Street in London. It was the country's leading enamelling studio, specialising in the finest figure painting on ceramics. The new technologies of the Industrial Revolution of the late eighteenth century may have emerged from the coalfields of the Midlands and the north of England, Wales and Scotland, but it was London that led innovation in art and design.

Around the edge of the Coalport plate are scenes depicting the Battle of Trafalgar and Nelson's death at his moment of victory. In the centre, next to the bust of Nelson and the figure of Britannia, sits the British lion. The plate speaks of a Britishness that is loyal and patriotic, anti-French and naval, classical and heroic. It is a high-style Britishness focused on warfare, military victories, classical virtue and loyalist triumphalism. However, it was not the only version of Britishness to find expression in late eighteenth-century art and design. Alongside it flourished a more romantic nationalism, which focused on the British landscape and the medieval, Gothic past. What both versions of Britishness had in common was an ambition to produce art that was authentically British, yet esteemed by foreigners.

A century earlier, on the eve of the Union of England and Scotland in 1707 and in the middle of another long war with France, such an ambition would have appeared wildly over-optimistic. At the start of the eighteenth century, Britain did enjoy respect among the other states of Europe for its recent achievements in the spheres of war, diplomacy and commerce, especially its victories on land and sea against Louis XIV's France. That respect did not extend to art and design. In these spheres it was France that dominated the rest of Europe, including Britain. Misson de Valbourg, a French Protestant refugee to England, commented in 1690 that 'on the whole, in jewellery and all sorts of frivolities more curious than necessary, they are surpassed by the French, and for these things their masters come from Paris.' Britain's neighbours saw little that was admirable or even worthy of comment, while the British themselves complained about the country's subservience to French taste: 'We Englishmen are justly styled apes of the French,' protested Edmund Verney at the end of the seventeenth century.

Nevertheless, in the course of the eighteenth century Britain did gradually achieve a powerful international reputation in art and design. Nationalistic rivalry with France was a crucial element in that achievement. As in many such rivalries, the British copied a great deal from the French, despite their virulent Francophobia. The British imported French stylistic ideas, such as Rococo and aspects of neoclassicism, as well as French artists – most prominently the Protestant Huguenots. However, they did not borrow the French royal family's policy of promoting the visual arts. In the constitutional monarchy of the British eighteenth century it was hardly possible to do so, because Parliament held the purse strings and had no enthusiasm for funding costly royal initiatives. Anyway, most of the kings descended from the Royal House of Hanover were unsuited to the task, both in their personalities and interests. George I's court was dull; the king's character retiring. Royal palaces continued to be refurnished and rebuilt; foreign ambassadors and the British nobility continued to attend at court. Yet neither George I's royal court, nor those of his two successors – his son, George II, and his great-grandson, George III – were crucial sites of national cultural display. In Britain there was no royal encouragement of international cultural domination, in contrast to France, where Louis XIV used his new palace at Versailles, outside Paris, as a showcase for French art and design in a remarkably successful attempt to manipulate European taste. Indeed, the only member of the Hanoverian dynasty who exhibited a special talent for the arts was George III's son and heir, the future George IV. His trendsetting activities as Prince of Wales included the rebuilding of Carlton House, London, in the 1780s; but whatever cultural influence he enjoyed was compromised by his moral shortcomings, which rendered him deeply unpopular at a time of growing religious seriousness. Moreover, the king was only one influence among many others. In the course of the eighteenth century, cultural leadership became dispersed among artists and designers, manufacturers and shopkeepers, noble patrons and Grub Street critics. Court was usurped by commerce.

This should not surprise us, for it was at commerce that eighteenth century Britons excelled. There was good reason for the late eighteenth century stereotype of the British as a nation of shopkeepers. Britain was the most successful European economy of the eighteenth century. No other major European economy was more heavily committed to trade – with the single exception of the Netherlands, a country in economic decline. Britain's self-image was

Silk gown, made in the 1740s and altered in the 1780s. Designed by Anna Maria Garthwaite and woven at Spitalfields, London.

that of a trading nation. 'Our trade,' announced Lord Carteret in 1739, 'is our chief support.' Indeed, Britons were so dedicated to the cult of trade that Thomas Mortimer, the historian, described commerce in 1762 as 'the great idol of this nation, and to which she sacrifices every other consideration.' Trade followed the flag. Britain was at war for more than a third of the period from 1714 to 1837, and was largely victorious, with the notable exception of the American War of Independence (1776–83). In all these wars, the French were her principal enemy, while trade and colonies were the predominant causes of conflict. Colonies offered unrivalled opportunities for the expansion of trade. They served as exclusive markets for manufactured exports, particularly Britain's North American territories, with their fast-growing populations of European and African descent. Colonies were the source of exotic goods, such as the ultra-fashionable muslins for women's dresses that came from India in the 1780s and 1790s. Colonies also supplied tropical foodstuffs, especially the West Indian sugar islands, the jewels in the imperial crown, where huge numbers of African slaves toiled to fill sugar bowls on tea tables across Britain.

The success of British commerce also reflected the success of British manufacturing. Britain was the industrial powerhouse of the age. In 1784, François LaCombe, the author of a guidebook for French visitors to London, listed 'the objects that no people can furnish in such a range and quality as the English'. The list was a long one – a testimony to Britain's industrial might – and included cotton, woollen and silk textiles, the decorative metal buttons and boxes produced in Birmingham, iron railings and grates, scientific instruments, clocks, furniture from tea stands to mahogany tables, tin-glazed pottery and the new white earthenware, and even coaches. The list reflects the wealth of innovation that transformed British manufacturing during the eighteenth century. It included new kinds of things, from cut glass to creamware dinner services. It included new materials, such as mahogany for furniture and Turkey red dye. It included new techniques, such as transfer printing on pottery and power spinning of cotton yarn for muslins. It included new design ideas, such as those developed by Josiah Wedgwood in the Staffordshire potteries. Above all, the list reveals Georgian Britain's capacity for invention and improvement – a phenomenon that astonished, delighted and sometimes, as in François LaCombe's case, worried foreigners.

This tide of innovation bears witness to profound changes in the ways things were made in Britain. Our view of these changes has been dominated by two inventions that have come to define the Industrial

James Watt's prototype steam engine, 'Old Bess', c. 1778. This was one of the defining inventions of the Industrial Revolution.

Revolution. The Industrial Revolution of 1760 to 1850 is usually associated with two inventions – James Watt's reciprocating steam engine and the cotton-spinning machines developed by James Hargreaves, Richard Arkwright and Samuel Crompton. They were combined in a new kind of productive unit: the factory. The impact of these inventions was immense. Cotton became the largest single British manufacturing industry by the early nineteenth century. Steam engines were used not just to drive new factories, but to pump water out of mines and to provide the blast in ironworks.

Nevertheless, the Industrial Revolution was only part of a wider process of improvement in British art, design and manufactures that

took place across the eighteenth century, not its sole cause. The range of industries transformed by the application of steam and powered machinery was narrow, confined principally to textiles and the production of raw iron. Consequently the direct impact of the new steam-powered technologies on art and high design was very limited. Outside of cotton and woollen textiles, most high-design goods continued to be made largely by hand tools and hand-driven machines (stamps, presses, lathes and the like). It was the artisanal workshop, not the factory, that remained typical of these trades. Pottery, glassware, silverware, cutlery, furniture, scientific instruments, clothes, printed engravings: all remained overwhelmingly hand trades. Making intricate, artistic, high-design goods demanded a combination of great manual dexterity and frequent changes in specification, which often proved impossible to mechanise. Thomas Chippendale's renowned furniture workshop in London employed no powered machines. Even Josiah Wedgwood's pottery at Etruria on the Staffordshire coalfield (opened in 1769) used only powered machinery to mix the clay and grind the colours. The persistence of hand techniques does not, however, indicate a lack of innovation. In the case of almost all the handmade products mentioned by LaCombe, handmaking was itself

Sir Richard Arkwright's spinning machine, patented in 1769. Cotton became the largest British manufacturing industry by the nineteenth century.

profoundly changed by innovations in technique, materials and design.

Crucial to these changes was drawing. At the start of the century British artists and craftspeople could not match the quality of their European equivalents in many spheres. The country relied on immigrants from all over Europe – from France, the Low Countries, Germany, Switzerland, Italy and Sweden. Protestant Huguenots, including Paul de Lamerie the silversmith and James Leman the silk designer, were especially prominent, with tens of thousands coming to Britain to escape religious persecution in their native France. Others were attracted simply by the opportunity to prosper in Europe's most successful economy. They included Michael Rysbrack, the Flemish sculptor, and Canaletto, the Italian painter. What most of these foreigners shared, irrespective of their trade or country of origin, were the freehand drawing skills that were the key to eighteenth-century design. These skills were in lamentably short supply among native Britons at the start of the eighteenth century, but by the second half of the century this weakness had been successfully addressed, if not wholly overcome. Private drawing schools had proliferated across London and beyond, prizes to encourage drawing were offered by the Society for the Encouragement of Arts, Manufactures and Commerce (founded in 1754), while the Royal Academy of Arts (established in 1768) set up its own prestigious art school. By the later decades of the century, British art and design were widely admired across Europe, as LaCombe's list attests, and the country's reliance on foreign artists and designers was much reduced.

London was the metropolis of British art and design in the eighteenth century. It was London that attracted the best painters, sculptors, designers and craftspeople and it was to London that talented young people flocked to train in drawing and the other artistic skills. The city was the arbiter of fashionable taste and the natural habitat of the *beau monde*. Its seductively designed shops dominated the retailing of high-design, luxury goods. Knowledge of painting, sculpture and music became indispensable for those who aspired to be in fashion. Not surprisingly, all three were incorporated into the entertainments at Vauxhall and the capital's other commercial pleasure gardens, which were frequented by London high society.

In 1700 London was already the most populous city in western Europe, with about 575,000 people – approximately a tenth of the country's population. London's size reflected its triple role as the

Thomas Rowlandson's engraving, Vaux-Hall, 1785. Among the crowd listening to Elizabeth Weichsel, the opera singer, Rowlandson depicts the cream of fashionable London society, including the Prince of Wales, his mistress Mary 'Perdita' Robinson, and the Duchess of Devonshire.

capital city, the leading port and the country's largest manufacturing centre. The city was rebuilt to new standards after the Great Fire of 1666. A guidebook published in 1708 described it as 'the most spacious, populous, rich, beautiful, renowned and noble [city] that we know of at this day in the world'. And London went on expanding through the eighteenth century. The author Daniel Defoe observed 'new squares and new streets rising up every day to such a prodigy of buildings that nothing in the world does, or ever did equal it, except old Rome in Trajan's time'. By 1800 its population was almost a million people.

London's growth was facilitated by a succession of transport innovations across the country. Rivers were made navigable and, from the 1760s, a new network of canals was built. The postal service was revolutionised. Roads were improved by establishing turnpike trusts, which charged tolls to pay for the cost of rebuilding them. The consequences were dramatic. In 1700 it took ninety hours to get from Manchester to London; in 1800 it took only thirty-three. Some, of course, disapproved. 'I wish with all my heart,' moaned the curmudgeonly traveller John Byng at the end of the eighteenth century, 'that half the turnpike roads of the kingdom were ploughed

*Map of the City of London, City of
Westminster, River Thames, Lambeth
and Southwark, 1736. Many of the new
squares built in the West End in the
eighteenth century can be seen on the left.*

The second edition of The Daily Courant, London's first daily newspaper, published 12 March 1702.

The Daily Courant.

Thursday, March 12. 1702.

up, which have imported London manners and depopulated the country.' Byng was wrong about depopulation, but right about manners. In the arts, literature and fashion London set the standard for the nation.

The role of the press was crucial for the dissemination of metropolitan culture. Improvements in communication were not simply a matter of the physical movement of goods and people. Just as important for the circulation of information was the development of new media. The most significant were the newspaper and periodical press. For much of the seventeenth century, only one, semi-official newspaper had been allowed to circulate. After restrictions were lifted in 1695, newspapers and periodicals began to be published as purely commercial enterprises in greater and greater numbers. The first daily paper, The Daily Courant, appeared in London in 1702; by 1792 there were sixteen London dailies. London newspapers and periodicals were widely read in the provinces, but local newspapers also sprang up in almost every major provincial town. Newspapers and periodicals

Plate from Nicolaus von Heideloff's magazine, The Gallery of Fashion, April 1796. The scene is fashionable St James's Park, London, with the Queen's House, now Buckingham Palace, behind.

Fig. 91.

(top) William Hogarth, Marriage à-la-Mode: Scene 2 : The Tete à Tete, *1735. The scene is a grand London townhouse. The clock shows that it is past midday, but the young nobleman has only just returned from a night on the town. His new wife has also been up all night, probably enjoying an adulterous affair. The despairing steward exits to the left with a sheaf of unpaid bills.*

(bottom) A printed engraving of Hogarth's Marriage à-la-Mode: Scene 2 : The Tete à Tete. *The engraving process required the image in the painting to be reversed.*

carried advertising for an enormous range of products and services. Advertisements for fine, luxury goods of every kind could be found alongside those for novels and art exhibitions, painters and drawing masters. Newspapers and periodicals also carried reviews of almost every aspect of the arts, following the model set by the much-imitated *Spectator*, published in London early in the century by Joseph Addison and Richard Steele. By the 1790s, specialist fashion magazines such as Nicolaus von Heideloff's *Gallery of Fashion*, had emerged, illustrated with high-quality engraved prints.

The importance of printed engravings for eighteenth-century art cannot be exaggerated. Take William Hogarth, the most original and the most stridently British painter of the century. Hogarth started his working life as an engraver, not a painter. His career blossomed in the 1730s when he began to produce the sets of narrative paintings he called his 'modern moral subjects'. The most celebrated were *A Harlot's Progress* (1732), *A Rake's Progress* (1734) and *Marriage à la Mode* (1743). Each comprised a sequence of paintings telling a story of pride, hypocrisy, corruption and ultimate disaster, offering, in the process, a series of reflections on the moral pitfalls of the age. Brilliantly realised, each painting is like a chapter in a novel. The resemblance is no coincidence. Hogarth painted these 'modern moral subjects' at the very moment the novel was establishing itself as a literary form. Samuel Richardson's hugely successful, trendsetting novel *Pamela* was published in 1740 and, in a further twist in the relationship between art and literature, was itself translated into a series of twelve narrative paintings by Joseph Highmore.

The 'modern moral subjects' made Hogarth rich and famous, but it was not the paintings that performed this feat. It was their reproduction in the form of printed engravings. Hogarth's paintings were put on display, but principally with the aim of securing subscribers to finance the engravings, which sold in their thousands. This was to be an increasingly common pattern as the eighteenth century progressed. Paintings were executed and exhibited specifically to be then reproduced as engravings, thus securing a healthy financial return. Indeed, the eighteenth-century public was most likely to encounter works of art as engraved reproductions, rather than as original paintings.

Engravings did not have to be reproductions of oil paintings to sell. They enjoyed huge popularity in their own right, especially the satirical prints. The eighteenth century was a great age for visual satire, of a kind that was virtually unknown in other European countries where strict censorship prevailed. Satirical prints were often cruel, grotesque and vulgar, but in the hands of the most accomplished

St. James's Street.

HUMPHREY

VERY SLIPPY-WEATHER.

London Published February 10th 1808, by H. Humphrey No 27 St James's Street.

practitioners, such as James Gillray and Thomas Rowlandson, they were hugely inventive and brilliantly drawn. For Gillray especially, everything and everybody was fair game – marriage, science, fashion, foreigners, politicians, royalty, the church, celebrities such as Emma Hamilton, even the print shops that sold his caricatures.

In design, too, engravings played a crucial new role, most strikingly in their capacity to reproduce and project new ideas. Thomas Chippendale is today the most famous eighteenth-century furniture maker. His firm produced exquisite furniture for a host of wealthy, often noble, clients, fitting out country mansions and elegant town houses. Yet Chippendale's renown, then and now, owed as much to his abilities as a furniture designer as to the actual furniture his firm produced. Not only were his designs original, but they quickly became immensely influential when Chippendale published his revolutionary book of designs in 1754: *The Gentleman and Cabinet Maker's Director*. It was a lavish publication containing 216 expensively engraved plates showing 'Elegant and Useful Designs of Household Furniture in the Gothic, Chinese and Modern Taste'. No furniture maker before Chippendale had attempted anything like it. It was both an advertisement to wealthy clients for his furniture-making business and a source of designs for other cabinet-makers, and it was a great success. Almost all Chippendale's large commissions to furnish grand houses date from after its publication. The book also spread his name and his ideas far and wide among his fellow furniture makers. Soon copies of Chippendale designs were being produced across Britain and in the British colonies in North America. Some cabinet-makers even copied his idea of publishing furniture designs in book form. The fact that we still associate the names of eighteenth-century designers such as Hepplewhite and Sheraton, with particular styles of furniture is because they followed Chippendale's example and produced their own books of designs.

If Chippendale's reputation rests on his abilities as a designer, where does that leave the idea of Chippendale the craftsman? We often assume that the masters of Georgian workshops personally made the fine objects we now associate with their names. But specialisation and division of labour were ubiquitous in the Georgian high-design trades. At the time he published *The Director* (1754), Chippendale's workshop probably employed about fifty workers. Sole responsibility for creating beautiful objects should not be ascribed to the skill and craftsmanship of the person whose firm sold them. Famous people such as Chippendale were not first and foremost

Chairs by Chippendale. 1754.

Three chairs by Thomas Chippendale. As Chippendale's designs became increasingly popular, copies of his designs were produced across Britain and in the British colonies of North America.

(left) Mahogany dining chair, 1770. Designed and made by Thomas Chippendale for Harwood House, Yorkshire.

master craftsmen, but master manufacturers – entrepreneurs who organised production. When their businesses were at their height, they can have handled, let alone crafted, very few of the large numbers of objects they sold, and which we now associate with their names. They may have played a key part in designing these goods, or at least in selecting and authorising their designs. Nonetheless, the work of handcrafting each object fell to a chain of specialist workers, each dedicated to a limited task and not necessarily under the master's direct supervision. In most of the high-design trades it was rare for a single craftsman to design and make an object from start to finish.

This was even true of painters. Sir Joshua Reynolds was an immensely successful artist, whose talents as a portrait painter enabled him to charge his sitters massive fees. By the 1750s he was producing over a hundred portraits a year in his London studio, many of them large, full-length figures. To sustain this vast output, he had to rely on professional drapery painters to paint his sitters' clothes. The fact that Reynolds' income rested on his abilities as a portraitist should not surprise us. Portraiture was the dominant form of painting practised in eighteenth-century Britain – the bread and butter business not just of the grand painters such as Reynolds, who were regularly sought out by the nobility, but also of jobbing provincials touting for work among foxhunting country squires and mayors and businessmen of insignificant market towns. Portraiture changed over the course of the century, from the stiff family portraits of the 1720s and 1730s, known as conversation pieces, to the fluid sophistication of Thomas Gainsborough's late portraits of the 1780s. Nevertheless, it remained central to the work of the country's leading artists.

That is not to say that painters were necessarily happy about relying on portraiture for a living, and the pandering to clients' egos it inevitably entailed. Gainsborough, for one, longed to 'walk off to some sweet village where I can paint Landskips [sic] and enjoy the fag End of Life'. Reynolds, too, devoted more and more time to other genres as his career progressed, particularly to history painting – the painting of stories from ancient Greek and Roman history and mythology, or from the Bible. In the state-funded painting academies of continental Europe, history painting was promoted as the pinnacle of artistic endeavour. Portraits and landscapes were regarded as decidedly inferior. Reynolds' enthusiasm for history painting was part of his broader effort to raise the international standing of British art. As first President of the Royal Academy of Arts he argued that the main way to elevate the quality of British painting was to follow the model provided by the greatest

Joshua Reynolds, Elizabeth Gunning, Duchess of Hamilton and Argyll, *1760. Elizabeth Gunning was one of the most celebrated beauties of her day. Reynolds shows her in her duchess's robes, wearing an ancient Roman costume underneath. Reynolds often portrayed his aristocratic female sitters in these imaginary costumes to achieve the effect of a classical sculpture.*

painters of the Italian Renaissance, particularly Michelangelo and Raphael.

Reynolds was ardently patriotic in his desire to advance British art, yet he approached the task not by promoting a distinctive British style of painting, but by encouraging British painters to excel by the standards set by foreigners. This approach was the opposite of that adopted earlier in the century by William Hogarth, who was even more ardently patriotic in promoting British art. Hogarth had attacked British connoisseurs who imported 'shiploads of dead Christs, Holy Families, Madonna's, and other dismal dark subjects, neither entertaining nor ornamental'. He sought to establish a British school of painting, distinctive in its subject matter and exemplified by his own 'modern moral subjects'.

Nevertheless, it was Reynolds' approach that was more in tune with dominant themes in the visual arts. In architecture, nationalism found expression in a succession of classical styles inspired by the buildings of ancient Rome. Early in the eighteenth century it was the Neo-Palladianism of the Earl of Burlington and William Kent that led the field. The Neo-Palladians rejected the French model of classical architecture represented by Louis XIV's palace at Versailles, instead promoting the work of sixteenth-century Italian architect Andrea Palladio, which they considered more faithful to the art's ancient classical roots. Palladio's work, and the new architectural designs by leading Neo-Palladian architects, were circulated in books of expensively engraved prints.

Later in the century it was the neoclassical architecture of Robert Adam and his contemporaries that prevailed. Their new classicism came from punctilious antiquarian knowledge of ancient Roman architecture, which they gained on the Grand Tour to Italy – an experience that budding architects shared with many of their future wealthy clients. Especially influential was the excavation, begun in 1738, of the Roman city of Herculaneum, which had been buried in the eruption of Mount Vesuvius in AD 79. The Britishness of these different versions of classical architecture was much trumpeted, but in practice they had a good deal in common with architectural styles elsewhere in western Europe, where classicism, broadly defined, also reigned supreme.

Classicism and continental academic standards did not go unchallenged. The later eighteenth century saw the emergence of a new, romantic nationalism in the arts. It promoted the idea that people's responses to works of art should rely less on intellectual discrimination and more on overwhelming, spontaneous inner feeling. This new art, like neoclassicism, looked to the past, but specifically to a

(above) Bute House, Charlotte Square, Edinburgh, designed by Robert Adam. His neoclassical style was inspired by the ancient Roman architecture he saw while on the Grand Tour of Italy.

(right) Robert Adam's design for the mouldings on the staircase, Headfort House, 1772

(left) Robert Adam's design for Home House, Portman Square, London.

painters of the Italian Renaissance, particularly Michelangelo and Raphael.

Reynolds was ardently patriotic in his desire to advance British art, yet he approached the task not by promoting a distinctive British style of painting, but by encouraging British painters to excel by the standards set by foreigners. This approach was the opposite of that adopted earlier in the century by William Hogarth, who was even more ardently patriotic in promoting British art. Hogarth had attacked British connoisseurs who imported 'shiploads of dead Christs, Holy Families, Madonna's, and other dismal dark subjects, neither entertaining nor ornamental'. He sought to establish a British school of painting, distinctive in its subject matter and exemplified by his own 'modern moral subjects'.

Nevertheless, it was Reynolds' approach that was more in tune with dominant themes in the visual arts. In architecture, nationalism found expression in a succession of classical styles inspired by the buildings of ancient Rome. Early in the eighteenth century it was the Neo-Palladianism of the Earl of Burlington and William Kent that led the field. The Neo-Palladians rejected the French model of classical architecture represented by Louis XIV's palace at Versailles, instead promoting the work of sixteenth-century Italian architect Andrea Palladio, which they considered more faithful to the art's ancient classical roots. Palladio's work, and the new architectural designs by leading Neo-Palladian architects, were circulated in books of expensively engraved prints.

Later in the century it was the neoclassical architecture of Robert Adam and his contemporaries that prevailed. Their new classicism came from punctilious antiquarian knowledge of ancient Roman architecture, which they gained on the Grand Tour to Italy – an experience that budding architects shared with many of their future wealthy clients. Especially influential was the excavation, begun in 1738, of the Roman city of Herculaneum, which had been buried in the eruption of Mount Vesuvius in AD 79. The Britishness of these different versions of classical architecture was much trumpeted, but in practice they had a good deal in common with architectural styles elsewhere in western Europe, where classicism, broadly defined, also reigned supreme.

Classicism and continental academic standards did not go unchallenged. The later eighteenth century saw the emergence of a new, romantic nationalism in the arts. It promoted the idea that people's responses to works of art should rely less on intellectual discrimination and more on overwhelming, spontaneous inner feeling. This new art, like neoclassicism, looked to the past, but specifically to a

(above) Bute House, Charlotte Square, Edinburgh, designed by Robert Adam. His neoclassical style was inspired by the ancient Roman architecture he saw while on the Grand Tour of Italy.

(right) Robert Adam's design for the mouldings on the staircase, Headfort House, 1772

(left) Robert Adam's design for Home House, Portman Square, London.

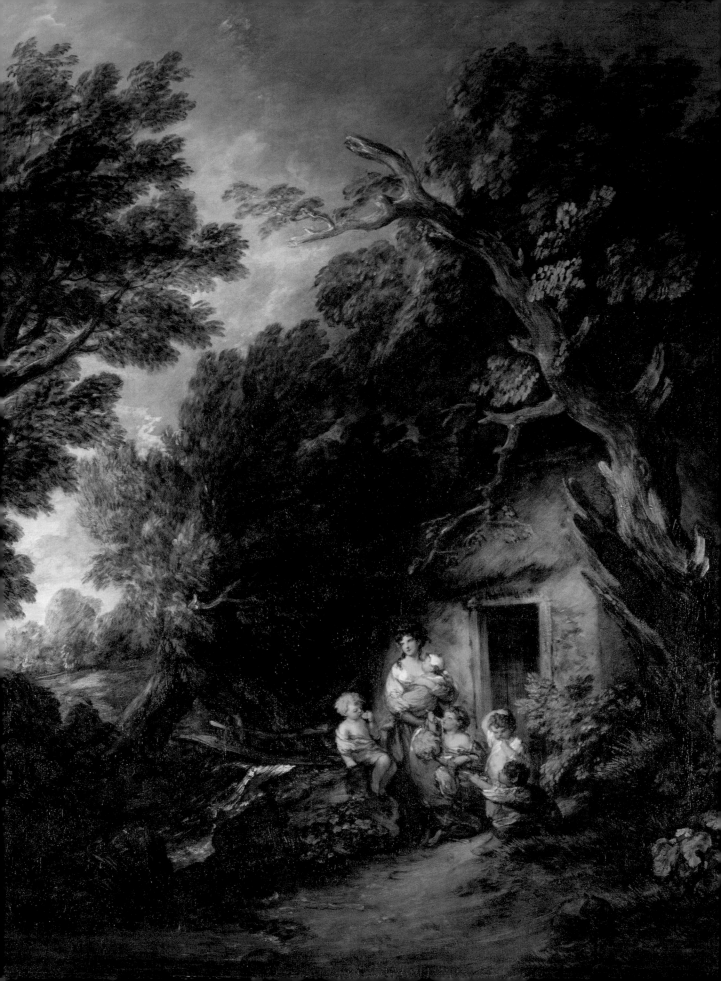

Thomas Gainsborough, The Cottage Door, *1780. Gainsborough portrays a poor but happy family at the door of a humble woodland cottage, suggesting the satisfactions of the simple rural life.*

medieval, Gothic past, firmly rooted in Britain. This new artistic nationalism was grounded in a Romantic view of art, which encouraged emotional authenticity and sincerity, and prized rustic simplicity over metropolitan polish. Artistic interest became focused on the British landscape, especially in the years after 1792, when the French revolutionary wars made continental travel (and thus the Grand Tour) difficult. Instead of travelling to Rome, tourists began to enthuse about wild and authentic nature at home – the Cumbrian mountains, the Welsh hills, the Scottish Highlands. In the process, they came to redefine what was quintessentially British.

The new focus on British history and the British landscape redefined national identity, and had profound political implications. Ancient Rome had provided models of heroic self-sacrifice for the benefit of the nation, as captured so arrestingly in the 1806 Coalport porcelain plate depicting Britannia unveiling a bust of Nelson. Now images of nature and rural simplicity evoked a Britishness uncorrupted by the soulless materialism of the growing industrial cities. Artists looked back to the distant Gothic past, which suggested a purer world untainted by the temptations of commerce and luxury. Here lay the roots of the full-blown Romantic view of art that was to dominate the nineteenth century.

Chapter 6

AGE OF EMPIRE

BY LAWRENCE JAMES

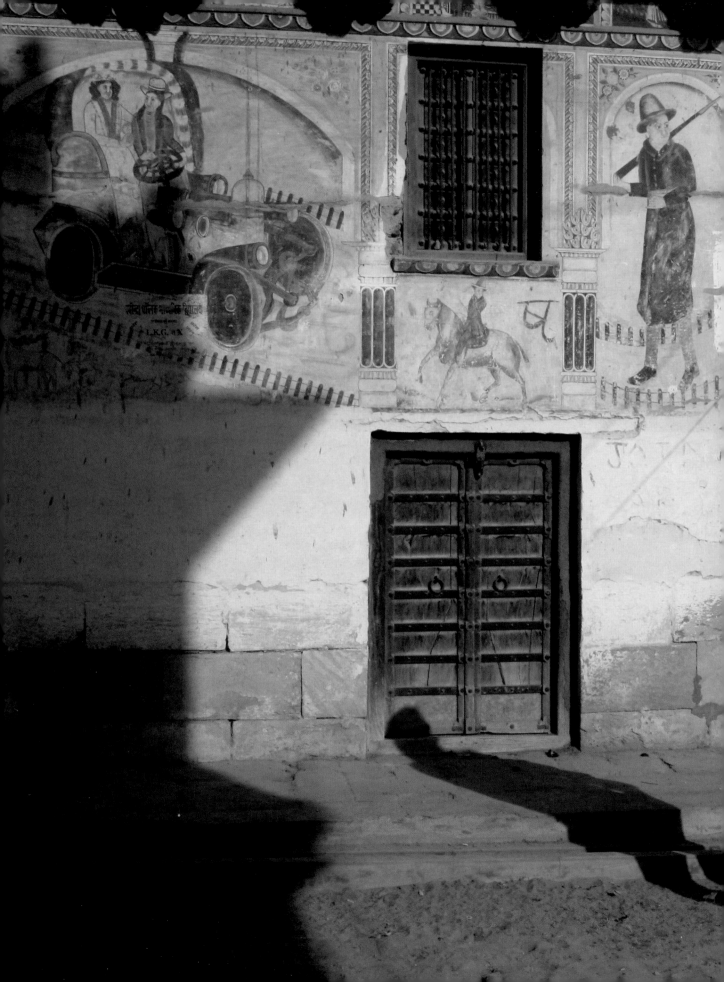

In the middle of the eighteenth century, with naval and commercial victories overseas, Britain was entering a new imperial era. It drew us into a different way of thinking about the world. A spirit of adventure and opportunity concealed the darker side of exploration and empire, as Britain tried by force to impose its will on the unwilling.

The Raj as others saw us. These crude but delightful frescoes on the exterior walls of merchants' houses in a remote part of Rajasthan were well worth the journey to see them. They show the British going about their daily business in new-fangled motor cars, bicycles and by trains, which look like little houses on wheels. The dry desert has preserved them as a reminder of one of our most extraordinary imperial ventures.

Art implanted the British Empire in the national consciousness. Its purpose was like that of the old sailor in Sir John Millais's *The Boyhood of Raleigh*, who captivates his two young listeners with tales of adventure, marvels (and perhaps profit) in distant lands beyond the horizon. Imperial art flattered the British people and exalted their nation's mission to govern and civilise. Images of heroes preserved the memory of the selfless patriots who created the Empire and their exemplary courage and dedication to duty. Images of battles confirmed the British self-image as a resolute and courageous race. Representations of the landscapes and the inhabitants of Britain's colonies generated a pride in possession and were reminders of the nation's responsibility for the welfare and betterment of what were considered 'primitive' or 'childlike' peoples. This work of instruction and conversion was complemented by the popular literature of Empire.

The range of imperial art was vast: it encompassed public buildings of pseudo-Roman grandeur, canvases of battles and crude woodcuts of heathen idols, which appeared in the missionary society pamphlets that were sold in Sunday schools for a penny. Imperial art was popular art aimed at a mass audience drawn from all classes. A portrait (perhaps an oleograph – a cheap coloured print) of General Gordon hung on a wall in Sherlock Holmes's lodgings in Baker Street.

The sketches and engravings of campaigns on distant frontiers filled the weekly illustrated magazines of Victorian Britain. They brought the exciting world of Empire into every home and stirred imaginations. Flora Thompson, a stonemason's daughter, recalling her childhood in Oxfordshire in the 1880s, remembered these images: 'Theirs had been the days of the bayonet and the Gatling gun, of horse-drawn gun-carriages and balloon observation, of soldiers fighting in tight-necked red tunics.' Her contemporary, the young Winston Churchill, read the weeklies in his nursery and prep school and was thrilled by stories and pictures of wars in Zululand and the Sudan.

Every image of Empire reminded the public that Britain was engaged in a great enterprises which was enriching the nation, raising its international prestige and bringing peace and regeneration to the

The Boyhood of Raleigh by Sir John Millais, 1870. This painting wonders whether Victorian young men will show the same daring and yearning for overseas adventure as their Elizabethan ancestors.

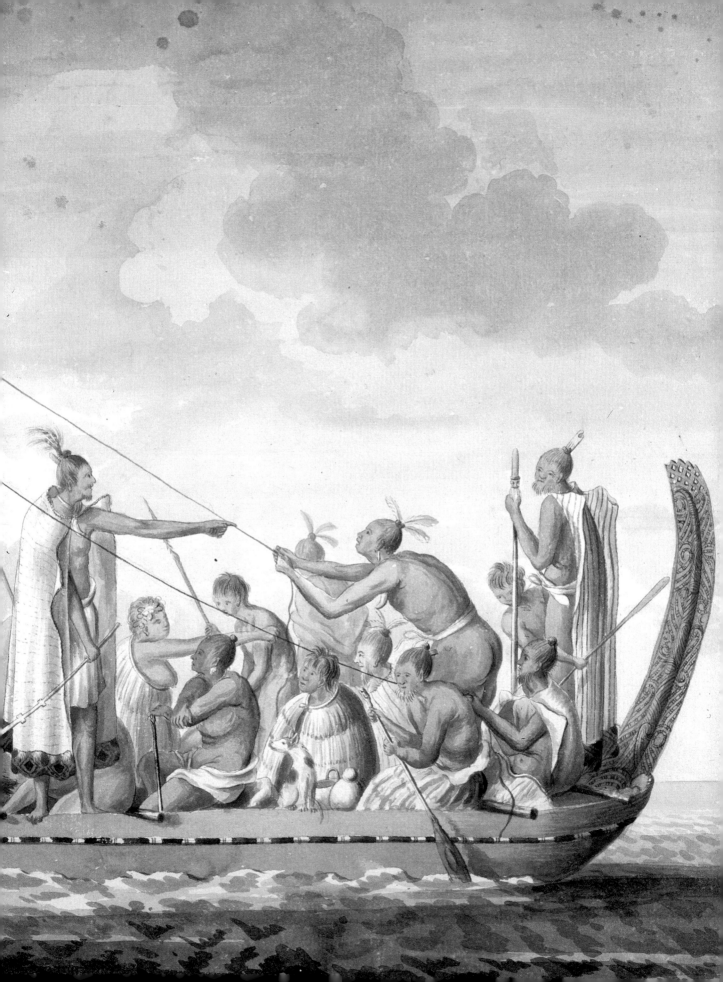

rest of the world. These imperial projects required, at the very least, the passive cooperation of the people of what Churchill called, in 1900, 'an Imperial Democracy'; or, at the very best, their wholehearted participation. On the whole the public accepted the idea of Empire. Roughly between 1750 and 1900, Britain acquired 1.8 million square miles of the world's surface and, when she died in 1901, Queen Victoria ruled over 294 million subjects, two-thirds of them Indians.

Imperial art was part of an art world that was intensely commercial and competitive. Painters and the engravers and publishers of prints were businessmen with a knack for detecting fashions, particularly among the growing middle class. Technical innovations in the manufacture of prints and ceramics during this period facilitated mass production and low prices. Benjamin West's *The Death of General Wolfe* painted in 1770 was reproduced as a print, which was sold in its thousands and earned the publisher £15,000 within fifteen years. Buyers of such prints had a taste for dramatic and historical subjects. Two were offered by the Art Union, which, in the mid-nineteenth century, produced inexpensive prints that were deliberately aimed at a middle-class market: Daniel Maclise's *The Death of Nelson* and his *Meeting of Wellington and Blücher after the Battle of Waterloo*. Both were bestsellers.

These tableaux showed a decisive moment in the history of the nation and its Empire. Trafalgar confirmed Britain's maritime supremacy, saved the country from invasion by Napoleon and underwrote the future security of the colonies, while Waterloo marked the final overthrow of Napoleon. Britain had emerged from the wars as the world's first industrial superpower with a strong and expanding economy and access to international markets. It was, as the Victorians loved to boast, 'the workshop of the world'.

Art was the servant of education, so it is easy to imagine that the Victorian father explained the significance of these two battles to his children and reminded them of what their country owed to brave and dedicated men. Heroes of this stamp continued to make Britain great and were celebrated in popular art. Gaudy Staffordshire ware figurines were mass produced, replicating heroes such as Lord Gough, whose victories over the Sikhs in 1846 and 1849 concluded Britain's conquest of India. The lower-middle and better-off working classes who bought and treasured these figures were clearly unconcerned by verisimilitude, for it is hard to distinguish one general from another.

Imperial art was also directly didactic: it taught lessons in geography, anthropology and natural history. Artists accompanied explorers such as Captain James Cook and returned home with images that illustrated

narratives of his travels, and were sometimes reproduced in popular magazines. During the eighteenth century, the British had become avid readers of newspapers and journals, and editors catered for their fascination with novelties, which included stories of hitherto unknown lands and their inhabitants. Cook's voyages to the Pacific in the 1770s captured the public imagination, both satisfying a curiosity about the unknown and generating speculation about the nature of humanity.

Those who pored over images of the natives of the Pacific islands wondered whether they were looking at men and women who inhabited another Eden. Were they noble savages, creatures of nature and untainted by the vices and artificial inhibitions of modern civilisation? If so, these innocents were to be admired; even envied. These favourable impressions of the Polynesians owed much to Cook's artist John Webber, who tended to show them enjoying themselves. Devout Christians, however, were not taken in by these scenes and, arguing from the narratives of explorers, insisted that the islanders were pagans whose paradise was a hell of tribal wars, sexual promiscuity, human sacrifice and cannibalism. This was the message of Bishop Heber's famous missionary hymn 'From Greenland's Icy Mountains' in which congregations were reminded that 'only man was vile' in the otherwise beautiful and fecund tropical Eden, which the artists had portrayed.

Artists' revelations of sublime landscapes and a lost world of innocence moved the Romantic imagination. Britain's money men saw things differently: here were peoples and lands ripe for investment and trade. Temperate wilderness could be transformed into arable land and pasture, forests could provide timber, mountain ranges were rich in minerals and rivers in fish. And there was an abundance of customers, for, as Cook had observed, the Polynesians prized the Birmingham steel knives he had given them as tokens of friendship and goodwill. Sadly, one may have been used to kill him.

The new world of the Pacific was also open to colonisation. Its inhabitants' legal rights of ownership were swept aside by legal and religious casuistry, which alleged that these rights had been forfeited because the natives had failed to exploit their God-given and bountiful environment. British lawyers reasoned that this apathy had rendered Australia vacant and open for settlement by industrious immigrants. In 1788 colonists arrived; some were convicts who had been given a chance to make themselves useful – that is to say, productive – subjects of the Empire. Prints of the early settlements around Botany Bay showed former thieves and prostitutes working the fields and building houses, which was comforting evidence of their redemption.

(on previous page) General Viscount Combermere liberates Indian refugees after the surrender of Bharatpur.

By 1800 attitudes to wealth creation were changing. The manic urge for profit was being diluted by what turned out to be a stronger belief that the Empire should directly reflect the humane values of a Christian nation. The new outlook was symbolised by the abolition of the slave trade in 1807 and of plantation slavery in 1833.

This new Empire of benevolent paternalism was portrayed in a huge canvas showing the capture of the north Indian fortress of Bharatpur in 1825. The victorious commander Lord Combermere extends a magnanimous hand to an Indian noblemen, peasants throw out welcoming arms to him and behind them are a lady and several men on horseback. They are unafraid, for the general on a white charger is welcoming them to a secure and peaceful future. The Union Jack flies over the massive fortress of the former raja of Bharatpur, which looms in background. It stands for a past of tyranny and disorder.

By this date, Britannia had ceased to be simply a hard-nosed asset-stripping entrepreneur. During the nineteenth century she was reborn as a patient but firm headmistress dedicated to the welfare of her pupils and to teaching them the benefits of the European intellectual and scientific enlightenment. English was the language of instruction, there was peace in the classroom and disruptive pupils received a salutary caning whenever they misbehaved. All around them was evidence of their new rulers' ability to master their environment: time, distance and disease were overcome by steamships, railways, the telegraph, sanitation systems and hospitals. It was sometimes a frightening new world, but also an intriguing one. In Mandawa (Rajasthan) in the 1870s Indian artists, reflecting the changing landscape, added scenes with railway engines, carriages and passengers to their traditional stock of subjects for decorating house exteriors.

The art of the British Empire mirrored its changing nature. It was appropriate that the Empire of money and power attracted the German artist Johan Zoffany to India in the 1780s. He had come to London to paint the rich and fashionable and he followed them to Calcutta and Lucknow. His new patrons were the 'nabobs' – the contemptuous name given to unscrupulous fortune hunters who were filling their own pockets at the same time as they earned dividends for their employer, the East India Company. Some of these characters appear in Zoffany's *Colonel Mordaunt's Cockmatch*, a colourful and animated portrayal of the colonel enjoying himself with Indian sportsmen, courtiers of the Nawab of Oude (Awadh).

Zoffany's India was aristocratic in tone. Indian princes and men

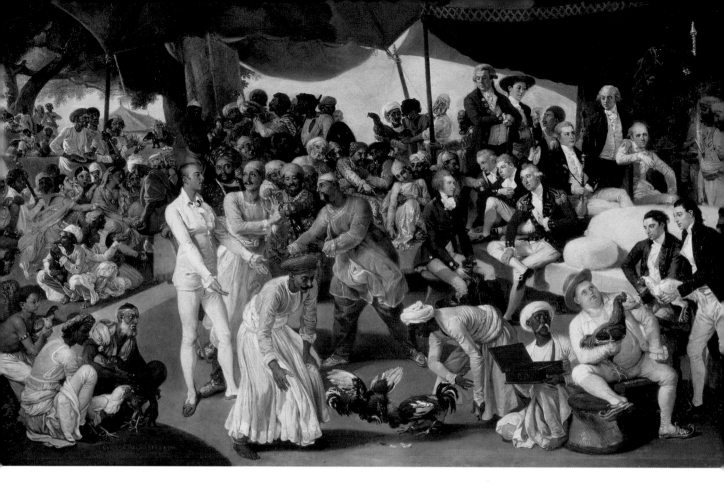

In this painting of Colonel Mordaunt's Cockmatch *by Johann Zoffany, English and Indian élites mingle for a sporting contest in the 1780s.*

of high rank mingled with European gentlemen (Mordaunt was an illegitimate son of an earl), drawn together by a common enthusiasm for sport. This proved a strong and enduring bond and, in the next century, photographs show Indian princes and British officers at race meetings or posing before the trophies of the chase: dead tigers and stuck pigs, hanging from stakes.

Yet the British were always the masters. They followed the precedent set by the Mughal emperors who had advertised their political supremacy by constructing huge and ornately decorated palaces. British paramountcy was asserted by public architecture that deliberately copied the styles of another imperial power – Rome. The results were massive in scale with a grandeur contrived to overawe the Indians and remind them of the permanence of British rule. Vistas of great arches, colonnaded official buildings and statues conveyed power – this had been the intention of Lord Mornington, the Governor-General of Bengal when he began to transform Calcutta into a truly imperial capital in the early 1800s. His subordinates followed suit: Captain William Kirkpatrick built his residency in Hyderabad in the Georgian neoclassical style with an impressive colonnaded façade, and the result looks like the country house of a contemporary English squire.

Regency architecture began to be influenced by oriental styles, such as the abundance of domes on the Brighton Pavillion, drawn here by John Nash for his Views of the Royal Pavilion, Brighton, 1826.

Proconsuls such as Kirkpatrick were importing the architecture of Rome to India at the same time as a few nabobs were exporting Indian styles to Britain. Indian motifs, including a mosque-inspired dome, appear at Sezincote in the Cotswolds, which was rebuilt in the early 1800s by Sir Charles Cockerell, a well-heeled former official of the East India Company. Variations on Indian themes (including an abundance of domes) appear on the Prince Regent's Brighton Pavilion. However, this ensemble was an expression of eccentricity rather than proof of any aesthetic attachment to Indian styles.

For the rest of the nineteenth century, the architectural exchange of styles was mostly one-way. British neoclassical and Gothic revival styles were used for dominion parliaments, Indian railway terminuses, colonial governors' residences and, of course, cathedrals and churches. In return, Britain got the suburban and seaside bungalow, which had started life as the cool and airy, one-storeyed house of Indian officials and Malayan planters.

The architecture, sculpture and painting of India were clear evidence that its élites were sophisticated men of taste and heirs to a distinguished civilisation. Indian temples, palaces and water gardens were admired and drawings of them reproduced in Britain. Erotic carvings were also copied and the results were discreetly circulated among gentlemen.

Many of the new generation of India's rulers would have been shocked by such images. They were high-minded Christians bent on humanitarian reforms and reshaping the Indian mind. The new proconsuls were obsessed with the collection and classification of information about every aspect of India. Scientific methods were adopted. In 1844 the new Governor-General of Bengal, Lord Hardinge, arrived in Calcutta with an artist and one of the novel Daguerreotype cameras with which they could take photographs to show Queen Victoria exact images of Indian landscapes, architecture and people. The Governor-General and artist were flummoxed by the complex chemistry then vital for printing photographs, but other, more adept British and Indian photographers were soon creating a modern, visual record of British India.

The photograph was an art form that satisfied the Victorian desire for factual exactitude. In the 1860s the Indian government undertook a vast photographic survey, which was published as *The People of India* and ran to twenty volumes. A few of the Indian subjects were 'very alarmed' by the photographers since many had never seen a white man before, let alone a camera. Each image had an explanatory caption, some of which were condescending or arch. Underneath a photograph of a buxom lady are the words: 'Zahore Begum is a Cashmere Mussulman (Kashmiri

Muslim), and follows the profession of a courtesan. As may be supposed, her character is not very respectable.'

Official and private photographs of Britain's colonial subjects helped confirm racial stereotypes and fuelled speculation about the existence of a universal racial hierarchy. Portfolios of photographs taken during the 1879 Zulu War showed *kraals* (fenced villages), warriors, herds of cattle and a female witch doctor, whose intuitive powers gave her the right to condemn to death anyone she suspected of employing magic to harm their neighbours. Another image of a bare-breasted girl aroused the fury of anti-vice campaigners who threatened to prosecute the studio that sold these pictures. Together these images portrayed what the Victorians categorised as 'primitive' mankind, 'childlike' (a favourite term of the time) creatures whose social, cultural and economic development had either been arrested or had lagged behind that of Europeans. Those who interpreted the human world in pseudo-Darwinian terms, and many imperialists did, saw photographs of Zulus and other Africans as proof of the inequality of the races.

That unequal state of affairs could be changed, however, and photographs faithfully recorded the elevation of the noble savage into an inhabitant of the modern world. Photographs taken of the Zulu King Cetshwayo after his capture showed him near naked in his tribal regalia, while those taken during his brief visit to England show him dressed in bourgeois frock-coat and trousers. His metamorphosis was complete when he returned to Zululand as a puppet prince under Britain's thumb, governing in accordance with the moral and legal codes of his sponsors.

For the Victorians, remaking the African required dressing him up. They were ambivalent about nakedness: it was admired in classical art and its modern counterparts, but in the tropics it was seen as backward and barbarous, particularly by Christian missionaries and their domestic supporters. The former American president Teddy Roosevelt was heartened when he saw Kenyans in European dress during his hunting excursions in the colony in 1909. In his eyes, trousers and shirts were the insignia of 'civilisation'. Banishing semi-nudity in Africa and elsewhere was also good news for Britain, which manufactured and exported textiles.

So, the modern art of photography became the factual art of the Empire. There were, of course, constraints imposed on what was published. Images of black labourers being flogged during the

Civilisation prevails: King Cetshwayo enters the modern world by exchanging the regalia of a Zulu warrior for the suit of a Victorian clerk, 1881.

Boer War did not find their way into newspapers and journals. The public wished to see their Empire as humane and there were domestic critics of the Empire who were quick to expose the callousness of some of its servants.

The Empire of the imagination (and the emotions) was the subject of creative artists. Imperial history was their raw material and they transformed it into a grand epic crammed with dramatic and stirring episodes. Battles were the favourite subjects and they were rendered as theatrical tableaux, often highly stylised and with little or no blood. Wars dictated the course of imperial expansion and were tests of national willpower and stamina. Above all, imperial wars enlarged the pantheon of national heroes whose lives and exploits demonstrated the spirit and virtues of an imperial nation.

Heroes led the way in battle and inspired their countrymen, particularly the young. In August 1914 Colonel Aylmer Haldane

General Sir John Pennefather and a light dragoon trooper pose for Roger Fenton's camera in the Crimea, 1885. The new techniques of photography portrayed the reality of war.

reminded his Highland battalion that they were about to go into action close to Waterloo, where nearly a hundred years before British soldiers had shown amazing bravery and determination. This was common knowledge to any child brought up in late-Victorian and Edwardian Britain. The young Tommies would have recalled scenes from Waterloo reproduced in their history textbooks and on the prints that hung on the walls of their primary schools. Such pictures complemented the late-Victorian schoolboy fiction of G.A. Henty in which plucky young men risked their lives fighting the Empire's wars and impressed the natives with their valour and sense of fair play. Art showed young Britons how they ought to behave.

Patriotic selflessness even to the point of death distinguished the imperial hero. This quality was displayed by James Wolfe, the commander of British forces in North America, who was killed in the battle for Quebec in 1759. His death occurred within minutes of being told that the French had been defeated and that all of Canada was now part of the British Empire.

Many artists depicted this poignant moment of glory, most famously Benjamin West, an American whose parents were Philadelphian Quakers. West was a daring innovator who depicted the

dying general and his staff in the uniforms they would have worn, which upset traditionalists. George III, the prime minister, William Pitt the Elder, and the revered portraitist Sir Joshua Reynolds were dismayed and would have preferred the soldiers to have been dressed as Romans. They wanted a classical pastiche, to reinforce the notion that Britain was the new Rome. West got his way; the King eventually changed his mind and bought a copy of *The Death of General Wolfe* for the Royal Collection, while the public brought thousands of prints of the scene.

Among those impressed by West's masterpiece was Admiral Lord Nelson, a vain man who freely and frequently admitted his hunger for fame and glory. He told the artist that if he should die in battle he hoped that West would paint the scene so that he could share Wolfe's immortality.

West obliged, but he deliberately ignored the exact circumstances of Nelson's final moments in a murky, candlelit cockpit below the decks of *HMS Victory* – which was, however, reproduced by other painters who strove for historic accuracy rather than attractive myth. West's *The Death of Viscount Nelson* shows the admiral expiring on the deck of the battleship, surrounded by officers, sailors and marines, while in the background British men-o'-war are still closely engaged in

The Death of General Wolfe *by Benjamin West depicts the death of a contemporary hero.*

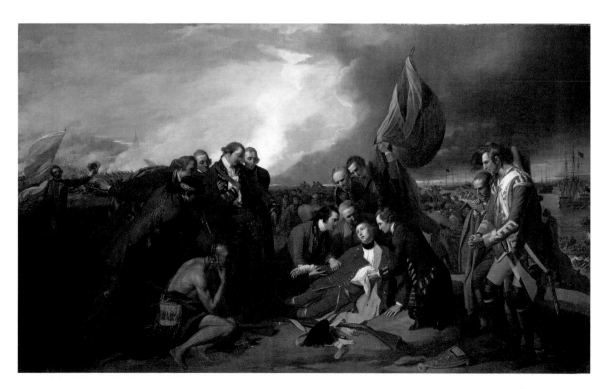

fighting French and Spanish vessels. The hero is dying surrounded by
other brave men, some of them wounded and, in the mid-distance,
marines are still priming and firing their muskets. Yet Nelson remains
the centre of attention, 'radiant in the glow of victory' in the words of
one contemporary critic.

The death of Lord Nelson was one of the greatest imperial icons of
imperial art, and immensely popular with the Victorians. It celebrated the
patriotism of an exceptionally brave man and a tactical genius who
sacrificed his life for his country. The nation was grateful: Nelson's
Column in Trafalgar Square remains the most spectacular monument
ever erected to any individual in Britain. The memory of Nelson was
inseparable from his virtues and the example of his life and death.

Waged in the name of civilisation and humanity, imperial wars captured
the public imagination. Colonial wars became a staple of the press and
front-line war correspondents were joined by war artists. Their sketches
gave a fresh immediacy to battles and skirmishes and many were
transformed into large-scale epic paintings which, in turn, were copied
and sold as prints. The principal ingredients were always the same: action,
drama and colour.

Interestingly these elements were not conveyed by the camera.
Photographers had made an extensive record of the Crimean War
(1854–6), which had been waged to defend imperial interests in the
Near East against Russia. The images were static, although photographs
of weary, underfed horses hinted at the logistical shortcomings that had
troubled the army in the first stages of the war, which had been
remorselessly exposed in the press. By the late 1890s reporters and
artists carried Kodak cameras and their snapshots appeared in the press
thanks to recent technical advances. Nonetheless, it was the artist who
crafted the animated and thrilling scenes that the public craved.

Thrilling scenes were certainly provided by the Indian Mutiny of
May 1857 and its suppression during the next eighteen months. The Raj
had been caught napping, swathes of northern India briefly passed out of
British control and frightened and bewildered sahibs, memsahibs and
their children withdrew into their cantonments (European living
quarters), together with British troops and loyal Indians. Four sieges
dominated the early operations: the mutineers were bottled up in Delhi
(where the decrepit Mughal Emperor had been reinstated) and the
British held Agra, Cawnpore and Lucknow. Each was portrayed as an
imperilled outpost about to be overwhelmed by primordial anarchy.

The British Raj appeared to be crumbling and the stage was set for

an extended melodrama, which shocked and thrilled the British public. Artists responded with often stark representations of the hopes and fears of the beleaguered, for capture meant a cruel death. These were subjects ideally suited to the fashionable genre of narrative painting, which prompted onlookers to ask the question: 'What will happen next?'

Edward Hopley's *An Alarm in India* of 1858 shows an officer grasping a revolver as he looks down from a window. Has he seen his sepoys (Indian soldiers) storming the cantonment, as the first mutineers did at Meerut? A fearful lady in a cashmere shawl, from which the tiny hand of a baby appears, is about to pick up another pistol. Or perhaps the scene is set in Jhansi? Here the garrison was overwhelmed and slaughtered, and one officer, Alexander Skene, shot his wife to spare her rape and death at the hands of the insurgents, and then killed himself. The incident deeply moved the poetess Christina Rossetti who imagined their final words in the poem 'In the Round Tower at Jhansi':

> *Kiss and kiss: 'It is no pain*
> *Thus to kiss and die.*
> *One kiss more.' 'And yet one again.'*
> *'Good bye.' 'Good bye.'*

Like the artists, she gave an intense human reality to stories in the press.

A wave of fury and revulsion convulsed Britain as news broke of real and imaginary atrocities. Women and children were murdered by mutineers in the Cawnpore massacre. This was a violation of the sanctity of womanhood and the innocence of childhood, which the Victorians cherished. The sheer horror of Cawnpore was conveyed by Sir Joseph Noel Paton's *In Memoriam,* which was exhibited at the Royal Academy's 1858 exhibition. Women and infants huddle in a cellar as fiendish, blood-splattered mutineers approach down the steps. Newspaper reports were given a terrifying immediacy and it was said that one young lady fainted on seeing the picture. Paton had overstepped the mark of decorum, and he hurriedly changed the picture under pressure from newspaper editorials. The menacing sepoys were replaced by kind, bearded Highlanders and the painting was renamed *In Memoriam: Henry Havelock* in honour of the commander of the troops who had relieved Lucknow.

The city's deliverance in September 1857 gave rise to the legend of Jessie Brown – a corporal's wife, who, semi-conscious with exhaustion, imagined she heard the distant skirl of bagpipes. The

scene is dramatically depicted in Frederick Goodall's *The Campbells are Coming* in which Mrs Brown alerts a nearby officer, who stands before a lady kneeling in prayer and holding a small girl. The picture is heartening: faith and fortitude have been rewarded.

Lucknow's deliverer was Sir Henry Havelock, who died during the campaign. He was a fervent evangelical who went to war with a Bible in his saddlebag and likened himself to an Old Testament warrior sent by God to chastise the wicked – which he did with the utmost severity. Havelock was a perfect imperial hero for his age, for he came from a middle-class background and he was both a gallant general and a Christian martyr. The middle classes took him to their hearts and subscribed to the costs of his statue, which was set on a plinth in Trafalgar Square – a fitting companion for Nelson.

General Charles Gordon succeeded Havelock in public

John Noel Paton's In Memoriam, *portrays the melodrama of the Cawnpore mutiny.*

The Campbells are Coming *by Frederick
Goodall depicts the moments before the
relief of Lucknow, when the faith and
courage of British colonials are rewarded.*

adulation. He too was as brave as a lion, had suppressed slavery in
the Sudan in the 1870s and believed himself a servant of God and
civilisation. In 1884 he was ordered back to Khartoum as Governor-
General of the Sudan with instructions to oversee the evacuation of
Egyptian troops and civilians. The country was being overrun by
insurgents led by a messianic Muslim holy man, the Mahdi, who, like
Gordon, claimed he was fulfilling the will of God. Gordon ignored his
orders, held Khartoum and declared that civilisation would never
retreat in the face of what he convinced himself was ignorance and
savagery. As in the Indian Mutiny, the siege symbolised the conflict
between imperial order and native disorder.

The public went wild. Here was a Christian hero isolated in a
far-off city, defending the Empire. A reluctant government sent an
army to rescue him, but it was too late. Khartoum was taken in
January 1885 and Gordon was killed. According to Military
Intelligence reports (which, forty years later, were confirmed by the
evidence of his Sudanese assailants) Gordon was killed fighting in a
corridor of his palace, firing his revolver. A soldier's death, but not
that of a Christian martyr. Art intervened and gave the British what
they wanted – an icon. George Joy's *General Gordon's Last Stand* shows
him standing disdainfully at the top of a flight of stairs up which the
dervishes are surging. Two are on their knees, suggesting awe in the

George Joy's General Gordon's Last Stand *perpetuated the legend of his calm and dignified martyr's death.*

presence of

this brave man about to die for an ideal. Like Benjamin West, Joy had painted the legend; which was, of course, what the public wanted.

The dash for Khartoum had been punctuated by a sequence of hard-fought desert battles between British forces and the dervishes, who were strong, fearless and athletic warriors. William Barnes Wollen's *The Battle of Abu Klea* (1885) freezes the terrifying moment when dervishes briefly broke into a British square. Hand-to-hand combat was by now a favourite with imperial artists, for it offered opportunities for striking pictures that also made a powerful moral point. The British fighting man still had the nerve, guts and skill to trounce his adversaries on their own terms with bladed weapons. Among those killed as the square fractured was Colonel Frederick Burnaby, who had been famously painted by James Tissot as the epitome of the languid, insouciant British officer. Perhaps it had been Burnaby who had carelessly remarked before the battle that it would be a shame to die without knowing the result
of the Derby.

The public was always thrilled by cavalry charges, which were spectacular, dramatic and embodied the glamour of war. Horsemen charge in dashing style in Richard Caton Woodville's *The Charge of the 21st Lancers at Omdurman* (1898). Winston Churchill, who took part in the charge, wrote afterwards that: 'My faith in our race and blood was much strengthened'. This was a common reaction to a glorious incident, which made it easy to overlook the fact that the Battle of Omdurman had been an unequal contest in which British firepower killed over 10,000 Sudanese in a few hours.

Revealingly, a Maxim machine-gun stands abandoned in the foreground of Caton Woodville's *A Chip off the Old Block, 5th Lancers at Elandslaagte* (1899), in which horsemen ride down terrified Boers. Cold steel triumphed again and, when it came to hand-to-hand combat, British soldiers again proved their superior toughness and fighting spirit. Patriots who purchased prints of Caton Woodville's battle-pieces could feel pride in the soldiers who were enlarging and guarding the Empire.

Their lives and actions would now be seen with a fresh immediacy thanks to the newsreel film. The journalist Frederick Villiers took a Tine camera to the Sudan and vainly attempted to film the battle of Omdurman. His successors were luckier, and in 1900 British cinemas were showing newsreel footage of the Battle of Spion

The dramatic scene in The Battle of Abu Klea *by William Barnes Wollen, 1885, was evoked in the opening lines of Sir Henry Newbolt's 'Vitaï Lampada'.*

Kop. A new art form had been brought into the service of the Empire. In the coming century the imperial adventure film would become an immensely popular genre with cinemagoers. Sir Alexander Korda's *The Four Feathers* (1939) revealingly opens with a scene showing Gordon's death just as it had been depicted by George Joy.

Conventional imperial art disappeared in the twentieth century. Its final grand flourish was the completion of Sir Edwin Lutyens's spectacular imperial capital at New Delhi in 1933. Its grandeur seemed anachronistic and paradoxical at a time when agitation for Indian independence was intensifying. Empires were about to go out of fashion and Lutyens's magnificent buildings would, in 1947, become home to an elected Indian government.

Late-Victorian bombastic, imperial patriotism withered, although during the First World War the penny illustrated magazines had plenty of fanciful artists' representations of hand-to-hand encounters in the trenches, and there was an abundance of brash flag-waving on official recruiting posters. By contrast, official war artists such as Paul

Richard Caton Woodville's A Chip Off the Old Block 5th Lancers at Elandslaagte, *is an elegy for the now anachronistic cavalry charge. The troopers are dressed in traditional red jackets, rather than contemporary khaki.*

Nash produced sober, melancholy and realistic impressions of industrialised, mass warfare. Nonetheless, there was still a place on the schoolroom walls for prints of the *The Death of Nelson* well into the 1940s, when the Empire he had died for was on the verge of dissolution. In fact, I possess one myself.

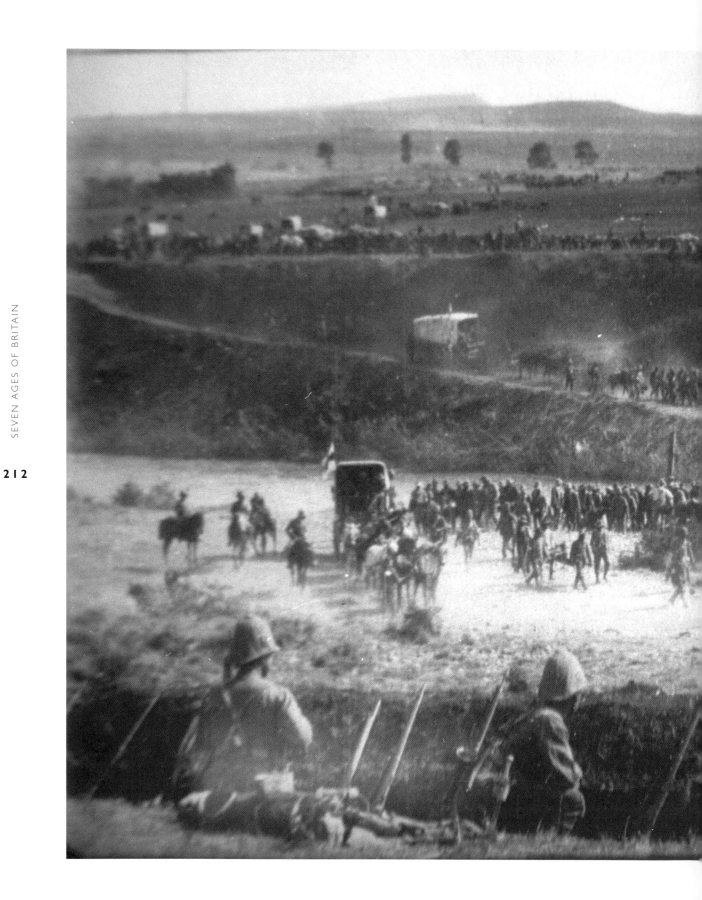

Newsreel footage from the battle of Spion Kop. This and other films of the Boer War were shown in cinemas and theatres throughout Britain. It was a modern medium for a modern war.

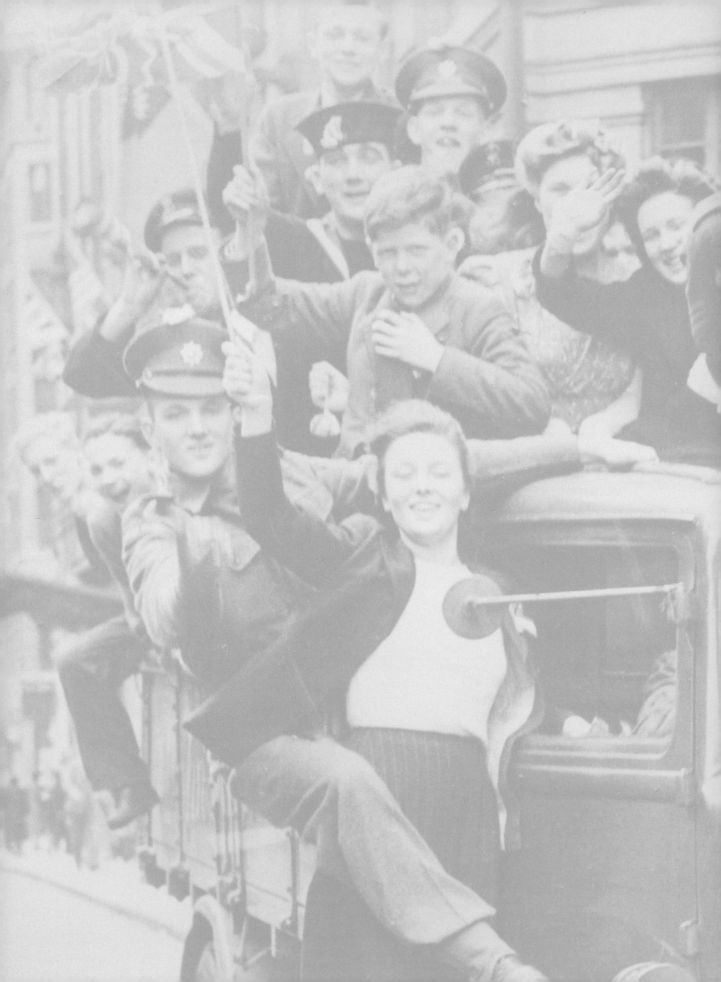

AGE OF AMBITION

BY FRANCES SPALDING

This is the story of how art, mirroring changes in society, came off the gallery walls, freed itself from old power structures, and became an instrument of self-expression at the service of the individual. The result is sometimes wonderful, sometimes obscure, but certainly the story of a nation re-inventing itself.

The artists Gilbert and George teaching me their famous 'Bend it' dance in their studio in Spitalfields in London. Their public persona is of a rather mannered couple, always maintaining a formal and reserved front. They could not have been more different when we met. They were friendly and eager to talk about their subversive work and why they believed in Art for All.

A Corner of the Artist's Room in Paris *by Gwen John. This placid scene contrasts with the bustle of the growing metropolis below.*

With the twentieth century, British art broadens its appeal. Stylistically more diverse than in previous periods, it chases the new, responds to technological innovations and is often challenging and subversive. But all this began slowly, with the Edwardians still clinging to traditions rooted in the Victorian period. The Royal Academy remained a powerful presence. The fashion was for subtle colour harmonies, elegance and restraint – all of which can be found, for example, in William Nicholson's exquisite still lifes – and portraiture was very much in demand. Those who had money went to John Singer Sargent. This cosmopolitan artist – he was born in Florence, of American parentage, and had trained in Paris – settled in London in 1886 and rapidly become the foremost portrait painter in England. His fluent and seemingly casual handling of paint gave to his sitters – self-made industrialists, financiers or art dealers – the aristocratic nonchalance they lacked by birth. Nobody else portrayed so well the panache of the upper classes. But beneath this display of glamour and wealth lay unease.

The Edwardian period, far from being one long garden party, was riddled with tension and strife. It was troubled by labour issues and a growing number of strikes, including one at the Welsh mining-town of Tonypandy where troops were brought in to quell a riot that lasted three days. There was also concern over the question of Home Rule in Ireland, and over the growing strength of the suffragettes who, lacking the means to change government, had begun to resort to violence. In these and other ways, old certainties were being called into question.

Everyday life, too, was changing in far-reaching ways. New technology brought faster travel and communications. The telephone was beginning to replace the calling card, and horse-drawn buses were giving way to motorised omnibuses and trams. Deep tunnels were being built beneath London to house the new underground railway system. As public transport diversified, social mobility increased and habits changed. Cities became increasingly attractive, representing exciting new freedoms. In response to this, artists began to look for new possibilities for subject matter and fresh methods of expression.

Reactions to the changing urban landscape were varied. Augustus John turned his back on it and lived as a nomadic bohemian, emulating the free-wheeling gypsy communities. Famous in his day for the uninhibited boldness with which he painted and drew, he is nowadays less highly rated than his sister, Gwen John, who spent much of her early life in his shadow. She eventually escaped to Paris, had an abortive love affair with the famous sculptor Rodin and became a recluse. Yet

A woman protests against the force-feeding of imprisoned suffragists. The suffragettes were just one of the causes of social upheaval during the Edwardian period.

Walter Sickert's Noctes Ambrosianae *depicts the ordinary audience of a London music hall. The pale faces sitting in 'the gods' form a rhythmical figure of eight pattern.*

the awareness of the hustle and bustle of the metropolis is what makes her paintings of isolated figures or the stillness of an attic room so poignant. Different again is the achievement of Walter Sickert. He did not turn aside from the modern world, but often looked at it from an oblique or unexpected angle. More than any other artist, it is he who introduced a new sense of purpose and direction into British art.

Sickert had originally trained as an actor and he could recreate the mood and atmosphere of almost any setting. He had a particular love of Camden Town – once a high-class area that had rapidly degenerated when the railways cut through to three large termini: Euston, St Pancras and Kings Cross. Regency houses had been turned into bedsits to house a shifting population and a workforce of navvies. Sickert delighted in the district's shabbiness and many of his pictures are set in sleazy lodging-house interiors.

This artist was in fact at home in any society and would startle his friends with his sudden changes of dress and address. He had

charm, wit and audacity, and in 1907 he gathered round him younger artists, among them Harold Gilman, Spencer Gore, Robert Bevan and Charles Ginner and formed the Fitzroy Street Group, named after the street where Sickert had his studio. At his suggestion, one floor of the house opposite was rented as the group's base and every Saturday they mounted an informal exhibition. Here some pictures would be found resting on easels while others were casually stacked nearby.

Sickert's ambition was to expand the audience for modern art. 'I want to keep up an incessant proselytising agency,' he said, 'to accustom people to mine and other painters' work of a modern character.' It did not matter to him whether a person was rich or poor, refined or vulgar, so long as they had an interest in painting and in what he called 'things of the intelligence'. In his work he took inspiration from the French artist Edgar Degas, who often cropped his subjects, like a snapshot, to give them immediacy. In London he haunted the music halls, where he revelled in the songs, the comic characters, the bawdy humour and the audience involvement. He often turned his head away from the stage and looked up, finding drama in the mirror reflections, the gilt architecture and in the patterns created by the pale faces that hung over the railings up in 'the gods'. All these he recreated in images that celebrate working-class culture. But at the same time he renewed the language of paint. Sometimes his touch was so abrupt and abrasive that his figures were reduced to blobs and jabs of paint. A brutal expressiveness in his treatment of nudes seems to anticipate the art of Francis Bacon.

Sickert's example made others question, more intently, what it was they wanted to draw, paint or sculpt. When the Fitzroy Street Group transformed itself into the Camden Town Group in 1911, there was a fresh burst of interest in urban subjects and London scenes. Bevan, Gilman, Gore and Ginner did not paint famous buildings or historical sites. They concentrated instead on the overlooked – an anonymous eating-house interior, for example, or the muted streets of an inner suburb. This was a new, probing realism, far removed from the slick nostalgia found each year at the Royal Academy Summer Exhibition, where views of Scottish glens and coastal resorts reminded visitors of their recent holidays. One hugely popular academician was Sir Lawrence Alma-Tadema whose domestic scenes set in ancient Greece or Rome sold for large sums of money. He excelled at painting marble, maidens and the Mediterranean, mixed in with dazzling effects of perspective. One has only to compare the finesse with which he crafted every detail in these scenes with the radical emptiness of

By 1912, when Vanessa Bell had completed Studland Beach, *Britain had begun to open up to modern art.*

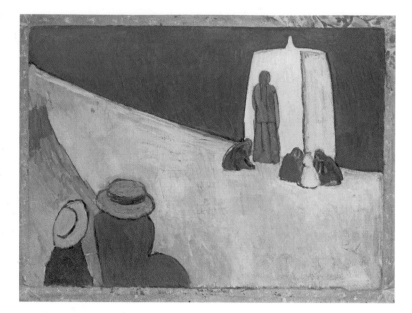

Vanessa Bell's *Studland Beach* to realise that between 1910 and 1912 Britain woke to modern art.

The cause of this artistic awakening was the arrival of the French Post-Impressionists. In 1910 Roger Fry, the critic and painter, brought large numbers of paintings by Cézanne, Gauguin, Van Gogh and others to the Grafton Gallery in London. He did it again in 1912, this time including recent work by Picasso and Matisse. The London audience was baffled. Most of the developments in French art that had taken place over the last thirty years had largely been ignored in Britain. Many viewers, including critics, could not stomach the strong colours, the expressive design and the flattening of space for decorative purposes. This modernist approach to painting, however, liberated artists from prevailing traditions, which had begun in the Italian Renaissance and had come to seem stale and academic.

In 1920 Roger Fry published *Vision and Design,* a collection of essays that touched on, among other things, African carvings, prehistoric art and ancient American art. Fry's straightforward prose was addressed to the layman and helped bring about a widespread change in attitude: art was no longer solely the concern of an educated élite; Fry showed that it could have democratic appeal, by stressing the expressiveness of form.

Interest now expanded into cultures beyond the Western European tradition. We find this in the work of Jacob Epstein, a sculptor who was also an early collector of African art. These anonymous carvings taught him, as they did Picasso, that artists could

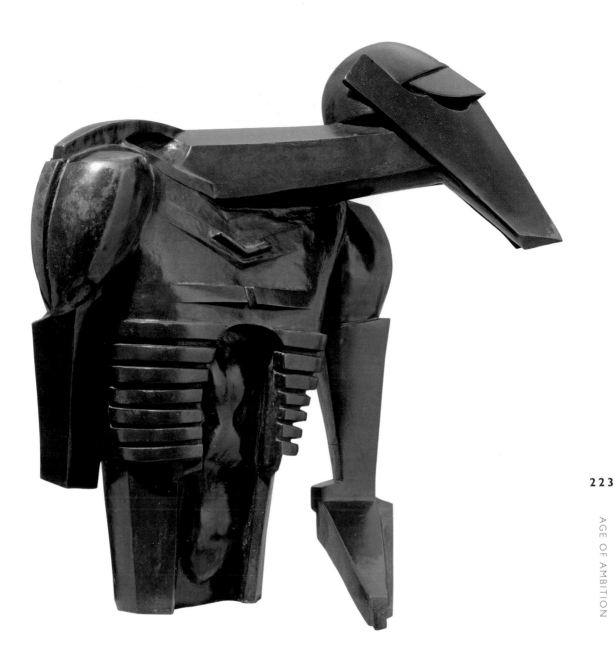

Originally The Rock Drill *by Jacob Epstein was full length and mounted on a real rock drill.*

work with information gained not just through the eyes but also from what they knew about a head, an animal or a figure. In other words Epstein, like others at this time, moved towards a more conceptual approach to art. In his *The Rock Drill* of 1913–14, for instance, he has abandoned realism in his depiction of the figure, giving it instead a robotic appearance, which conveys the toughness needed to operate this shatteringly noisy drill. A strange detail is the small figure inside the cavity in the workman's chest – a reference perhaps to future generations and the new world that this drill is helping to create.

Epstein was not alone in his search for a machine aesthetic. The Vorticists, led by Percy Wyndham Lewis, also wanted to create art

David Bomberg's In the Hold *depicts the shattered faces of refugees emerging from the hold of a ship. In the lower right hand corner is a ladder leading to the upper deck.*

Mark Gertler was a conscientious objector, and in The Merry-Go-Round, *1916, he transforms a fairground ride into a disturbing image of the futility of the First World War.*

that was hard and impersonal like a machine. The masterpiece of this period is *In the Hold* by David Bomberg. It is as if we are looking at this image through a kaleidoscope, since geometrical divisions have splintered the scene into fragments. The resulting disorientation suits the subject: beneath these glittering shards refugees are emerging from the hold of a ship to resume their shattered lives.

These new, fractured forms and the 'machine aesthetic' reflected the gathering violence of the First World War. Mark Gertler used the image of a merry-go-round to express the futility of war. Like Bomberg, Gertler was one of a talented group of artists to emerge from the Jewish ghettos of London's East End. The painting's garish colours and huge size further emphasise the nightmare of war. But it is Paul Nash's *We Are Making a New World* that, with its ironic title, offers the most pungent condemnation of war. Nash wrote to his wife from the Front:

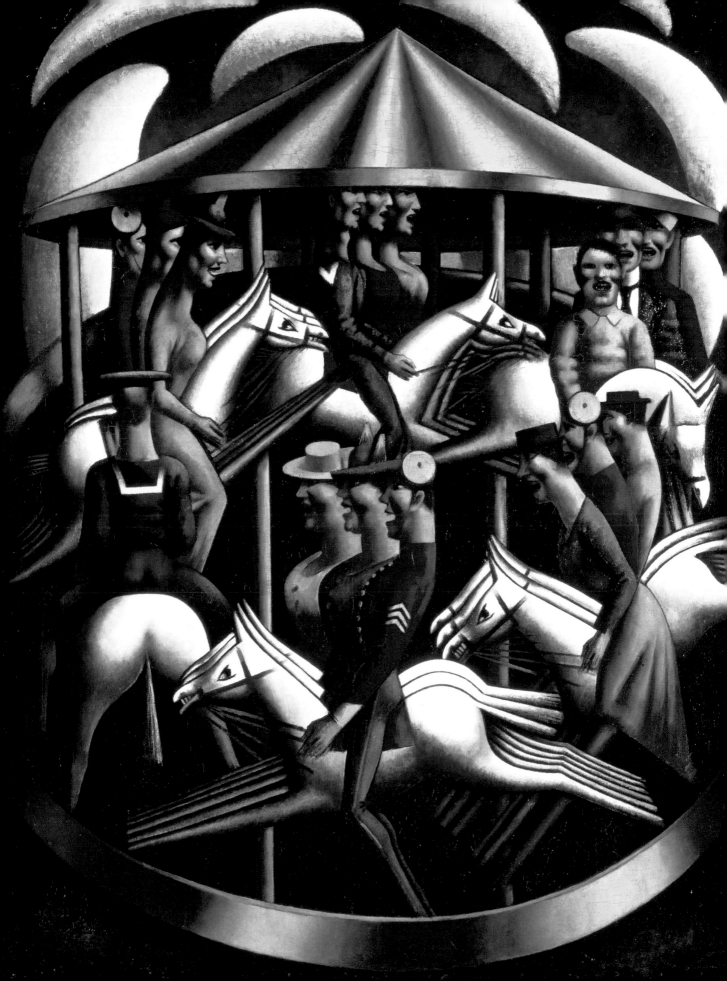

Paul Nash's
We Are Making
a New World
*portrays the bleak
landscape of the
First World War
battlegrounds he
had experienced
at first hand as an
infantry officer at
Ypres in 1917.*

'The rain drives on, the stinking mud becomes evilly yellow, the shell holes fill up with green-white water, the roads and tracks are covered with inches of slime, the black dying trees ooze and sweat and the shells never cease … It is unspeakable, godless, hopeless. I am no longer an artist interested and curious. I am a messenger who will bring back word from the men who are fighting to those who want the war to go on for ever. Feeble, inarticulate, will be my message, but it will have a bitter truth, and may it burn their lousy souls.'

Over a million lives were lost by the British Empire forces in the First World War, and almost no family remained untouched by the death of friends or relatives. Once peace returned, there was an enormous demand for war memorials, for every parish in Britain and a great many institutions wanted to commemorate their dead.

Memorials ranged from variations on the cross to full-blown architectural monuments, such as those built by Sir Edwin Lutyens in France to commemorate the battles of the Somme and Arras. One of the most prominent is Charles Jagger's *Royal Artillery Memorial* at London's Hyde Park Corner, which is topped by a gigantic howitzer. Most people glimpse this monument while passing by in a bus, car or taxi, but it is best seen on foot, since many details of trench warfare are carved into its side reliefs.

Sculpture at this time benefitted from a close relationship between artist and architect. This had developed in the late Victorian period, for no large commercial building or public office was thought complete without the addition of some form of figurative detail or sculptural decoration. At the start of the twentieth century, Ezra Pound noted wryly that sculptors were hard at work producing 'large, identical ladies in night gowns holding up symbols of Empire or Commerce or Righteousness'. He was referring to the mass-production of monuments to Queen Victoria, which were much in demand among the expanding industrial towns and universities. One of the largest and most impressive of these sculptures is the 1901 *Victoria Memorial* by Thomas Brock which sits at one end of the Mall, in front of Buckingham Palace.

Owing to this need for monuments and memorials, sculpture became the public art form *par excellence.* It was expected to educate the living as well as commemorate the dead; to promote ideal posture, moral virtue and high ideals; to fill the passer-by with elevated

thoughts. But as modern art developed, British sculpture, no longer an expression of civic pride, took on a different role..

Between the wars, Henry Moore and Barbara Hepworth were the two most innovative sculptors in Britain. Their work appeals to our emotions chiefly through the forms, shapes and tactile surfaces they use. They had much in common. Both came from Yorkshire, attended Leeds Art College and won scholarships to the Royal College of Art. Both drew inspiration from European and non-European sources and were committed to direct carving. In the late 1920s they lived and worked alongside each other in the Mall Studios in Hampstead, and

Henry Moore's Reclining Figures, *such as this one from 1929, were inspired by Mayan sculptures of the rain god* chacmool.

by the mid-1930s both were positioned at the forefront of the avant-garde. Yet despite their shared interests and similar background, their work is fundamentally different. Moore wanted to express the latent power and the energy contained within the materials he worked with, while Hepworth gave her attention to alterations in direction and movement that are closer to the surface of her carvings.

Moore's versatility is best revealed through his handling of the reclining figure, which became in his work a lifelong theme. His interest in this subject began in 1929, when he discovered a Mexican sculpture of the rain god, the *chacmool*, from the Mayan

settlement of Chichen Itzá. He soon broke with its rigid symmetry and experimented with variations on the pose. Moore used the body's limbs and torso to create arches, plateaus and slopes that carry echoes of time-worn landscapes. Aware of Surrealism, he brought an imaginative freedom to his handling of the figure and punched a hole in the thorax, breaking the body into two or more parts. As commissions began to arrive from all round the world, Moore became one of the most famous living artists.

Painting was slower to gain momentum after the First World War. The pity and horror of war had knocked the stuffing out of the avant-garde. Even a fighter such as Wyndham Lewis admitted: 'The geometrics which interested me so exclusively before, I now found

Swan Upping at Cookham by Stanley Spencer shows the annual bringing in of swans in order to clip their wings. The bridge in the background still exists at Cookham.

The cover of the Great Western Railway's brochure. During this time more people than ever before were travelling throughout Britain.

bleak and empty. They wanted *filling.*' This loss of confidence permitted the return of a more conservative approach and more traditional styles. There was a flight from the city and a revival of landscape painting. For example, two of the Scottish Colourists, F.C.B. Cadell and S.J. Peploe, began making regular visits to Iona, painting mostly on its north shore where rocks break through the pale sand and are offset by the green sea and dazzling blue sky. Closer to home, country cottages were easily available as weekend retreats at cheap rents. Paul Nash disappeared for a period to Dymchurch in Kent, where he recovered from a breakdown while painting the bleak coastline and its sea wall. Meanwhile, in Essex, Edward Bawden, Eric Ravilious and their wives shared Brick House at Great Bardfield, where they painted crisp watercolours of very English subjects.

While landscape remained a major inspiration for British art, Stanley Spencer also helped revive a love of narrative painting. Spencer was born in the Berkshire village of Cookham, which became for him an earthly paradise. Here, as a child, he imagined the Bible stories taking place just the other side of the high garden walls. All his life he retained the belief that the everyday and the divine are in close proximity. Out of this grew a desire to see what he called 'the wholeness of things': to unite spirit with body, the sacred with the profane. He brought the same fervour for truth to religious subjects as he did to his paintings of dustmen, suburbia and the intimacy of physical love.

This was the period in which there was a vogue for celebrating England and Englishness. It was encouraged by the growth in travel, by increased awareness of English heritage, by organisations such as the Council for the Preservation of Rural England (now the Campaign to Protect Rural England) and by the publication of county guides and travel books. Access to the countryside was enhanced by the establishment of the Youth Hostel Association (1929), the Ramblers Association (1932) and the Footpaths Act of 1934. But at the same time the countryside was rapidly changing. Almost four million new homes were built in England between 1919 and 1939, and concern was being loudly voiced over jerry-builders, the destruction of town centres and the curse of suburbia. There is a recurrent apocalyptic note in much of the protest against development during the 1930s, but it did seem, by the end of the decade, as if this development was indeed out of control. 'We are all now apprehensively aware,' wrote Clough Williams-Ellis in *Britain and the Beast* in 1937, 'that a mere handful of active speculators of only average barbarity can quite easily destroy the virginity of a whole territory in no more than a year or two ...'

Towards the end of this decade, renewed fear of war, and the possibility of attack and invasion, re-established appreciation of Britain's landscape and architectural heritage.

Despite this growing interest in the look of England, it seemed to Paul Nash that there was a recurrent weakness in British art. He identified it as 'a lack of structural purpose'. To counter this he set up, in 1933, Unit One – a group of eleven pioneering artists – and announced its existence in a letter to *The Times*. Unit One only lasted a year, but it stirred up a desire to experiment. Barbara Hepworth and future husband Ben Nicholson began making visits to Paris, where they came into contact with artists who had fled the totalitarian regimes in Russia and Germany where abstract and experimental art was censored. As a result, Paris had become a centre for non-figurative art, which was associated with a 'free' international style. Thus to be an abstract artist in the mid-1930s was to be on the side of personal freedom and democracy.

　　Nicholson contributed to this development a series of white reliefs. Confined often to two or three simple geometrical shapes in relief formation, they present an ideal of purity. Nicholson did not regard them as a retreat from reality – far from it. To him, this

In this radical White Relief, carved from pavatex, Ben Nicolson reduced the colour to white to achieve a sense of purity.

extreme simplicity, beauty and order formed an opposition to the muddle and disorder of society. Such rigorous purity, Nicholson and others hoped, would become the popular standard of good taste. But an abstract Mondrian painting, a Nicholson white relief or a serene Hepworth carving from the mid-1930s retains a high-brow seriousness that, even today, limits its appeal.

For a slightly younger generation of artists living through the economic slump of the 1930s, abstract art also seemed worryingly out of touch with the needs of the day. William Coldstream became convinced that art ought to be directed to a wider public. With three others, he set up the Euston Road School of Painting and Drawing. They rejected all ideas about the need to be progressive. Inspiration was drawn from Sickert's choice of subject matter, the brushwork of Degas and Cézanne's searching analysis. The result, seen in Coldstream's *On the Map*, is a quiet realism, which looks at everyday subjects in a restrained and economical manner.

As the political situation in Europe worsened, artists began to rethink their allegiances. John Piper became a significant figure. In the mid-1930s he had worked closely with Nicholson, developing a definite and distinctive abstract style, but in the late 1930s he reverted to representation. With the approach and onset of the Second World War, it seemed inadequate to paint abstracts that were unconnected to the past or to any particular country. Though he was considered by some a traitor to the modern cause, Piper set out to revive native traditions. He rediscovered a sense of national identity in English art, architecture and design, writing articles and books on this subject, and in his own pictures promoted a fresh interest in the sense of place, in memory, literary associations and in history.

Neo-Romanticism became the dominant style during the Second World War. It was dark in mood, broodingly romantic and patriotic. This was the period when London's Soho offered a haven to artists and writers as well as to servicemen on leave. While the bars and restaurants were restricted in the sale of alcohol by licensing laws, the clubs were not. Heavy drinking contributed to the counter-culture that flourished in

In On the Map, *William Coldstream shows his fellow artist Graham Bell holding a map, and his friend Igor Anrep sitting on the ground. For Coldstream, abstract art seemed irrelevant to modern life.*

Soho during the war years. It generated a flair, energy and often vicious wit, a mixture that was never fully recaptured after the return to peace. Elsewhere, during the 1940s, official war artists struggled to capture in their work an authentic record of the war. One problem was that they were kept at a distance from the Front. Many only ever saw the Home Front and had to paint scenes of factory production, steel and quarry workers. Some of the most memorable wartime images are Henry Moore's drawings of people sheltering for the night on the platforms of the London Underground, with blankets wrapped round them like winding sheets. Still more dramatic were the ruins created by the Blitz. In November 1940 John Piper was sent to Coventry the day after the city had suffered blanket bombing. His task was to paint the cathedral, which had been reduced overnight to a crumbling ruin, open to the skies.

Coventry Cathedral by John Piper. Piper visited Coventry the day after the terrible bombing by the German Luftwaffe in 1940.

The decade immediately following the Second World War was a period of austerity and anxiety; feelings of victory and relief at the return to peace were overshadowed by revelations concerning the Holocaust and by the fearsome destructiveness of the atom bomb. Though a Labour government under Clement Attlee embarked on a period of social reform, a vein of pessimism underlay this period, and emerges in post-war art.

In 1950 Cyril Connolly closed down his magazine *Horizon* with an editorial that contained a gloomy prediction: 'From now on an artist will be judged only by the resonance of his solitude and the quality of his despair.' Two artists he may have had in mind when he wrote these words were Lucian Freud and Francis Bacon. Both concentrated on depicting the human figure, often alone, in a bare interior, neither enhanced nor diminished by any social or professional accessories that might detract from the raw facts of existence. Bacon frequently blurred the details of his paintings – a technique that muffled his subjects in a disquieting manner. By contrast Freud, in the course of his long career, has pursued a relentless objectivity that aims at unveiling every detail of physical existence. Often little is conveyed about the personality of his sitters, but their vulnerable humanity is evident in the unremitting focus on hair, flesh, veins and skin.

There were other artists in the early 1950s searching for ways in which to catch the character of the period. Frank Auerbach painted building sites; Prunella Clough focused on working figures – fishermen, factory workers, printers and lorry drivers; and the Kitchen Sink painters – John Bratby, Edward Middleditch, Derrick Greaves and Jack Smith – painted dour subjects with gutsy realism. Bratby specialised not in tasteful still lifes but in dustbins, milk bottles, beer bottles, cornflake packets: the clutter and debris of ordinary domestic life.

Almost overnight, these various forms of realism were knocked out of court by the arrival of the Americans. In exhibitions at London's Whitechapel Art Gallery and at the Tate, the public was introduced in the late 1950s to American Abstract Expressionism through the art of Jackson Pollock, Mark Rothko and others. The sheer scale of these paintings, and the total commitment they seemed to represent, made much of English art seem suddenly dilettante, tasteful and outmoded. The painter and critic Patrick Heron spoke for many when he wrote of the new American art: 'I was instantly elated by the size, energy, originality, economy, and inventive daring of many of the paintings. Their creative emptiness represented a radical discovery.'

A whole generation of British artists responded to the public excitement over American art. Art schools were suddenly awash with large-scale abstract paintings. There followed an art boom – a joyful confidence and optimism that chimed with an economic resurgence and Harold Macmillan's famous remark, 'you've never had it so good'. London became a hotbed of cultural vitality. Much abstract art seemed to explore the limitations of the picture's surface. Op Art explored the destruction of that surface by illusion. Patterns and colours were composed in such a way as to create movement, not actually on the surface but in the retina of the viewer's eye. Bridget Riley became the foremost exponent of this style; while in sculpture Anthony Caro

Bridget Riley's Cataract 3 creates the illusion of movement on the surface of the painting.

turned away from modelling and carving and began bolting and welding together steel units. This, too, proved a radical move, as it removed sculpture from the rarefied discourse of high art. Caro also did away with the pedestal and placed his sculptures on the floor, in real space and amid the everyday world. He also painted many of the sculptures a single colour – the strong hue acting as a unifying ingredient.

One of Caro's followers, Phillip King, used a steel sculpture to play with the idea of a rosebud, inverting the natural colours so that the green seems to be bursting through the pink cone. This playfulness was also evident in Pop Art, a movement that sidestepped the mainstream, embraced popular culture and dealt knowingly with the imagery generated by advertisements and the media. Pop Art proved to have wide appeal, owing to an astonishing array of talented individuals – Eduardo Paolozzi, Peter Blake, David Hockney and Patrick Caulfield, to name just a few.

The movement began in the 1950s, during meetings of the Independent Group at London's Institute of Contemporary Art. One of its members, John McHale, brought back from America in 1954 a trunkload of comics and colour magazines. These aroused huge interest, for these intellectuals were aware that new technology, an expanding economy and a fast-developing mass-media culture were changing the way people viewed the world. Another member, Richard Hamilton, moved from relative obscurity to become world famous as the father of Pop. His famous collage – *Just What Is It that Makes Today's Homes So Different, So Appealing* (see page 244) – was designed for the exhibition 'This is Tomorrow' in 1956, and remains the most iconic piece of Pop Art in existence. The following year Hamilton drew up a list of all the things he thought Pop Art should be: 'Popular (designed for a mass audience), Transient (short-term solution), Expendable (easily forgotten), Low cost, Mass produced, Young (aimed at youth), Witty, Sexy, Gimmicky, Glamorous, Big Business.'

But this dazzling period, in which one movement seemed to follow another, fell into disarray in the late 1960s and early 1970s when a crisis arose in relation to modernism. Suddenly the various critical theories used to explain the latest development in art lost their authority and began to seem inappropriate or irrelevant. The reason for this was that artists had started to employ a bewildering, eclectic range of styles and practices. Sculpture, for instance, had expanded into the landscape – Richard Long made art out of his walks, which introduced dimensions of time and space. Gilbert and George began making 'living sculpture', using themselves and their daily lives as

We Two Boys Together Clinging by
David Hockney was inspired by the
urgency of street graffiti.

material for a subversive doubleact. If they belong to any movement it is to an international avant-garde that works with conceptual ideas.

Admittedly, there was a revival of interest in painting in the 1980s, but it was not until the end of that decade that British art once again regained the confidence it had displayed in the 1960s. It was then that the YBAs (Young British Artists) emerged, mostly from Goldsmiths College of Art in London. Adopting the entrepreneurship of the Thatcher era, they mounted exhibitions, published catalogues, drew upon the contacts provided by their tutors and got the attention – from critics, curators, collectors and corporate sponsors – that they sought. The 'Freeze' exhibition organised by Damien Hirst in July 1988, during his second year at Goldsmiths, has become legendary. So too has his shark in formaldehyde, which was showcased by Charles Saatchi in 1992 in his first 'Young British Artist' exhibition. The shark is memorably titled *The Physical Impossibility of Death in the Mind of Someone Living*. This same year, Hirst first exhibited *Pharmacy (page 246)*, a literal recreation of a chemist's shop, in a gallery in New York. The piece now belongs to Tate, London.

Hirst has come to personify a new stance in art – one that uses bold, shocking or punchy solutions and puts art in the public domain with a vigour and chutzpah that overrides the usual checks and balances that govern the art world. But he is not alone in his determination to tackle highly charged content and big themes. Cornelia Parker is best known for her large-scale installations. In order to create *Cold Dark Matter: An Exploded View* she had a garden shed blown up by the British Army and afterwards suspended the fragments in mid-air, as if the explosion has been stilled and fixed in

Richard Hamilton created Just what is it that makes today's homes so different, so appealing *from magazine cuttings that he and his wife collected. On the ceiling is a photograph of the earth taken from a satellite.*

Damien Hirst's Pharmacy is a room-sized installation representing a real pharmacy.

time. This installation has a light at its centre so that the shards of wood and debris cast dramatic shadows over the walls of the gallery.

Bomb scares have become part of modern life, but so too is death, beauty, ugliness, destruction, regeneration and memory – all topics with which today's artists engage. Rachel Whiteread began her career as a sculptor by taking casts of empty spaces – the inside of a bath or a hot-water bottle or the underside of chairs. Surprisingly, these anonymous spaces associated with very ordinary objects, when caught in plaster, rubber or resin, become icons of memory and loss. In 1990 she cast an entire room in concrete and called it *Ghost*. In 1993 she created a cast of a whole council house in London's East End, shortly before it was due for demolition. The work was intended as a monument to the ideals surrounding social housing that came in after the Second World War. But anyone who saw this looming concrete cast will recall how it touched a nerve and activated memories at many levels. Sadly, the London Borough of Tower Hamlets did not see it this way. Bulldozers destroyed the work in 1994, despite massive lobbying for its retention.

These powerful conceptual works show how far artists have moved towards closing the gap between art and the general public. This move brings to a climax a development that began with Sickert's determination to create a new audience for modern art. It was encouraged by Fry's democratisation of culture, and further broadened by the Pop artists' embrace of mass media. In the course of the twentieth century, art, once the preserve of an educated élite, gained popular appeal. The Turner Prize joined hands with the media to make contemporary art a topic of broad concern. No longer confined to the often rarefied air of the private gallery, it could now be found in warehouses, converted chapels, in factories or in the streets where it was closely interlinked with the issues of the day. In the course of this tumultuous century, it had become art for the people in a people's age.

House by Rachel Whiteread: a vanished work of art.

Further Reading

General

The Story of Britain by Roy Strong
The Spirit of Britain by Roy Strong
Albion by Peter Ackroyd
The Isles by Norman Davies
The English: A Social History by Christopher Hibbert
Great Tales from British History by Robert Lacey

Age of Conquest

Work of Angels by Susan Youngs
Mosaics in Roman Britain by Patricia Witts
Roman Britain by TW Potter
Sutton Hoo: Burial Ground of Kings by Martin Carver
Surviving in Symbols by Martin Carver
Vikings by David Miles
Alfred the Great by Justin Pollard
The Tribes of Britain by David Miles

Age of Worship

Thomas Becket by Anne Duggan
England in the Late Middle Ages by A R Myers
England Under the Norman and Angevin Kings, 1075-1225
 by Robert Bartlett
Shaping the Nation: England 1360-1461 by Gerald Harriss
Age of Chivalry: Art in Plantagenet England
 eds. Jonathan Alexander and Paul Binski
The Wilton Diptych by Dillian Gordon
The Canterbury Tales by Geoffrey Chaucer
Everyday Life in Medieval England by Christopher Dyer
King Arthur by Christopher Hibbert
Romance and Legend of chivalry by Hope Moncrieff
Chaucer by Peter Ackroyd

Age of Power

A New World by Kim Sloan
Hans Holbein: Portrait of an Unknown Man by Derek Wilson
Sir Francis Drake by John Sugden
Ralegh and the British Empire by D B Quinn
Tudor England by John Guy
The Cheapside Hoard by Hazel Forsyth
Gloriana: The Portraits of Queen Elizabeth I by Roy Strong
Elizabeth's London by Liza Picard
The Stripping of the Altars by Eamon Duffy
Hampton Court: A Social and Architectural History by Simon Thurley
Bloody Foreigners by Robert Lacey

Age of Revolution

Ingenious Pursuits by Lisa Jardine
A Gambling Man: Charles II and the Restoration by Jenny Uglow
The English Civil War by Diane Purkiss
Van Dyck and Britain ed. Karen Hearn
The Sale of the Late King's Goods by Jerry Brotton
Building St Pauls by James W P Campbell
The Trial of Charles I by C V Wedgewood
Charles II by Christopher Falkus
Oliver the First: Contemporary Images of Oliver Cromwell by John Cooper
The Mistresses of Charles II by Sonya Wynne
The "Windsor Beauties" and the Beauties Series in Restoration England
 by Catharine MacLeod and Julia Marciari Alexander
The Great Fire of London by Stephen Porter

Age of Money

Britons by Linda Colley
City of Laughter by Vic Gatrell
Enlightenment by Roy Porter
Dr Johnson's Dictionary: The Extraordinary Story of the Book
 That Defined the World by Henry Hitchings
Hogarth by Jenny Uglow
Age of Wonder by Richard Holmes
The Pursuit of Victory: The Life and Achievement of Horatio Nelson
 by Roger Knight
Josiah Wedgwood by Brian Doolan
The Dress of the People by John Styles

Age of Empire

Empire by Niall Ferguson
The Rise and Fall of the British Empire by Lawrence James
Decline and Fall of the British Empire by Piers Brandon
Stones of Empire: The Buildings of the Raj by Jan Morris
Edge of Empire by Maya Jasanoff
Imperialism and Popular Culture by John M Mackenzie
The Victorians by A N Wilson

Age of Ambition

After the Victorians by A N Wilson
Our Times by A N Wilson
British Art Since 1900 by Frances Spalding
Soho, A History of London's Most Colourful Neighbourhood
 by Judith Summers
Austerity Britain by David Kynaston
British Art in the Twentieth Century by Susan Compton
Constructivism to Reconstruction: Barbara Hepworth in the 1940s
 by Chris Stephens
A Bitter Truth: Avant-Garde art and the Great War by Richard Cork

Contributors

Martin Carver

is an archaeologist who has explored early medieval sites in England, Scotland, France, Italy and Algeria, directing excavations at the seventh century royal burial ground at Sutton Hoo and the eighth century Pictish monastery at Portmahomack. He was professor of archaeology at York until 2008 and is now editor of *Antiquity*, the journal of world archaeology.

John Goodall

is the architectural editor of *Country Life* magazine. He took his doctorate at the Courtauld Institute, London. Besides publishing widely on architecture, he acted as the series consultant for David Dimbleby's BBC1 series *How We Built Britain* (2007). His next book *The English Castle, 1066-1650* is to be published in 2010.

Susan Doran

is Senior Research Fellow in History at Jesus College, Oxford, and Director of Studies in History at Regent's Park College, Oxford. She has written extensively on the Tudor period, and also edited the catalogues for the exhibitions on Elizabeth I at the National Maritime Museum (2003) and Henry VIII at the British Library (2009).

Catharine MacLeod

is Curator of Seventeenth Century Portraits at the National Portrait Gallery. She co-curated the exhibition *Painted Ladies: Women at the Court of Charles II* at the National Portrait Gallery in 2001 and co-wrote the catalogue of the same title.

Recent publications include *Politics, Transgression and Representation at the Court of Charles II*, edited with Julia Marciari Alexander.

John Styles

is Research Professor in History at the University of Hertfordshire. Previously he worked at the Victoria and Albert Museum, where he was historical advisor to the museum's new 'British Galleries, 1500-1900'. He specialises in the study of fashion, design and material culture in the eighteenth century. His most recent book is *The Dress of the People: Everyday Fashion in Eighteenth-Century England* (2007).

Lawrence James

is the author of *The Rise and Fall of the British Empire*, *Raj: The Making and Unmaking of British India*, and biographies of Lawrence of Arabia and the Duke of Wellington. His latest book is *Aristocrats*, which is a history of the British nobility.

Frances Spalding

is an art historian who specialises in twentieth century British art. She is the author of fifteen books, including *British Art Since 1900* and a centenary history of the Tate. She is also the biographer of the artists Roger Fry, Vanessa Bell, John Minton, Duncan Grant and Gwen Raverat, and of the poet Stevie Smith. Her most recent book is *John Piper, Myfanwy Piper: Lives in Art*. She teaches at Newcastle University.

David Dimbleby would like to thank:

The seven contributors whose expertise made this book possible: Martin Carver, John Goodall, Sue Doran, Catharine MacLeod, John Styles, Lawrence James and Frances Spalding.

At Hodder & Stoughton: Rupert Lancaster, Laura Macaulay, Camilla Dowse and Will Webb whose skill and enthusiasm supported the project from the start. And my literary agent, Rosemary Scoular.

The former Controller of BBC One, Peter Fincham, who first proposed *Seven Ages of Britain* as a BBC television series, Jay Hunt, the present Controller, who subsequently supported the series. My Executive Producer Basil Comely. After producing two previous art series, he has once again been the benevolent godfather of *Seven Ages*.

Jonty Claypole was the Series Producer. His creativity and energy brought the project to fruition.

Other key participants were:

Directors: Karen McGann, Helen Nixon, John Hay, Kate Misrahi and John Mullen.
Series Editor: Andrea Carnevali, the best there is.
Researchers: Suniti Somaiya, Georgina Leslie and Andrew Saunders who diligently prepared the ground and patiently answered all my questions.
Cameras: Chris Titus King, Justin Evans, Ben Wheeler
Sound: Freddie Claire, John Thomas and Marc Wojtanowski.
Music: Chris Nicolaides and his team
Production Co-ordinators: Paul Birmingham, Jenny Scott, Emma Fletcher, Alice Lister, Jane Chan and Helene Roseby.

Key members of The Open University team, who have backed *Seven Ages* from the outset: Rachel Gibbons, Caroline Ogilvie (Executive Producer of the OU) and Catherine McCarthy (BBC Liaison Executive Producer with the OU).

I am also grateful to all the experts and curators who gave their time and advice so generously. Among the many institutions that have helped us are the British Museum, Bignor Roman villa, Ashmolean, Bodleian Library, Tower of London, Hereford Cathedral, Canterbury Cathedral, The Parker Library, Corpus Christi Cambridge, The National Gallery, Westminster Abbey, Hampton Court Palace, The Pepys Library, Magdalene College Cambridge, Portsmouth Royal Dockyard, The Victoria and Albert Museum, Tate Britain, The British Library, The National Portrait Gallery, The Royal Hospital Chelsea, Greenwich Royal Observatory, The Science Museum, St Paul's Cathedral, Bank of England, Kenwood House, Wedgwood Museum, Johnson's house, Sir John Soane's Museum, Royal Academy, Kew Palace, Queen's House, Imperial War Museum, Bolton Museum, as well as Paul Binski, John Guy, John Morrill and Henry Wyndham, chairman of Sotheby's.

Lastly, and crucial to the project on the home front: my assistant Samantha Stonard, my son Fred for his forbearance, and my wife Belinda for her loving support and encouragement.

Picture acknowledgements

© akg-images: 30-31, 46/photos Erich Lessing. © Alamy Images: 42/photo National Trust Photolibrary, 69/photo Angelo Hornak, 80/photo Robert Harding Picture Library, 88/photo David Pledger, 101/photo Glyn Thomas, 130/photo Mike Booth, 146/photo The Print Collector, 148-149, 163/photos Classic Image, 150-151, 162/photos World History Archive, 179 top/photo Streetlife, 229/photo imagebroker, 234/photo Lordprice Collection. © The Art Archive: 102. © Ashmolean Museum, University of Oxford/photo Bridgeman Art Library: 10. © BBC 2009: 6-7/photo Jenny Scott, 8-9, 11, 26, 27, 32-33 184-185/photos Georgina Leslie, 12, 122-123/photos Marc Wojtanowski, 15, 18, 60-61, 92-93/ photos Suniti Somaiya, 23, 152-153/photos Andrew Saunders, 28/photo Jonty Claypole. © BFI Stills: 212-213. © Bodleian Library, University of Oxford (MS. Tanner 10, fol. 54r): 55. © The British Library Board 2009: 47/photo Bridgeman Art Library, 74 (Add. 42130 f.208), 78-79 (detail) (Arundel 83 f.127), 84-85 (detail)/photo Bridgeman Art Library, 188-189/photo akg-images. © The Trustees of the British Museum: 34 (1857,0715.1), 35/photo Bridgeman Art Library, 40 (1861,1024.1), 43 (1939,1010.93.B.4), 44 (1939,1010.4), 118/photo Bridgeman Art Library, 165 (1880,1113.5484), 172 (1868.0808.7623). © Burghley House Collection, Lincolnshire/photo Bridgeman Art Library: 114. © Martin Carver: 50 bottom. © By kind permission of the Estate of William Coldstream/The Bridgeman Art Library/photo Tate, London 2009: 236. © Corbis: 62/photo London Aerial Photo Library, 65/photo The Art Archive, 75/photo Angelo Hornak, 219/photo Hulton-Deutsch Collection. © Corpus of Anglo-Saxon Stone Sculpture/photo T. Middlemass: 52. © By kind permission of Coventry Cathedral/ Herbert Art Gallery & Museum/photo Bridgeman Art Library: 238. © Dorset County Museum/photo Bridgeman Art Library: 36. © English Heritage/photo Photolibrary: 66-67. © The Estate of Sir Jacob Epstein/ Tate, London 2009: 223. © The Estate of Mark Gertler/Tate, London 2009: 225. © Getty Images: 38-39/ photo Adam Woolfitt, 58-59/photo Peter Macdiarmid, 168, 182-183, 199 left and right/photos Hulton Archive. © By kind permission of Gilbert & George/White Cube Gallery/photo Jonty Claypole/BBC 2009: 216-217. © Crown Copyright, UK Government Art Collection: 106-107. © Estate of Duncan Grant. All rights reserved, DACS 2009/Estate of Vanessa Bell, courtesy Henrietta Garnett/Tate, London 2009: 222. © Guildhall Library & Art Gallery/photo Photolibrary: 166-167. © Richard Hamilton. All rights reserved. Kunsthalle, Tubingen, Germany, DACS 2009/photo Bridgeman Art Library: 244. © Harewood House Collection: 174 bottom. © Headland Archaeology (UK) Ltd: 50 top. © Damien Hirst. All rights reserved, DACS 2009/photo Press Association Images: 246. © David Hockney ("We Two Boys Together Clinging" 1961): 243. © Courtesy of the Huntington Library, Art Collections, and Botanical Gardens, San Marino, California: 180. © Imperial War Museum: 214-215, 226-227. © Estate of Gwen John. All rights reserved, DACS 2009/National Museum Wales/photo Bridgeman Art Library: 218. © Lady Lever Art Gallery, National Museums Liverpool/photo Bridgeman Art Library: 176. © Leeds Museums and Galleries/photo Bridgeman Art Library: 209. © Longleat House, Wiltshire/photo Bridgeman Art Library: 105. © Mary Evans Picture Library: 174 top. © Reproduced by permission of The Henry Moore Foundation: 230-231/photo Leeds Museums and Galleries/ Bridgeman Art Library, 232/photo Hulton Deutsch Collection/Corbis. © Treasury of the Munich Residenz, Germany: 81. © Musée de la Tapisserie, Bayeux, France: 56-57/photo Bridgeman Art Library. © Museum of London: 21. © Museum of London: 51/photo Bridgeman Art Library, 72, 144-145/photos Photolibrary. © National Army Museum, London/photos Bridgeman Art Library: 207, 210. © National Gallery, London: 83 top and bottom, 94, 98-99 (detail), 170 top/photos Bridgeman Art Library. © National Museum of Ireland, Dublin/Boltin Picture Library/photo Bridgeman Art Library: 45. © The Trustees of the National Museums of Scotland: 49. © National Portrait Gallery, London: 113 (detail), 127, 136, 140. © National Portrait Gallery, London/photos Bridgeman Art Library: 90-91 (detail), 103. © Ben Nicholson. All rights reserved. Private Collection, DACS 2009/photo Bridgeman Art Library: 235. © Norwich Castle Museum and Art Gallery: 86. © The Collection at Parham Park: 124. © Pierpont Morgan Library 2007/Art Resource/Scala, Florence: 54. © Private Collection/photos Bridgeman Art Library: 120-121 (detail), 134 (detail), 138 (detail), 197. © Harry Ransom Humanities Research Center, The University of Texas, Austin: 200. © Bridget Riley 2009. All rights reserved. Courtesy Karsten Schubert London: 241. © The Royal Collection © 2009, Her Majesty Queen Elizabeth II: 96 (detail), 133, 143, 201. © The Royal College of Art Collection: 240. © Science Museum/ Science & Society Picture Library: 156-157. © Walter Sickert. All rights reserved. Nottingham Castle Museums and Galleries, DACS 2009/photo Bridgeman Art Library: 220. © Courtesy of The Trustees of Sir John Soane's Museum, London/photo Bridgeman Art Library: 178. © Sotheby's Picture Library: 206. © The Estate of Stanley Spencer. All rights reserved DACS 2009/Tate, London 2009: 233. © Tate, London 2009: 97, 186, 195, 224. © The Thomas Ross Collection www.rosscollection.co.uk: 211. © V&A Images: 76 (detail), 77, 128, 155, 161, 169. © Victoria & Albert Museum, London/ photos Bridgeman Art Library: 112, 116. © Walker Art Gallery/National Museums Liverpool/photo Bridgeman Art Library: 109, 111 left and right (detail), 202-203 (detail). © By kind permission of Warwickshire Museum Service: 41. © Reproduced by kind permission of Rachel Whiteread/photo John David Begg: 247. © Whitworth Art Gallery, The University of Manchester/photo Bridgeman Art Library: 170 bottom. © Yale Center for British Art, Paul Mellon Collection, USA /photo Bridgeman Art Library: 179 bottom. © York Minster Glazier Trust/photos Nick Teed: 70, 71.

Every reasonable effort has been made to trace copyright holders, but if there are any errors or omissions, Hodder & Stoughton will be pleased to insert the appropriate acknowledgement in any subsequent edition.

INDEX

Figures in italics indicate captions.